In Memory of Oskar Hagen

PREFACE

This collection of essays about Goya does not aim to present the entire range of attitudes and opinions that critics and art historians have held about his work. I have tried instead to gather together texts that document the amazing relevance that Goya has had to different critical moments of modern history and modern civilization. Only in the decades in which western civilization achieved a semblance of permanence did Goya become relatively meaningless. In the self-confident years before the outbreak of World War I, for instance, it was possible for a man as sensible and as sophisticated as Meier-Graefe to note in his *Spanish Diary* that Goya's *Majas* were nothing but *kitsch*. Gautier's comments also sound singularly detached, speaking as he did for a generation that had won many of its battles. Yet Baudelaire, the poet who in his work and in his life brought into focus all the sombre conflicts of his times, already saw Goya with a more discerning and a more anguished eye.

The texts chosen here are meant to bring Goya closer to a generation of students whose life has been overshadowed by foreboding events and by circumstances that are just barely covered up by a superficial appearance of well-being. For those students who want to familiarize themselves with the extent of Goya's work and with the variety of art-historical scholarship that has been inspired by that work, a bibliography of the most important studies is appended to this volume. Above all, however, the student ought to look carefully at the superb critical bibliography by Jutta Held. The best

compendium of all that has been said and thought about Goya can be found in the recently published four-volume catalogue raisonné by José Gudiol, which includes an excellent biographical study as well as an encyclopedic listing of attributions. Several essential works must here be mentioned for the use of those students whose appetites are whetted by the present collections. The first is Lafuente Ferrari's monumental *Antecedentias* (cf. Bibliography) which brings together an enormous body of scholarly material which remains the *sine qua non* of all future Goya studies. Jutta Held's invaluable critical assessment of Goya literature is another tool for which all Goya lovers will always be grateful. The masterly research into the iconography of Goya's imagery found in the works of George Levitine affords astonishing insights into the breadth of Goya's intellectual preparation and ought to be consulted by all advanced students. For the understanding of Goya's graphic work, Tomas Harris' monumental study cannot be praised highly enough. Harris not only catalogues all known proofs and states of the entire graphic *oeuvre*, but he also presents all the drawings and paintings that relate to the prints.

Thanks go to the holders of copyrights. Without their help, the present anthology would have been unthinkable. The author also gratefully acknowledges the hospitality of the Harvard library at Villa I Tatti. The vastness of this library made my Goya studies a pleasure, as did the ever helpful staff, among whom Gloria Ramakus must be singled out. Vivian Volbach undertook the translation of Hetzer's article, while Elena Radutzky translated Lafuente Ferrari's essay. Both of these translations as well as all the other material in this volume, including my own contribution, were carefully checked and edited by my wife; she also shared the clerical work with Judith Munat. Actions rather than words will have to prove my gratitude to them.

CONTENTS

INTRODUCTION

Fred Licht

The public in Spain is impartial; it applauds the bull and the matador according to their individual merit. If the bull disembowels a horse and throws one of the men: "Bravo toro!"; if it is the man who wounds the bull: "Bravo torero!" But cowardice in man or beast is considered intolerable.

THÉOPHILE GAUTIER
Voyage en Espagne

Goya is the *éminence grise* of modern painting. One suspects his influence everywhere without ever being able to establish direct connections. One suspects that Delacroix, who refers to Goya several times in his writings, must have learned from him, yet there is no definite evidence. Daumier, Courbet, and the powerfully influential illustrators of the mid-nineteenth century seem to stand in direct line of inheritance, but one is again at a loss when it comes to proving true kinship between Goya's realism and the work of these later artists. With Manet we seem to be on safer ground; surely his *Reclining Model in Spanish Costume* and the great *Execution of Emperor Maximilian of Mexico* can almost be considered plagiarisms. Degas' startling juxtapositions seem to owe a great deal to Goya. Eakins' *Gross Clinic* teasingly suggests a strong connection with his world. In our own century expressionism, in both Germany and America, continues this supposed lineage. There are passages in cubism that immediately bring to mind similar visual episodes in Goya's graphic work. With surrealism we enter upon a tradition that stems directly from Goya, and who but a Spaniard, counting Goya among his most influential ancestors, could have conceived *Guernica?*

1

Not only the avant-garde seem to have learned from Goya. Official propaganda and, indeed, commercial advertising suggest many a derivation from Goya, who was, after all, the first artist to use painting aggressively, polemically. The comparison with Hogarth is instructive, for Hogarth's perception of human folly and social injustice is equally bitter. But his expression of this bitterness is still traditional in its composition and its pictorial technique. We "read" Hogarth's paintings and prints, admiring the artist's skill and his sense of detailed observation. He instructs us by simultaneously delighting us. The broken crockery of *Marriage à la mode*, the defensive boredom of the husband's inelegant pose, the cunning contempt of the servants, all these episodes are displayed with great aplomb for our appreciation. We approach the painting because its very surface, its colors, its composition promise us a reward. In Goya's work, it is frequently the image that approaches us. The unfamiliar, deliberately disorienting juxtapositions strike us and command our attention without promising us any recompense for having shaken our normal equilibrium. This striking element, which begins with Goya and which marks so much of modern imagery, pertains not only to painting and the graphic arts of the nineteenth and twentieth centuries but also is a specific component of the most typically modern art: photography. The "frame," whether in still or in cinematic photography with its powerful onslaught on the emotions, is directly related to the compositional revolution first instituted by Goya. Looking at Matthew Brady's sober photographs of the American Civil War, one cannot help but be reminded immediately of Goya's *Disasters of War*. Even the more officially accepted and popularly understood tendencies in modern art, from the social realism of public decorations in post offices and railway stations to the vacuous society portrait, all fashion and no face, owe a profound debt to Goya.

Yet when one begins to trace the genealogy of Goya's supposed progeny one comes away with the most ambiguous results. Goya's presence turns out to be a spectral one at best. In most cases it is downright impossible to prove any kind of direct influence was exerted by him on any of his supposed disciples. The romanticists and realists knew hardly any of Goya's work. It is believed that Delacroix had seen the *Caprichos*, perhaps all of the series, but even that is by no means sure. In the Musée Espagnol, which played, according to contemporary critics, such a big role in the formation of young

talents, Goya was very poorly represented. Private collections in Paris, although they contained a few, a very few paintings, were for the most part closed to artists; certainly such socially reprehensible personages as Daumier and Courbet would not have been admitted to the salons and galleries where these paintings could be seen. Even in the case of Manet, despite some fairly obvious "borrowings" staring us in the face (the two paintings mentioned above and the *Balcon*), Manet's references to Goya's work are so deliberately oblique and ironic that we can never be quite sure that they are references. Recent critical studies of Manet have gone to great lengths to minimize, even destroy, the old idea of his admiration of Goya. Indeed, although one can learn a great deal about his admiration for Velazquez in Manet's letters from Madrid Goya isn't even mentioned. Nor do such masters of the daring *mise en page* as Degas and Toulouse-Lautrec, whose work is so deeply germane to Goya's, show any deliberate or conscious interest in his work.

The nineteenth century, though it is strangely dominated by Goya's prophecies, shows little indication of active interest in the master from Zaragoza. When the Black Paintings were exhibited to the public for the first time, nearly a century after their creation, only one newspaper—a provincial one at that—even mentioned the most strikingly enigmatic visions in the whole of Western art. The increasing importance of his reputation and our growing understanding of his fundamental discoveries about modern man are primarily due to the perceptive interest taken in Goya's work by a handful of French poets and writers. Spanish publications during the nineteenth century, though they are fundamental for the scholar and provide us with important documents, are essentially indifferent to the true value of Goya's *oeuvre* and stay, critically speaking, entirely within the very provincial framework of the nineteenth-century Spanish viewpoint. It is typical of the slow awakening of the Spanish awareness to and of Goya's real worth that the first truly public edition of the *Caprichos* dates from 1850, the earlier edition of 1799 having been taken off the market almost as soon as it appeared. The *Disasters of War* weren't published until 1863. A pirated edition of the *Disparates* was offered to the public in 1850, and the first official publication of this startling series was edited in 1864 by the Academia de San Fernando. Not until that date can one speak of an even approximately complete knowledge of Goya's graphic work on the part of a fairly large public. His paintings had to wait even

longer before they came into the public domain. For decades only the *Uprising in the Puerta del Sol* (Fig. 2) was exhibited in the Prado; the *Third of May* (Fig. 3), now universally recognized as the first and most profound visual expression of modern man's tragic destiny, lay rolled up and forgotten in the museum depot.

At the time that Gautier undertook his trip to Spain, his travel diary constituted something of an audacious novelty. Probably his trip was not quite as fraught with difficulties and dangers as he would like to have us think; nevertheless, his diary is the first which is meant either to induce us to follow in his footsteps or to furnish us with a substitute for such a voyage. All earlier travel books had quite the opposite effect. They were meant to guide those who had the misfortune of being forced to undertake a trip to Spain and to move others to an ardent prayer of thanks for having been spared such a nasty adventure. Even in the later nineteenth century one did not go to Spain for the sheer joy of tourism. Manet, although he had every reason to be interested in Spain and Spanish art, thought the country intolerably barbaric, and even the paintings of Valazquez, one reads between the lines, were barely sufficient recompense for the hundreds of large and little offenses against his accustomed sense of civilized comfort.

To the French, the notion that Spain was nearly as distant as the moon persisted, despite a superficial hispanicism that reached its apex when Eugenie de Montijo became Empress of France. Even in the 90s Octave Mirbeau, in his parodistic novel *Les vingt-et-un jours d'un neurasthénique,* depicted the average *bon bourgeois français* as regarding the farthest streetlamp of a small spa in the French Pyrenees as the last outpost of civilization; between that and the French colonies of North Africa lay nothing but darkness. Zachary Astruc was perhaps the only cultivated and perceptive traveller to Spain in the second half of the nineteenth century to carry away a positive impression that went beyond the superficial picturesqueness of those earlier nineteenth-century artists who painted Spanish themes without the slightest understanding of Spanish traditions.

The second phase in the history of the slow and difficult discovery of Spanish art by non-Spaniards is closely related to the vagaries of the art market. Towards the end of the nineteenth century the major sources of art for the vigorously growing and violently competitive national museums of Europe and America were beginning to show signs of depletion, and clever museum directors,

especially Wilhelm von Bode of the Berlin Museums, looked to Spain as a new and as yet unexploited source of pictures. Spanish fifteenth-century art, El Greco, Zurbaran, Ribera, and many fascinating but utterly unknown painters were suddenly presented to a public that up to that moment had been able to admire only Velazquez and Murillo. Travellers became more adventurous and travel in Spain became far less arduous. Although Meier-Graefe's *Spanienreise* of 1910 created a stir similar to that caused by Gautier in 1842, it induced Germans to visit Spain and made a trip there almost as canonical as the grand tour of France and Italy. Most important of all, his travel journal, with its extravagant praise of El Greco (who was an obscure master even at this late date), roused academic interest in Spanish art, and the era of Hispanic studies was ushered in.

In America, interest in Spanish art had always been much stronger than in Europe; the immensely fashionable Hispanic Society, which at the turn of the century drew larger crowds than the Metropolitan Museum, propagated an attitude that rendered Americans more susceptible to the values and attractions of Spanish and Hispano-American art. It was in the wake of increasing fascination with Spanish art in general that Goya assumed the place he holds today in the mind of the art-interested public.

In the light of this development it appears even more ironic that Goya has never been fully studied in relation to the traditions and principles common to century after century of Spanish art. Instead, although he has always been considered the very incarnation of the Spanish spirit, he has been studied much as Spanish art is generally studied: archaeologically. For unlike our fairly exhaustive study of French, German, and, above all, Italian art, the exploration of Spanish art lacks the careful, historical investigation that must precede attempts at critical evaluation. Archives and libraries are still to be explored, and there are vast areas in the history of Spanish art that are utterly puzzling to us because of this lack of intensive study. Some art historians have devoted themselves to doing this groundwork but their number is small.

We have certain workable notions about the character of French, German, Italian, and even British and American art, but the associations and images that are summoned up by the phrase *Spanish art* are still confused and vague. Yet it is precisely in this context that Goya will have to be studied in the future now that the pioneering

work of gathering documents and sound criteria for attributing works to the *oeuvre* is underway. For Goya, though widely loved and admired, remains one of the least understood artists. In this one aspect he can be associated with his great contemporaries Canova and David. Though utterly different from Goya, Canova and David have this in common with him: all three participated in the most radical revolution that the western world had known since the collapse of the Roman Empire; because the revolution of which they witnessed the beginning is still going on, it is extremely difficult to see them in an objective perspective.

That Goya must be understood as a Spanish artist increases the difficulties rather than diminishes them. Few problems are more delicate and less susceptible to discussion than the problem of nationality. Now that our ideals are increasingly oriented towards supranational sentiments, one is in danger of being regarded as a racist or chauvinist. But even the most superficially trained amateur of painting and sculpture can distinguish whether a given work is by an American, a Flemish, or an Italian hand. In most cases the question of an artist's nationality is only marginally important. It gives us certain clues about his upbringing and the environmental influences that may or may not have played a part in his early years, and, especially before the nineteenth century, it tells us something about his training. With most Spanish artists the consciousness of being Spanish has a far more deep-rooted function; it becomes a destiny in itself. This is not simply a matter of the provincial's diffidence vis-à-vis a superior civilization, for almost constantly during its centuries-long history Spanish art *was* provincial, just as German and English art were provincial when regarded from the vantage point of major European centers. But where as such initially provincial talents as Dürer and Poussin learned readily from a more cosmopolitan culture without necessarily giving up the traditions they held dear, Spanish artists seem to have admired the progress that art made outside Spain without modifying their style. Often, especially during the fifteenth and sixteenth centuries, Spaniards allowed themselves to be inspired superficially by Flemish or Italian prototypes while deliberately refusing to absorb their essential elements. There is a disdain for anything non-Spanish that is expressed even by the most sophisticated and cosmopolitan artists of the Catalan or Valencian schools. For instance, though fifteenth-century Spanish artists were aware of perspective they consistently scorned to use it. In the same

manner, in the sixteenth and seventeenth centuries the Spanish court considered it perfectly permissible and even admirable for Titian and Tintoretto and Rubens to paint female nudes and elaborate mythological scenes, which they collected eagerly, but it was unthinkable that a Spanish artist should do so. Even Flemish artists with a strong native tradition thought themselves provincial and quickly absorbed Italian lessons, but the truly provincial Spanish school remained uncompromisingly itself—for better or for worse. There is no denying that there are vast arid stretches in the history of Spanish art; figures such as Velazquez, Murillo, Zurbaran, and Goya attain a stature that is even more staggering and puzzling when they seem to sprout from barren, exhausted soil.

What then are the components of the Spanish style, a style so easily recognized and yet so impossible to describe. Perhaps the most striking common denominator of Spanish painting after the unification of the realm is its peculiar impartiality. The astonishing universal rejection of linear perspective in Spain is closely linked to this national constant. Linear perspective is a device that automatically confers a visual hierarchy upon a composition. It imposes a logical interpretation of relationships in a finite environment that is essentially abstract and intellectual; it is a construction of the mind and not of the senses. Aerial perspective, on the other hand, is eagerly taken up by Spanish artists and reaches its highest development in the canvases of Velazquez. Whereas artists in other countries compose in such a way as to recommend to our attention a hierarchy of composed visual values, with ancillary motifs, the Spanish artist withholds such a scheme and gives to each object its own, distinct importance so that its visual emphasis is equal to that of the other surrounding objects. Whether we look at the retablos of the quattrocento masters, in which every part of the surface is exploited with equal vigor, or at a baroque still life, in which all the objects are ranged for our eye without any comment about their inherent nobility, we always come up against this strange impartiality, this impassable unwillingness to judge. Figural compositions follow much the same pattern. Zurbaran's solemn, isolated figures come most readily to mind, but even in such a sociable painting as Velazquez's *Las Meninas* (Fig. 11) there is no real compositional center that dominates the ancillary forms; there is no clearly defined climax to which other forms lend their support. Instead the accents are spread evenly throughout the canvas; a tiny figure holding open a door in

the extreme background, a dog sleeping in the foreground, a mirror with reflections on the back wall, and a canvas on a large stretcher that cuts off our view in front-stage-left are all equally important rivals of the little princess. The artist bears witness to the world he observes but he rarely plays the judge. Murillo deviates from this rule in some of his late paintings, but his major works—the beggar boys, the *Angels' Kitchen,* the *St. Anthony of Padua* in the Cathedral of Seville—are all firmly within the same tradition.

The extremes of caricature and idealization are equally foreign to the Spanish temper; Goya's royal portraits (Fig. 25), which have so often been wrongly described in terms of caricature, are just as soberly realistic as Velazquez's calm, impassive descriptions of the sallow, heavy-jawed Habsburgs. Neither intends to pillory his sitters' vices or extol their virtues. Even the most flattering Spanish portrait is in striking contrast to the most sober French, Italian, or German portrait. The French artist, when he finds little to attract him in his subject, generally pushes the social rank of his sitter into the foreground, or else he disregards the worthlessness of his sitter and concentrates our attention upon the excellence of his technical facility and the inventiveness of his clever poses and juxtapositions. Has anyone ever seen a repulsive, or even displeasing, French portrait? German, Flemish, and Dutch portraitists, whenever they deal with sitters whose exteriors are unprepossessing, either dramatize the pathos of ugliness (Altdorfer, Burgkmair, Rembrandt) or present their homely sitters in the light of comfortable domesticity. Plainness becomes a virtue in their hands because it represents the average of human experience in polemical contrast to the confusing and often downright dangerous eruption of beauty. Italian portraits go far beyond mere observation of human ugliness or beauty. An exalted sense of the dignity of human individuality is expressed directly by the compositional schemes into which all portraits are cast. Surely neither Battista Sforza nor Federigo da Montefeltre can be called attractive in any way, but Piero's noble way of tracing their profiles, monumentalizing them in relation to the proportions of his panel, immediately brings home to us the exceptional esteem he felt for them. Leonardo's caricatures are merely the reverse side of the medal. They are the instruments by means of which we can analyze the profoundly expressive forces of human character. Spanish portraits are radically different. Art and artifice are deliberately sacrificed in favor of a straightforward representation that allows no partiality, no prejudice against or in favor of the sitter. The artist

does not inquire into the sitter's interior destinies. God, it may be supposed, can see behind these tragically isolated, tragically proud masks. The artist usurps no such right.

Sculpture, not painting, is the national art of Spain precisely because the very nature of sculpture proposes a more direct confrontation of palpable reality and a consequent diminution of illusion and illusionism. Painting proceeds by fits and starts throughout Spanish history and lacks continuity. Sculpture, on the other hand, is produced at a consistently high level through all periods of Spanish art. And a very remarkable kind of sculpture it is. Unlike the sculpture of other Western schools, Spanish sculpture is meant to be functional in popular devotions. The differences between folk art and "high" art begin to be obliterated by the great sculptors of the sixteenth, seventeenth and eighteenth centuries whose *estofado* figures (painted and clothed sculptures) go beyond the esthetic boundaries of canonical sculpture. They achieve an integration of real objects (clothing, glass eyes, real hair wigs, etc.) that exile these sculptures from the realm of art into the realm of every day reality.[1]

[1] Spain is certainly not the only nation to produce highly realistic, polychromed, and dressed sculptures. Especially in Italy, the genre is very widespread and often has produced results of surprising quality; one need only think of the magnificent Sacro Monte of Varallo and Varese. But two important points distinguish the non-Spanish from the Spanish. (1) Outside Spain, the realistic, bewigged, and dressed sculpture is understood to belong to the popular arts. Peasant and prince alike recognize the difference between, say, the Sacro Monte chapels and the Cornaro Chapel by Bernini. Sometimes, of course, the difference between what we today would call folk art and "high" art disappears. Nobody would want to call Michelangelo's Crucifix from Santo Spirito an example of folk sculpture. But such examples are extremely rare. In Spain, on the other hand, the distinction hardly exists at all. Or rather it is considered as a national distinction. Ideal art is commissioned of foreigners (for example, the tombs of the Royal Chapel in Granada). The native artist, whether he be an enormously talented, highly individualistic sculptor such as Montanez or an anonymous provincial artisan, works within the traditions of Spanish sculpture. (2) Outside of Spain, even in highly realistic sculptural groups such as the ones at Varallo mentioned above, are *tableaux* that are set in all their details by an artist and by his assistants. Once their work is finished, the chapel is closed and the composition that was established by the artist remains for all time. Vestments are changed only in a very few cases (for example, the black draperies cast over statues of Madonnas in certain villages during the Passion week) and poses are never changed. Only in Sicily and southern Italy, where Spanish traditions came to prevail for long centuries, do we encounter jointed statuary that is actually moved about to conform to different expressive poses.

It is easy to condemn these sculptures as a superior kind of wax-works. But such criticism misses the point. Spanish sculpture of the baroque, unlike Italian or French sculpture, is never serenely "fin-ished." Often the gestures of hands, the positions of heads or of legs can be altered in these images and of course, since these sculptures have vast wardrobes, the color, shape and rhythm of their draperies can be constantly varied. To think of changing a single drapery fold in a work by Bernini or Puget strikes one immediately as sacrilege. Spanish sculpture which so accurately reflects Spanish sensibilities in art, belongs to a different category of creation and experience, a category for which we are only now beginning to find an adequate critical vocabulary. Recent developments in the art of our century are beginning to open our eyes to the true significance of this great Spanish cultural tradition. Today, as we see ourselves deprived of our comfortable aristotelian apparatus by modern science, modern philosophy, and modern art, we begin to be aware of the startling and powerful prediction of present-day phenomena in the arts of Spain. Don Quixote's madness is our madness—nor is it clinical mad-ness in the accepted sense of the word. It is merely an inability to face naked reality without the consoling belief in "higher" values that gives luster and meaning to what is otherwise a confusing welter of irrelevant events and meaningless observations. This is the enchant-ment of Spanish art. It poses for us the eternal enigma of impassive realities that we perceive with our senses (and how sharp are the senses of Spanish artists—sharp to the point of vulgarity if neces-sary) and with which we must make our peace, imposing upon them interpretations and meanings that are produced by our own spiritual necessities and not by the objects perceived. These values and inter-pretations are changing and ephemeral in nature, although the ob-jects and events to which they apply remain eternally the same.

Does this mean that Spanish art is secular art? And is such a conclusion tenable in view of most Catholic Spain? How does the Spanish artist reconcile an unshakeable faith in religious principle with his tragic perception of the impenetrability of reality? Is it be-cause the very density and impenetrability of the real world repre-sents the most concrete proof of the existence of mystery? Is it be-cause the universality of the death of all things gives a sacramental meaning to every moment of human life, so that buying a glass of water from an itinerant watercarrier becomes an act of communion, as it does in Velazquez? Certainly the texts of the great religious

leaders of Spain offer a variety of tantalizing clues. The earthy perceptiveness of St. Teresa of Avila, who expresses her visions with the same clarity and realism she uses to describe the chores of the cloisteryard, gives us some idea. Comparing her writings to Bernini's great sculptural group, one realizes that Bernini did not just translate literature into stone, he also translated Spanish into Italian. St. Ignatius of Loyola's "Discipline" is another text that could only have been written by a Spaniard. The exclusive use he makes of the imagination for somatic rather than spiritual effects is directly comparable to Spanish sculpture and painting. Much of the repertory of Spanish Renaissance and baroque religious poetry is marked by a lack of the rhetoric present in similar Italian poetry. The emotional exaggeration of German religious poetry is totally absent.

More, much more, must be studied about the nature of Spanish art, including the reasons for its inability to fulfill decorative functions (all great fresco cycles in Spain were executed by Italian artists). Goya's great cycle of tapestry cartoons (Fig. 15) bears out this native inability to conceive of painting in a decorative key. The cartoons are enchanting because one regards them as paintings independent of an architectural purpose; the tapestries woven after the cartoons are deplorable failures because they do not fulfill their decorative mission by harmonizing with an architectural interior. It is wrong to speak of a Spanish *retablo* in the way that one speaks of an Italian *pala d'altare*. The two are used in totally different ways and the painters knew it. Formal and iconographic studies of such pictures as *The Surrender of Breda* are all very well, but until we can accurately reconstruct the architectural setting of the picture in relation to the other scenes in the gallery we will remain uninformed, even misinformed, about its meaning. In Spain paintings have a degree of concrete, down-to-earth functionality that they do not have elsewhere. They are not ideal constructions that delight or instruct; they are presences that intrude upon our world just as furnishings do. What Hetzer has to say about Goya's poster-like effects applies to Spanish art as a whole. There is a clamorous insistence about these paintings and sculptures that makes it difficult to pass them by; they demand our exclusive attention and make active war on the objects around them. It is possible to participate in a ceremony in Raphael's Stanza della Segnatura or in Rubens' Medici gallery without being distracted by the paintings. But how disturbing it would be to have to function attentively in a room that contained

Las Meninas! The few attempts at painterly decoration that have come to us intact, such as Zurbaran's paintings in the sacristy of the monastery at Guadelupe, make us realize that the pictures are not images in the ordinary sense. To come upon the scourging of St. Jerome is to be shocked out of the attitude of art-amateur and into the attitude of a devout monk who interrupts his religious duties in order to contemplate not a painting but the act of saintly flagellation. It is neither the technical skill that matters (and how often have critics had occasion to complain about the lack of craftsmanlike finish in Spanish art!) nor the stylistic interpretation. What matters is the intense reality of what is represented.

Goya, like all great artists, is a phenomenon to be regarded for and by himself. He also has roots that strike deep, and because he was a Spaniard these roots were fully understood and sensed by the artist himself. As Gautier rightly remarked: ". . . one of their [the Spaniards'] essential presumptions is to be neither poetic nor picturesque." They know that they are utterly different and perversely reject all attempts by outsiders to interpret their character—an attitude often encountered among people who know themselves to be in the minority and are proud of it. It may very well be that much of Goya's work will remain forever enigmatic to us, but the time has not yet come to resign ourselves to leaving the riddles and problems that he poses unresolved. Much has been done; much more must be done by future historians and critics. Jutta Held's excellent survey of Goya literature clearly shows how much certainty has been achieved in the past thirty years concerning his *oeuvre*. Though several important problems of attribution still remain, we have a firmer grasp of the criteria and the methods we must use in order to establish the authenticity of a given work. The studies of Lafuente Ferrari and Lopez-Rey are equally enlightening; they present us with a surprisingly rich picture of the cultural background against which Goya's career was played out. The political and social picture, as well as the whole world of cultural events, both ephemeral and weighty, has taken on new density. Thanks to Lopez-Rey we have an astonishingly large frame of reference to popular proverbs, popular preoccupations, and contemporary chronicles against which to match some of the more obscure images of the *Caprichos*. Lafuente Ferrari has combed through contemporary illustrated publications and come up with some startling sources for Goya's perplexing

imagery; certainly this direction of investigation is still full of prom-
ise. To a man such as Goya the visible world in its entirety was of
extraordinary fascination, and if we can compile such frequently
ignored sources as broadsides and advertising, as well as the primi-
tive but effective images carried about by itinerant harlequins and
singers, we are bound to come up with important discoveries. Re-
cent studies related to the work of Courbet, who was close to Goya
in his desire to derive imagery from sources easily accessible to a
vast public, have brought excellent results. Gombrich's discovery in
this line of research has not only caused us to reconsider our precon-
ceptions of Goya's working methods but also leads us to a tre-
mendous wealth of unexplored material.

Helman proves that we cannot afford to ignore fields such as
jurisprudence. Her investigation of labor laws promulgated by
Charles III clarifies a new and significant connection between
Goya's tapestries and certain social conditions to which we were
blind before. To those admirers of Goya who are eager to exploit
this vein, Klingender's book will be of special importance. Mar-
shalling a tremendous amount of fascinating documentation about
social injustice and administrative failure, about the historical ballast
of later eighteenth- and early nineteenth-century Spain, he offers a
brilliant picture of those conditions most likely to rouse Goya's
indignation; this material must be extended and sifted more thor-
oughly. It is also imperative that we learn more about the political
ideals Goya harbored. His compromises during the various stages
of his career are such that we must stake out clearly the limits of his
integrity. It is no longer sufficient to speak of Goya's liberal and
democratic sentiments; we must learn how he managed to maintain
democratic convictions without jeopardizing his position as a faith-
ful subject and direct servant of the Spanish crown.

Another approach, broached primarily by Nordstroem, gives
us a surprising new view of Goya's intellectual range. By studying
the books Goya had in his library as well as those written by his
friends, Nordstroem proves that Goya was far from being the will-
fully spontaneous, anti-intellectual artist often presented to us in
earlier literature. It would seem in fact that he often had recourse
to such traditional atelier resources as emblem books. An essay re-
cently discovered by Jutta Held in the archives of the Academia de
San Fernando proves that Goya thought about artistic theory and had

very precise notions about the teaching as well as the practice of art. The question now is: to what degree did he apply these intellectual concepts to his own work?

Every phase of Goya's life still requires study. An investigation of his voyage to Italy could prove enlightening. What was the probable itinerary? Did he sail to Naples or did he travel overland? What major commissions were the gossip of the studios and artists' taverns during his stay in Rome? Roberto Longhi has already indicated that Gonzalez Velazquez's frescoes in the Church of the Trinity are extremely close to Goya's later work. We may take it for granted that the Spanish academy played a far more important part in the artistic life of Rome than is generally supposed. The hardy realism of the Lombard school, particularly in Brescia, may very well have been known to Goya if he travelled to Venice, which seems probable.

Even more important would be a study of his earliest work. The frescoes by Goya in the Church of the Pilar have been neither properly seen nor adequately photographed. The sketches for these frescoes need considerably more critical attention than they have received in the past. These paintings and others that have recently come to light seem to indicate a fresh inspiration from French or frenchified painting that has never been discussed.

The first great commission Goya received in Madrid is the tapestry cartoons, and here again a fruitful field of Goya studies opens up for us. Since those who have written about Goya have obviously felt somewhat ashamed of the tapestries that were manufactured from the cartoons, we have been left without a study of the tapestries themselves—a grave omission that no one working on, say, Raphael's tapestry cartoons would have allowed himself. Thus there are no discussions of the borders, so essential for the effect of a tapestry series, nor do we know anything about the way the tapestries were meant to be set into the boiseries (if, indeed, a boiserie was contemplated). We also suffer from the lack of a critical analysis of those elements that make the cartoons appealing works of art but that turned sour once they were translated into textile, the sorry products of the looms of Santa Barbara. Hetzer's tantalizing remarks on the subject lead us in a fascinating direction that no one has yet cared to explore. Unfortunately art historians rarely have the specialized training that is necessary for dealing with the so-called minor arts; yet a comparison of Goya's tapestry cartoons

and the resultant tapestries with those by contemporary artists in Spain and France would be of great importance.

The *Caprichos* are the best studied of all of Goya's *oeuvre*. Not only has the series been known longer than any other graphic or pictorial series by Goya but its success was almost immediate. The striking novelty of the artist's vision, his totally new and revolutionary dislocation of Renaissance-baroque perspective, and his demoniac idiom caught the imagination of specialist and amateur alike. At the same time the *Caprichos* are tempered by sly humor, social satire, and other more familiar approaches that give these pages a popular ring. In comparison to the later *Disasters*, horror is still represented within rational limits; it can be overcome by awareness and intelligence. The shock of this new vision, therefore, could be more easily absorbed. A certain picturesque element, especially in the plates dealing with the quaint demimonde of *majos* and *majas*, was readily appealing. Although Lopez-Rey has provided us with ingenious schemes for deciphering many of the captions and has also hazarded the theory of a certain thematic continuity within the opus, a great deal more study must be devoted to popular imagery, popular chronicles, and contemporary entertainment before we can hope to see through the veils of allusions to the real intention of the artist. A methodical exploitation of the technical data brilliantly assembled by Harris should also be undertaken in order to establish once and for all the precise chronology of the plates so that the sequence of their creation can be seen in proper perspective. Our understanding of the whole temper of Spain in the early nineteenth century would be greatly enlarged if light could be shed on the concrete events that led the artist to withdraw the first edition of the *Caprichos*. Our knowledge of the circumstances is still curiously limited; we know hardly anything about the motivations that permitted the king to accept such an explosive set of etched plates, at the same time preventing a new publication until several decades later.

The formal history of these images has still to be written. The whole character of illustrative graphics in the late eighteenth and early nineteenth centuries has been badly neglected; it will be important for future scholars to look at the *Caprichos* in relation to contemporary book illustrations, illustrated pamphlets, and popular broadsides. With the *Caprichos* we arrive at a crucial point in the history of image-making. The whole function of pictorial representa-

tion begins to change just as visual techniques undergo radical trans-
formations. The destruction of perspective and the change from
light-dark values to black-white values (that is, the exclusion of
light as a symbolic force and its consequent interpretation as a
purely physical, optical energy) are all explicit in the *Caprichos*.[2]
Perhaps no other work of art calls out so clearly for the invention of
a new method of image-making, and it is not long before Nicéphore
Nièpce answers the call by inventing photography—an art that in
its moral and technical implications is profoundly related to the
Caprichos. No longer will personal invention and interpretation be
preeminent in art; no longer is it the accepted duty of art to transmit
established ideas and ideals. First the *Caprichos* and then pho-
tography respond to the new needs and exigencies of modern times:
they communicate to us a vast range of facts; they bear witness,
impartially, to the infinite variety that the human condition assumes
on earth. The true impact of the *Caprichos*, their truly chilling effect,
derives not so much from the artist's fantasy as from the artist's
sober, pragmatic observation of the anomalies of human existence
by disconnecting these anomalies from the conventions with which
we surround our own absurdities in order to make them socially
acceptable. Goya transcribes our illogical behavior by means of
disruptive, inconsequential visual forms. It would be interesting to
investigate the relationship between Goya and nineteenth-century

[2] What is tentatively begun in the *Caprichos* is then developed more in-
sistently in the *Disasters*, the *Disparates*, and the *Tauromaquia*. The un-
inked parts of the plate begin to stand for a graphic value instead of
indicating the path of light. They are white shapes. The black areas
also tend to lose their traditional character of shadow and become inde-
terminate, perplexing black shapes. The darkness usually associated with
Caravaggio's dramatic lighting effects is carried forward into the nine-
teenth century by David but not by Goya. Whether we look at the tender
obscurity of Rembrandt or the menacing shadows of Piranesi, we remain
aware of there being *something* that is hidden from sight because of the
trajectory of light. In Goya, darkness tends to be a visual equivalent of
nothingness. The moral implications are far-fetching but by no means
clear or even consistent. Just as later on in Picasso's *Guernica* we can
never identify the symbols of horse and bull as unambiguously "good"
or "bad," so is the darkness and the light of Goya's paintings and prints
open to varieties of interpretation. In the *Third of May* for instance, the
light functions as an instrument in the hands of the executioners. It pins
the victims against the hillock. In the *Disasters*, too, light is not the pre-
rogative of the noble (or even the compassion-arousing) victim.

photographers. Though it is dangerous and even unseemly to publish personal guesses, it would not surprise anyone who is familiar with the *Caprichos* if it turned out that great photographers, beginning with Nadar, assiduously studied and admired Goya.

The first fifteen years of the nineteenth century witnessed the birth of Goya's most significant work. The great *Portrait of the Royal Family* (Fig. 25), the two *Reclining Majas* (Fig. 10), the *Battle at Puerta del Sol* (Fig. 2), its sequel, the *Third of May* (Fig. 3), and the *Disasters of War* have all entered the repertory of modern art, together with a small handful of masterpieces by David and Canova, as the essential pictorial and philosophical ancestors of modern art. Each of these works shows a decisive reevaluation of a traditionally important category of painting: the group-portrait, the nude, the historical painting, and the martyrdom scene. In each case Goya reveals himself in the double (and often ambiguous) role of destroyer and creator. Of all the works of this period, the *Portrait of the Royal Family* and the two Majas are the most devious and perplexing. Our information about the circumstances that produced these paintings is again extremely sparse. Of the *Majas* we can presume that they formed part of Godoy's collection, but the nature of the commission is still a mystery. How were these paintings meant to be displayed? What is the meaning of the deliberate contradiction between the voluptuous subject and the barren, drab setting? Is their shock value (which persists even in an age that has seen the disappearance of almost every sexual tabu) motivated or is it fortuitous? And what is the meaning of the peculiar difference in proportion, expression, and even physiognomy between the two heads? Is the head of the naked *Maja* overpainted? Perhaps an x-ray could clear up this latter point, but only a far more rigorous examination of the erotic mores of Spain at the end of the eighteenth century could shed any light on the meaning of this strange pair of paintings. The mystery deepens when one remembers how inimical Spain has always been to the expression of erotic sentiment in the visual and literary arts.

Equally charged with teasing riddles is the large portrait of the royal family. The uncompromising realism of the individual portraits, the renewed paradox of ornate court dress against a shabby setting, the position of the artist behind rather than in front of his sitters, and the overly insistent, almost caricatural reference to

Velazquez's *Las Meninas* (Fig. 11) are all part of what may well be the most sardonic and elaborate riddle of Western painting.

It is not just the meaning of the painting that has to be unravelled; its historical position has never been fully comprehended. Goya achieved his success as court painter by translating eighteenth-century English portraiture into a Spanish idiom. Then, at the very pinnacle of official approbation, he suddenly and willfully relinquished precisely those elements that made it possible for him to receive the commission for a royal group portrait. Not only are the characters in the portrait pictured as parvenus, the painter portrays them in a style that is totally at variance with the tranquil nonchalance of British portraiture. The pompous display of flashy virtuoso passages in the sitters' costumes is in itself a comment on their characters—but it would be a mistake to think of the picture in terms of caricature. There is a tragic note that goes far beyond satire. The individual is suddenly divested of traditional dignity, of his own sense of immortality. The function of portraiture changes and when, later in the century, photography begins to monopolize this formerly important branch of art, it is able to do so because the branch has already atrophied.

War and extinction, history as a sequence of events rather than the expression of a superior destiny are themes first introduced into art by Goya under the impact of his experience during the Napoleonic invasion. Critics are almost unanimous in labeling *The Battle at Puerta del Sol, May 2, 1808* (Fig. 2) one of Goya's failures. It is a failure to the same degree that Stendhal's description of the battle of Waterloo in *The Charterhouse of Parma* is a failure. The confusion, the inability to discern the significance of a moment that only in retrospect can be understood as "historic" is typical of the modern battle picture. That is why this genre, too, soon disappears from the repertory of European art. Gros and his companions who exalted the battles of Napoleon avoided the issue by falling back on traditional solutions. The Emperor is usually presented as lifted above the confusing fray, commanding history, dividing, as it were, right from wrong. In the few Napoleonic-history paintings that attempt to portray the inscrutability of a historic event, the picturesque, exotic settings (*Battle of Nazareth* by Gros, for example) compensate for the lack of clarity. There is a failure connected with the *Second of May, 1808*—but it isn't Goya's failure. It is the failure of a dawning epoch in which sides are never clearly drawn, in which the moral meaning

of history is obscured as our perception of historic events change.[3] After all, the populace that rose against the French invader sacrificed their lives for a royal family that had ignobly bartered away its crown for a petty but secure position, utterly betraying its staunchest defenders.

It is generally accepted that the *Second of May* and its sequel, the *Third of May*, were part of a triumphal decoration created in honor of the return of King Ferdinand. The two most revolutionary paintings of modern times would thus have been part of a tribute to one of the most infamously reactionary occasions of Spanish history. How fascinating it would be if we could reconstruct the rest of the triumphal pageant! What did the other paintings look like? What kind of architectural settings were imposed upon Goya's paintings— paintings that seem to defy the whole idea of framing because they have the impetus of "stills" torn from an endless film entitled *Homo homini lupus*.

Here again the question is brought up of the function that modern painting is to fulfill. Since it is not created in answer to a dynastic, a decorative, or a religious need, it must find other functions to justify its existence. To whom does the artist want to speak? What effect does he want his art to have? These are questions of supreme importance in the study of nineteenth- and twentieth-century art. Our makeshift solution of banishing all art to the no-man's land of museums has hushed the questions but it hasn't answered them. Goya's paintings, when one comes upon them in the Prado, fairly shock one into asking these same questions over and over again. After roomsful of Titians, Rubenses, and Velazquezes, Goya's paintings seem to explode the comfortable idea of the museum as a public institution.

The *Third of May* (Fig. 3) and the *Disasters of War* represent the culminating point of Goya's urge to call out to his and to future

[3] The Crusaders may have been aware that their lust for plunder was greater than their desire to liberate the Holy Sepulchre, but the sacred purpose of their campaigns was deeply rooted and thoroughly real even though it was often perverted and manipulated to serve ends that were far from sacred. The slogans that begin to make their appearance in the late eighteenth century do not have the same roots in a commonly shared faith. They are understood as propaganda that appeals to violent instincts or else speaks of such abstractions as "patrie" or "liberty." To the warriors of the middle ages, the Renaissance, and the baroque era the battlecry of "For God and for the King" had quite different degrees of reality.

generations. The horrors inflicted by man on man, the endless, pointless suffering of war and famine and mindless cruelty wrench a great cry from Goya. It is not so much his own deafness that is Goya's tragedy but the deafness of others. For no one heard the cry; the *Third of May* was downgraded to a decorative position in a macabre pageant and the *Disasters of War* were not published in Goya's own lifetime. When he died he had no reason to believe that the works into which he had poured his most burning convictions, his most urgent testimony, would ever reach the eyes and the heart of posterity. It is with the certainty of not being heard and with the threat of political persecution hanging over him that he prudently retired to his country house; having learned of the futility of creating images for the blind, he painted a series of pictures that, almost like Egyptian tomb art, were painted in order *not* to be seen: the Black Paintings.

It is highly probable that speculation about these paintings will continue to the end of time without any conclusion being reached. Perhaps even Goya did not understand their meaning. That does not mean that the discussions engendered by this remarkable series are futile; on the contrary, each new interpretation has enriched our understanding of the problems that beset artists working in a consciously modern frame of reference just as it has opened our eyes to the vast new possibilities that lie open to a painter resolutely working in accordance with the needs and opportunities of his own time.

Since these feverish visions must certainly be connected with the serious illness Goya suffered in 1819, and since we have a painting by Goya that deals openly and directly with this illness, it has always seemed to me that one of the keys to the mysteries of the Black Paintings can be found in his remarkable *Self-Portrait with Dr. Arrieta* (Fig. 1). The painting is composed in two very distinct styles: the foreground is kept fairly naturalistic, though the forms are very loosely modeled; the palette is warmed by the dense red tonality of the counterpane, which has a raspberry-like bloom to it. The lighting is diffuse. Surrounding the sickbed and the two central figures there hover grimacing, huddled shapes painted in phosphorescent earth colors that do not participate at all in the action of the foreground. Are they the ephemeral, sometimes solicitous, sometimes menacing figures that haunt the uneasy dreams of the feverish patient? It would be difficult to determine their precise character, but

visually and emotionally they are like some murmuring Greek chorus that gives an amplified sonority to the action played out in center stage; they are also stylistically identical with the figures of the Black Paintings. Surely there is a hint here, thrown out by Goya, that has not yet been followed.

Taken by itself, the *Self-Portrait with Dr. Arrieta* leads one to ponder on Goya's sense of religion, for this is obviously a religious scene. The painting's votive character has often been observed; certainly the offering of the picture "for grace received" makes it one of the most moving of the whole genre of *Freundschaftsbilder* that plays so prominent a part in the iconography of early nineteenth-century romanticism. But the religious references go beyond the votive; the solemnity of mood indicates a direct connection with the traditional theme of communion, a theme that is frequently portrayed, especially in Spain, in a secular vein—as happens, for instance, in the work of the young Velazquez. Surely no other painting expresses the whole meaning of communion with greater dignity or greater intensity. It is possible that Goya may have been inspired by another traditional theme, that of Christ and the cupbearing angel at Gethsemane (Fig. 5). There is something curiously tense about Goya's body, as if he were straining away from the medicine that Arrieta offers him. Arrieta, though deeply solicitous, has the inexorable insistence that the angels radiate in Gethsemane pictures, where they are depicted as glorious consolers but also as bearers of a cup that must be drained. It is surely more than a mere accident that two major religious paintings on just these themes, *The Communion of San Jose de Calasanz* (Fig. 4) and the *Agony in the Garden* (Fig. 5) were painted by Goya in the same year.

More puzzling than the Black Paintings and just as hallucinatory is Goya's largest work, which must have been a commission, unlike the Black Paintings; this gives its inscrutability a further turn of the screw. *The Junta of the Philippines* at Castres is his last and fiercest word on the horror and the bestially blind cruelty lying suppressed behind the human facade. The very air of the painting insinuates poison and the terror of utter emptiness. Involuntarily one is reminded of Joseph Conrad's *Heart of Darkness* and its paralyzing culminating scene, in which Kurtz drops the mask which, to a greater or a lesser degree, we all wear—a mask of ambition justified by altruism—and discovers nothing but emptiness. "The horror of it!" That final judgment of a profoundly felt Spanish *Nada* makes the

picture in the Museum of Castres the most total, the most lasting, and the most prophetic expression of modern nihilism. How could Goya have conceived a group portrait in these terms? How could any commissioner have accepted the finished painting? Where did it hang? At every turn we come up against unanswered and perhaps unanswerable questions.

Goya experienced the full range of anguish and loneliness during these disconsolate years, isolated by his deafness, his sickness, his political past, and the gradual disappearance of the friends who had been close to him; of that there can be no doubt. But the artist who looked deeply into the desperation of modern man's secularized condition was too vigorously healthy in spirit and too rich in his imaginative powers to give way to despair. He was sometimes moved to pronounce judgment on and to condemn the seemingly infinite capacity of man to victimize his neighbor, but his indignation was never complete enough to preclude reminiscences of the pleasures that come with life. Of all his contemporaries, he and Beethoven are perhaps the only ones who realized the full extent of the revolutionary change that had come to humanity without giving way to bitterness or misanthropy.

Four paintings of proletarian subjects express a sentiment that, perhaps, can't quite be called hope but, nevertheless, reflect the convictions of a man who knew from his own experience the consolations and the dignity of work. The last of these, perhaps Goya's last work, was painted in Bordeaux; the famous *Milkmaid* is an intimate, lyrical homage to the humble of this world. The other three, probably painted shortly before his wife died in 1812, are far more public in spirit. There is a certain rhetoric of quality about them. Unlike the *Milkmaid*, these pictures were meant to speak to a large audience; the pair representing a *Knifegrinder* and a *Watercarrier* were probably painted for a friend. Their scale is modest, although the intensity with which these robust, self-confident figures are painted lends them a dignified monumentality. *The Forge* however, must have been a commissioned work. It is unlike Goya, who had a shrewd and canny business sense, to paint so large and ambitious a canvas without receiving a commission and a decent advance payment for it. Earlier on in his career, probably in 1797, he had painted allegories of human activities (Agriculture, Industry, and so forth) that are totally different in their tame composition, banal color, and traditional iconography. *The Forge* leaves late-baroque allegory far

behind; it is closer in spirit to Courbet than to Goya's own earlier work. Once again the sacramental solemnity that invests so much of Spanish paintings comes to the fore. The realism of *The Forge* is a realism with many overtones—loyalty to work and to companions, communion within a common cause, which give it a resonance that lifts it well beyond descriptive realism. Who could have commissioned such a painting in the first quarter of the nineteenth century? Even in the unlikely event that the painting wasn't commissioned, how could Goya have hoped to sell a picture such as this? Of course one must keep the vagaries of art collectors in mind. After all, who would have thought that a painting such as this would eventually come to rest in the collection of a man whose interests in metallurgy were totally inimical to the ideals expressed in the painting? Such tragi-comic episodes shed a sharp light on the spiritual homelessness of nineteenth-century art.

VOYAGE EN ESPAGNE

Théophile Gautier

Goya is recognizably kin to Velazquez. After him come painters such as Aparicio and Lopez; the decline is complete, the artistic cycle is closed. Who will begin it again?

He is a strange painter, a singular genius, Goya. Never has originality been so marked; never was there a Spanish artist more local than Goya. A sketch by him—four strokes in a cloud of aquatint—says more about the customs of his country than the most detailed descriptions. With his adventurous existence, his fire, his many talents, Goya seems to belong to the golden age of art—and yet in a certain sense he is a contemporary: he died in Bordeaux in 1828.

Before undertaking an appreciation of his work, let us give a brief outline of his biography. Don Francisco Goya y Lucientes was born in Aragon of parents with a modest fortune—sufficient, nevertheless, to allow his natural ability to develop. He demonstrated a talent for drawing and painting very early in his life. He travelled and studied in Rome for a time and then came back to Spain, where he rose rapidly in the court of Charles IV, who granted him the title of "painter to the King." He was received by the Queen, by Prince Benavente, and the Duchess of Alba and led the lordly life of a great gentleman (as had Rubens, Van Dyck, and Velazquez)—conditions favorable to the blossoming of pictorial genius. He had a charming country house near Madrid, where he gave parties and had his atelier.

"Voyage en Espagne" by Théophile Gautier. From *Le cabinet de l'amateur* (1842).

Goya produced a great deal; he did religious subjects, frescoes, portraits, scenes of Spanish life, etchings, aquatints, lithographs, and everything, even his roughest drawing, bears the mark of a vigorous talent; his strength is evident even in his most casual drawings. His talent, though absolutely original, is a singular mixture of Velazquez, Rembrandt, and Reynolds: he has something of each of these three masters, as a son has something of each of his ancestors. There is no servile imitation: the similarity is due not to an explicit desire to be similar but rather to a congenial kinship.

At the Madrid museum one may see his equestrian portraits of Charles IV and the Queen: the heads are wonderfully painted, full of life, delicacy, and spirit; the *Picador* is there and the *Massacre of the 2nd of May*, an invasion scene. The Duke of Osuna possesses many of Goya's paintings, and there is hardly a large house that does not have some portrait or sketch of his. The interior of the church of San Antonio de la Florida, half a league from Madrid—where a yearly popular feast takes place—was frescoed by Goya with the freedom and daring that is so characteristic of him [Figs. 7 and 8]. In Toledo, in one of the chapter houses, we saw his painting of Jesus betrayed by Judas, with a night effect evocative of Rembrandt (to whom I would have attributed it had not a canon shown me the signature of Charles IV's favorite painter). In the sacristy of the cathedral of Seville there is a fine painting by Goya representing the Saints Justina and Ruffina, virgins and martyrs, both daughters of a potter, as can be seen by the *alcarazas* and *cantaros* at their feet.

Goya's manner of painting was as eccentric as his talent: he kept his color in buckets and applied it with sponges, brooms, rags —anything that came to hand; he worked with his pigments as a builder works with trowel and mortar and added touches of emotion with strong strokes of his thumb. With this rapid and peremptory method he could cover thirty feet of wall in one or two days. All this goes somewhat beyond the limits of fury and passion: even the most passionate artists seem mere decorators compared to him. In the painting of the *2nd of May*, where one sees Spaniards being shot by the French, he used a spoon instead of a brush. It is a work of incredible verve and spirit—a curious painting that has been relegated, with little honour, to the antechamber of the Madrid museum.

The individuality of this artist is so strong and clear-cut that it is difficult to give even a vague idea of it. He is not a caricaturist like Hogarth, Bamburry, or Cruikshank: Hogarth, serious, phleg-

matic, precise, and punctilious as a Richardson novel always lets a moral undercurrent show through; Bamburry and Cruikshank, noted for their malign spirit, their clownish exaggeration, have nothing in common with the author of the *Caprichos*. Callot, half-Spanish, half-gypsy, comes closest—but Callot is clean, clear, fine, precise, true to life, in spite of his elegant elaborations and the dramatic extravagance of his costumes. Even his most singular devilry is absolutely possible. It is bright daylight in his etchings; attention to detail precludes effects of light and shade, which can be obtained only by sacrificing other aspects. Goya's compositions present darkest night; one or two flashing rays of light outline pale silhouettes and strange ghostly forms.

He is a combination of Rembrandt, Watteau, and the strange fantasies of Rabelais; what an odd mixture! Add to this a strong Spanish flavour, a dose of the picaresque spirit with which Cervantes created the portraits of the *Escalanta* and the *Ganaciosa* in his *Rinconete y Cortadillo*, and you still do not have an accurate idea of Goya. We will try to explain him, if it is possible to do so with mere words.

Goya's prints are executed in aquatint, enlivened by etching; no technique could be more direct, more free and easy. A stroke indicates an entire physiognomy: the trail of a shadow serves as a background, or suggests dark, fragmentary landscapes, mountain gorges, settings for a murder, a witches' sabbath, or a gypsy *tertulia;* even this is rare because for Goya background does not exist. Like Michelangelo he scorns nature and furnishes only what is essential to his figures—even then he puts many of them in the clouds. Occasionally one finds a bit of wall cut off by a strong shadow, a bleak prison archway, a hedge barely suggested—that is all. We said, for lack of a better word, that Goya was a caricaturist—but it is Hoffman-like caricature, where imagination is mixed with criticism and often reaches the point of being gloomy and terrifying; it is as if all these grimacing faces had been drawn by the claw of Smarra on the wall of a lewd alcove by the flickering light of a dying lamp. One feels transported to a fantastic world—impossible and yet real. Tree trunks look like ghosts, men look like hyenas, owls, cats, donkeys or hippopotami; their nails may be claws; puffy shoes are worn by goat-like feet; an apparently young knight is actually an old corpse—his beribboned hose envelop fleshless femurs and two thin tibias; not

even Doctor Faust's cauldron produced more mysteriously sinister visions.

Goya's caricatures are said to contain political allusions, but there are not many; they concern Godoy and the old duchess of Benavente, the queen's favorites, and one or two gentlemen of the court whose vices and ignorance they ridicule—but one must search for them through the thick veil that hides them. Goya did other drawings for his friend the duchess of Alba that have not come to light—perhaps because they were drawn so casually that they have escaped identification. Some drawings [for the *Caprichos*] take their inspiration from fanaticism, from gluttony, or from the stupidity of monks; others deal with local customs or witchcraft.

A portrait of Goya serves as frontispiece to his series of prints called the *Caprichos*. It shows a man of about fifty with narrow squinting eyes hidden behind ample lids, surrounded by malign and mocking wrinkles. The chin curves upward like a clog; the upper lip is thin, the lower prominent and sensual. The whole is framed by sideburns and topped by a Bolivar-style hat—a powerful face that shows strong character.

The first plate represents an "arranged" marriage; a poor young girl sacrificed to a feeble, monstrous old man by her greedy parents. The bride is charming with her little black velvet mask and her fringed skirt—for Goya is marvelous in rendering the grace of Andalusia and Castille. The parents have been made hideous by rapacity and poverty; they look like grotesque sharks or crocodiles. A child smiles through its tears, like rain in the month of April—it is nothing but eyes, claws, and teeth. The young girl is so excited by her elegant attire that she is prevented from feeling the full extent of her unhappiness. This theme is often repeated in Goya's drawings and he always derives striking effects from it. Further on we find "el coco," the old bogeyman who comes to frighten small children—and who is bound to frighten many more because, except for the wraith of Samuel in Salvator Rosa's painting of the *Witch of Endor*, nothing is as terrible as this scarecrow.

Farther on we have some *majos* courting smart young girls on the Prado—beautiful girls with sleek silk stockings, with small slippers that have pointed heels and hang on to the foot only by the nail of the big toe—with rows of pierced tortoise-shell combs, higher than the crown of Cybele; black lace mantillas are worn as hoods

and throw their velvety shadows on the most beautiful black eyes in the world; skirts are weighted to accentuate the opulence of the hips; beauty patches settle at the corners of the mouths and on the temples and large fans are spread out like peacocks' tails. There are *hidalgos* in pumps, in prodigious dress coats with sickle-shaped hats under their arms and bunches of ornaments on their chests—bowing deeply, leaning against the backs of chairs to blow, as if it were cigar smoke, mad puffs of madrigals into beautiful clouds of black hair—or pointing out, with the tip of a white glove, some more or less suspect divinity. Then there are the overbearing mothers, giving the advice of the Macette by Regnier to their excessively obedient daughters—washing them and anointing them to go to mass. The overbearing mother is marvellously well rendered by Goya who, like all Spanish painters, has a deep and acute feeling for the ignoble; it would be impossible to imagine anything more grotesquely horrible, anything more viciously deformed; each of these witches embodies all the ugliness of the seven capital sins—the devil is attractive in comparison. Imagine wrinkles like ditches, eyes like embers that have been snuffed out with blood, noses fluted like an alchemist's retort, swollen with warts and growths, hippopotamus snouts, bristling with rough horse-hair, tigers' whiskers, mouths like moneyboxes contracted in horrible sneers—there is something in them that reminds one of the spider and the wood-louse, that provokes the same sense of disgust that one feels when one steps on the soft belly of a toad. So much for the realistic side—but it is when Goya abandons himself to his capacity for fantasy that he is most admirable; no one can equal him in making black clouds, filled with vampires and demons, rolling in the warm atmosphere of a stormy night, breaking up a cavalcade of sorcerers on a strip of mysterious horizon.

There is one engraving of pure fantasy that is the most terrifying nightmare one could ever have dreamed; it is called *Y aun no se van* (And still they won't leave). It is ghastly; not even Dante was able to obtain an effect of such suffocating terror. Imagine a bare, dismal plain; above this plain trails an odd-shaped cloud, looking somewhat like a ripped-open crocodile; then imagine a large stone, a tombstone, and a thin, sickly-looking figure trying to raise it up. The stone, too heavy for the frail arms that support it (one feels they are about to give way), falls back, in spite of the efforts of the ghost and other little phantoms who stretch out their shadowy arms

to help; many are already caught under the stone, raised only for an instant. The expression of despair on all the corpselike faces, in all the eyeless sockets of those who understand that their effort has been in vain, is tragic; it is the saddest symbol of the futility of endeavor, the most somber poem, the most bitter derision ever expressed for the dead.

The *Buen viage* engraving is notable for its vivacity and energetic movement: it depicts a flock of demons, disciples of the Barahona coven, who flee swiftly, rushing towards some nameless task. One seems to hear those membranes, hairy and nimble like the wings of bats, palpitating in the thick night air. The collection ends with these words: "Y es ora"—the time has come; the cock crows and the ghosts vanish; it is daybreak.

What of the aesthetic and moral value of this work? We know nothing about it. Goya seems to have offered his opinion on this point in a drawing that represents a man resting his head on his arms; around him hover owls and fantastic creatures. The caption of the picture is *El sueño de la razón produce monstruos* (The sleep of reason produces monsters). It is true—but it is a harsh truth.

The *Caprichos* are the only part of Goya's work in the possession of the Bibliothèque Royale in Paris. He produced other printed works: the *Tauromachia*, a collection of thirty-three plates; the Invasion scenes [*Desastres de la Guerra*], twenty plates in all, which should be more than forty; etchings after Velazquez, and others.

The *Tauromachia* is a collection of scenes representing aspects of the bullfight from Moorish times to our day. Goya was an *aficionado* and he spent a good deal of time with *toreros*—thus, he was the most competent man in the world to treat this subject. Although the attitudes, defences, and attacks, or, to use technical terms, the various *suerteas* and *cogidas*, are irreproachably exact, Goya infuses these scenes with mysterious shadows and fantastic tonalities. What bizarre, fierce heads! What savagely strange costumes! What fury of movement! His Moors, looking somewhat like Ottoman Turks, have the most distinct physiognomies. A hastily indicated feature, a black spot, a white streak: here are characters who live and move, whose faces remain engraved forever in the memory. Although the shapes of the bulls and horses are sometimes a bit fantastic, they have a life and thrust that is often lacking in the work

of professional animal painters; the feats of Gazul, the Cid, Charles V, Romero, the student of Falces, Pepe Illo, who perished sadly in the arena—all are recounted with typical Spanish fidelity. Like the *Caprichos*, the plates of the *Tauromachia* are executed in aquatint, heightened by etching.

The *Desastres* bear a curious relationship to the *Misfortunes of War* by Callot. Nothing is represented but men who have been hanged—piles of bones are plundered, women are raped, wounded are carried away, prisoners are shot, convents are looted, entire populations are in flight, families are reduced to begging, patriots are being strangled—and all this is depicted with such fantastic costumes and huge figures that it conveys the impression of a four-teenth-century Tartar invasion. But what delicacy, what deep scien-tific knowledge of anatomy is present in all these groups—which ap-pear to have been created by pure chance, as if they were the result of a caprice of the pen! Can one really believe that the mother who kneels with her family in the face of the French bayonets is any less desolate or noble than the ancient Niobe? Among these drawings, which seem so easily explained, we find one that is truly mysterious and terrible—whose meaning, which one can only vaguely guess at, produces chills and terror. It shows a dead man, half buried in the ground, supporting himself on one elbow; without looking, he writes —with a skeletal hand—one word on the piece of paper beside him —a word worthy of Dante's darkest: *Nada*—nothing. Around his head, which has just enough flesh left to make it more horrible than a bare skull, monstrous nightmares, lit here and there by vivid flashes, whirl about, barely visible in the darkness of the night. A prophetic hand holds scales whose plates are overturned. Can one imagine anything more sinister or more desolate?

Just at the end of his life—which was long, for he died in Bordeaux when he was over eighty—Goya did some rough litho-graphs, drawing directly on the stone, that bear the title *Dibersión de España*. They are all bullfight scenes. In these sheets of paper, blackened by the hand of an old man who had long since been deaf and was nearly blind, one still recognizes the vigour and movement of the *Caprichos* and the *Tauromachia*. The appearance of these lithographs recalls, funnily enough, Eugène Delacroix's illustrations of *Faust*.

The ancient art of Spain is buried in Goya's tomb—that world has disappeared forever; the world of *toreros, majos, manolas,*

monks, smugglers, thieves, *alguazils,* sorcerers—all the local colour of the peninsula. He arrived just in time to capture it all and make it permanent. He thought he was only expressing his fantasies; instead, he painted the portrait and the history of Old Spain, believing he was serving the ideas and beliefs of the New. His caricatures will soon become historic monuments.

SOME FOREIGN CARICATURISTS

Charles Baudelaire

New horizons in the comic have been opened up in Spain by a most extraordinary man.

On the subject of Goya, I must start by referring my readers to Théophile Gautier's excellent article in the *Cabinet de l'Amateur*,[1] which has since been reprinted in a miscellaneous volume. Théophile Gautier is perfectly equipped to understand a nature such as Goya's. Moreover, with reference to his technical methods—aquatint and etching mixed, with heightenings of drypoint—the article in question contains all that is required. All I want to do is to add a few words upon that very precious element which Goya introduced into the comic—I want to speak about the *fantastic*. Goya does not fit exactly into any of the special or particular categories; his is neither the absolute nor the purely significative comic, in the French manner. Often of course he plunges down to the savage level, or soars up to the heights of the absolute, but the general aspect under which he sees things is above all fantastic; or rather, the eye which he casts upon things translates them naturally into the language of fantasy. The *Caprichos* are a marvellous work, not only on account of the originality of their conceptions, but also on account of their execution. I like to imagine a man suddenly faced with them—an enthusiast, an amateur, who has no notion of the historical facts alluded to in several of these prints, a simple artistic soul who does not

"Some Foreign Caricaturists." From Charles Baudelaire, *The Mirror of Art: Critical Studies*, trans. by Jonathan Mayne (London: Phaidon Press Ltd). Reprinted by permission of the publisher.

[1] Vol. I, 1842, pp. 337 ff.; reprinted in the *Voyage en Espagne*.

know the first thing about Godoy, or King Charles, or the Queen; but for all that he will experience a sharp shock at the core of his brain, as a result of the artist's original manner, the fulness and sureness of his means, and also of that atmosphere of fantasy in which all his subjects are steeped. I would go further and say that in works which spring from profoundly individual minds there is something analogous to those periodical or chronic dreams with which our sleep is regularly besieged. That is the mark of the true artist, who always remains firm and indomitable even in those fugitive works—works which are, so to speak, hung upon events—which are called *caricatures*. That, I declare, is the quality which distinguishes *historical* from *artistic* caricaturists—the fugitive from the eternal comic.

Goya is always a great and often a terrifying artist. To the gaiety, the joviality, the typically Spanish satire of the good old days of Cervantes he unites a spirit far more modern, or at least one that has been far more sought after in modern times—I mean a love of the ungraspable, a feeling for violent contrasts, for the blank horrors of nature and for human countenances weirdly animalized by circumstances. It is curious to note that this man, who followed after the great destructive and satirical movement of the 18th century and to whom Voltaire would have acknowledged his debt for all those monastic caricatures of his—for all those monks yawning or stuffing their stomachs, those bullet-headed cut-throats preparing for matins, those brows as crafty, hypocritical, sharp and evil as profiles of birds of prey (or rather for the idea only of these things, for the great man is to be pitied for not being much of a connoisseur in other artistic matters); it is curious, I say, that this monk-hater should have dwelt so much on witches, sabbaths, scenes of devilry, children roasting on the spit, and Heaven knows what else—on every debauchery of dream, every hyperbole of hallucination, and not least, on all those slim, blond Spanish girls of his, with ancient hags in attendance to wash and make them ready for the Sabbath, perhaps, or it may be for the evening rite of prostitution, which is civilization's own Sabbath! Light and darkness play across all these grotesque horrors; and what a singular kind of playfulness! Two extraordinary plates above all come to mind. The first[2] represents a fantastic landscape, a conglomeration of clouds and boulders. Is it a corner of some unknown and unfrequented Sierra? or a sample of primeval chaos? There, at

[2] *Caprichos*, No. 62, "Quien lo creyera!"

the heart of that abominable theatre, a life-and-death struggle is taking place between two witches, hanging in mid-air. One is astride the other, belabouring and mastering her. Locked together, these two monsters are spinning through the gloomy void. Every kind of hideousness, every vice and moral filthiness that the human mind can conceive, is written upon these two faces which, according to a frequent custom and an inscrutable procedure of the artist's, stand half-way between man and beast.

The second plate[3] shows us a wretched being, a desperate and solitary monad whose one desire is to get out of its tomb. A crowd of mischievous demons, a myriad lilliputian gnomes are bearing down with all their united efforts upon the cover of the half-gaping sepulchre. These watchful guardians of death have banded together against a rebellious soul which is wearing itself out in its impossible struggle. This throbbing nightmare is set amidst all the horror of the vague and the indefinite.

At the end of his career Goya's eyesight weakened to the point at which it is said that his pencils had to be sharpened for him. Yet even at this stage he was able to produce some large and very important lithographs, amongst them a set of bullfighting scenes,[4] full of rout and rabble, wonderful plates, vast pictures in miniature— new proofs in support of that curious law which presides over the destinies of great artists, and which wills it that, as life and understanding follow opposing principles of development, so they should win on the swings what they lose on the roundabouts, and thus should tread a path of progressive youth and go on renewing and reinvigorating themselves, growing in boldness to the very brink of the grave.

In the foreground of one[5] of these prints, in which a wonderful tumult and hurly-burly prevails, is an enraged bull—one of the spiteful kind that savage the dead. It has just unbreeched the hinder parts of one of the combatants. No more than wounded, the poor wretch is heavily dragging himself along on his knees. The formida-

[3] Klingender (*Goya in the Democratic Tradition,* London 1948, p. 221) suggests that Baudelaire is here confusing his recollection of *Capricho* No. 59 (*"Y aun no se van!"*) with Gautier's description of the *Nada* print in the *Desastres de la guerra.* Certainly Baudelaire's description is inaccurate if he has *Capricho* No. 59 in mind. [For an extract from Klingender's *Goya in the Democratic Tradition,* see pp. 36–70.—ED.]

[4] The four lithographs known as the *Toros de Burdeos.*

[5] *Diversión de España.*

ble beast has lifted his torn shirt with its horns, thus exposing his buttocks to view; and now, once again, down comes that threatening muzzle—but the audience is scarcely moved by this unseemly episode amid the carnage.

Goya's great merit consists in his having created a credible form of the monstrous. His monsters are born viable, harmonious. No one has ventured further than he in the direction of the *possible* absurd. All those distortions, those bestial faces, those diabolic grimaces of his are impregnated with *humanity*. Even from the special viewpoint of natural history it would be hard to condemn them, so great is the analogy and harmony between all the parts of their being. In a word, the line of suture, the point of junction between the real and the fantastic is impossible to grasp; it is a vague frontier which not even the subtlest analyst could trace, such is the extent to which the transcendent and the natural concur in his art.[6]

[6] Some years ago we possessed several precious paintings by Goya, though they were unhappily relegated to obscure corners of the gallery; they disappeared, however, along with the *Musée Espagnol*. (c.b.)

GOYA IN THE DEMOCRATIC TRADITION

Francis Klingender

THE CONFLICT OF REASON
AND FANTASY

The *Caprichos* are Goya's first truly personal inventions. Their style differs entirely from that of his earlier work. Each plate resembles a darkened stage in front of which one or two actors are picked out by the footlights. The background, produced by the coarse-grained aquatint medium of which Goya made such original and masterly use, varies from deep black to a modulated grey. Sometimes it resembles a dark cloud suspended menacingly over a glowing horizon; occasionally a tree or part of a building is hinted at, or else the shadowy outlines of mysterious figures appear in the gloom. The nightmare atmosphere of these designs culminates in the final sequence. The young girl, for example, who is running away from vile monsters in *Capricho* 72 is, clearly, glued to the spot. But the more realistic appearance of the figures in the first part is also deceptive. Those seductive girls and terrifying hags, those sinister plotters whispering together, are not creatures of flesh and blood: they are phantoms, born in the artist's mind, to concentrate and intensify reality. For this kind of art the "natural style" Goya had acquired with the help of Mengs in the period of the tapestry cartoons was useless. He himself wrote in a prospectus he drafted for publication with the Caprichos:

"Goya in the Democratic Tradition." From Francis Klingender, *Goya in the Democratic Tradition* (London: Sidgwick & Jackson Ltd., 1968), pp. 99–105, 154–56, 164, 167–75, 179–89, 193–95, 206–13. Reprinted by permission of the publisher.

The artist begs the public to be indulgent with him, because he has neither imitated other works, nor even used studies from nature. The imitation of nature is as difficult as it is admirable, if it is really perfect. But an artist may also, surely, remove himself entirely from nature and depict forms of movements which to this day have only existed in the imagination. . . . Painting, like poetry, selects from the universe whatever it considers most suitable for its purposes. It unites qualities and characters which nature has scattered among different individuals and concentrates them in a single fantastic being. Thanks to this creative combination, the artist ceases to be a mere copyist and acquires the title of an inventor.[1]

It is interesting to compare this statement with the following passage from Mengs' letter to Ponz:[2]

Painting imitates every visible thing in nature not exactly as it is, but according to outward appearances, or might be; the intention being principally to instruct in giving pleasure. This would not happen if nature was copied closely; for the same or greater difficulties would occur to comprehend the productions of art than those of nature: so that the expression given by art is to furnish a clear *idea* of what nature has produced; and such works will be so much the more valuable, as the idea conveyed will be perfect, distinct and clear.

Everything which art produces exists already in nature . . . [but] the art of painting may in general be said to out-do nature, because it unites those perfections which in nature are dispersed, or else disencumbers her from such attributes as may not be necessary to a chosen subject . . . from whence it happens that the invention may often yield more delight than the original. In consequence of this I must add that imitation in painting should not be servile, but *ideal;* that is it should imitate those parts of natural objects which give us an idea of the thing we perceive. . . . This line of beauty is therefore called *ideal,* as not to be found in the common course of nature; from whence many have supposed that the ideal has no reality. A perfect piece of painting should always have something ideal. . . .

[1] This draft prospectus has never been published in full. Carderera, then its owner, published extracts from it in the *Gazette des Beaux Arts* in 1860. It was exhibited by Maggs Brothers at the Bibliothèque Nationale show of 1935. The passage quoted is taken from Mayer, *Goya,* Munich, 1923.

[2] Sir John Talbot Dillon, *Sketches on the Art of Painting, with a description of the Most Capital Pictures in the King of Spain's Palace at Madrid, in a letter from Sir Anthony Raphael Mengs, Knt, to Don Antonio Ponz,* London, 1782.

It is curious to note how literally Goya—or, possibly, his friend Cean Bermúdez—adopted certain words of his predecessor, while defining a diametrically opposed conception of art. Mengs selects from Nature in order "to instruct in giving pleasure"; he rejects imitation for *idealisation*. Goya's principle of selection is not ideal beauty, but *truth*. He goes to Nature for his details, which he fuses into a fantastic whole in order to reveal the *substance* of reality, and not "its outward appearances, or as it might be." . . .

The "removal from nature" of which Goya speaks does not imply a removal from reality. The basis of artistic creation, as he defines it, is observation: the study of Nature in all its manifold variety. But that is only the beginning of the artist's task. Its essence is selection and concentration, the recreation of reality on a higher plane. The new reality resulting from the fusion of reason with fantasy has the power of a revelation. It is not the outcome of a mechanical addition. It is a new entity, born of the union of two contradictory elements, a union which is creative because it is the resolution of a conflict. Reason and fantasy were ceaselessly at war in Goya's mind. From the first *Capricho* sketch to his last pencil stroke, every one of his works was an offspring of that struggle. No two of them contain both ingredients in the same proportions. In times of fierce reaction, when the light of reason battled in vain to penetrate the gloom of an apparently hopeless situation, the fantastic monsters, born of reason's weakness, assailed it with a fury which could only be withstood by a supreme effort. It is Goya's greatness that he was never overpowered by them. He did not run away from them. He was not afraid to let loose the furies of hell that tormented him. But he never submitted to the narcotic enticements of morbid satanism, eroticism, or mysticism, as did so many other artists during the counter-revolution and restoration periods.[3] Even in the most terrifying of his later nightmares Goya invariably retained control over the creatures of his imagination. For even in times of the deepest depression he never lost his faith in the ultimate victory of freedom.

Velazquez inspired Goya's realistic portrait style. Goya's new programme of imaginative realism was conceived under the influ-

[3] *E.g.* Romney, Fuseli, Barry, and even to some extent Blake among the English painters, or Girodet and some later romantics in France. For literary examples *ad nauseam* cf. Mario Praz, *The Romantic Agony*, Oxford, 1933.

ence of an artist no less important in the history of Spanish culture. The fusion of realism with fantasy, "forms and movements which exist only in the imagination," "single figures combining the qualities and characters which nature has scattered among different individuals"—where are these to be found, if not in the art of Hieronymus Bosch? Bosch, like Goya, lived in a world labouring in the birth-pangs of a new social order,[4] in a world of conflict the essence of which is embodied in his works. Combining the bourgeois naturalism of the Van Eycks with the demoniac imagery which had vegetated for centuries in the popular tradition (*e.g.* in gargoyles, choir-stool carvings, or popular prints), Bosch made his disturbing and elemental art the mirror of all the "vices and follies" of his time. That explains the paradox of his influence during the sixteenth century. He directly inspired Brueghel, the painter of beggars, at a time when the insignia of mendicancy had become the symbol of the Flemish national revolution. And he was a favourite painter of the arch-enemy of that revolution, Philip II, sword-arm of the Counter-Reformation. The critique of human vanity, created as a weapon of the Flemish people in their struggle against the worldly ambitions of the Church, could also assist the militant Counter-Reformation in its revival of spiritual universalism in opposition to the new bourgeois order. Philip II thus filled the Escorial with all the paintings of Bosch he could lay his hands on, and with few exceptions all the most important works of that master which have survived are still, or were in Goya's time, in Spain.[5]

But Philip's taste does not reflect the main reason for the ap-

[4] Bosch died in 1516 on the eve of the Lutheran Reformation. The turbulent state of fifteenth-century Flanders—a veritable chronicle of wars and revolutions—is described by M. H. Gossart, *Jérôme Bosch*, Lille, 1907.

[5] Cean Bermúdez recorded sixteen paintings by Bosch in the Spanish royal palaces and in Valencia (this list excludes copies, but it includes Brueghel's *Triumph of Death*, now in the Prado, and there may have been other wrong attributions. Carl Justi traced references to thirty-eight Bosch paintings in Spanish seventeenth-century documents. Cf. his important article, "Die Werke des Hieronymus Bosch in Spanien," *Jahrbuch der königlich-preussischen Kunstsammlungen*, 1889. On Bosch cf. also, apart from Gossart, *Jérôme Bosch*, F. v. Schubert-Soldern, "H. Bosch und P. Brueghel," *Beiträge zur Kunstgeschichte F. Wickhoff gewidmet*, Vienna, 1903; H. Dallmayer, "H. Bosch und die Darstellung der vier letzten Dinge," *Jahrbuch der kunsthistorischen Sammlungen des allerhöchsten Kaiserhauses*, Vienna, 1898; and the most recent study by C. de Tolnay, *Hieronymus Bosch*, Basle, 1937.

peal of "El Bosco" to the Spaniards. In his synthesis of reason and fantasy the accent rests on the democratic, popular elements. Fantasy serves to enhance and to render elemental the moral satire of Bosch's realism. Therefore his art could only be tolerated during the first, heroic phase of the Hapsburg régime. After the death of Philip II, Bosch, the painter of devilries and "absurdities," was attacked as a dangerous heretic. In his capacity as art censor to the Holy Office, Pacheco warned the Spanish painters against the error of regarding the extravagant fantasies of El Bosco as profound mysteries. As time went on the critics became more and more violent, although the Flemish artist was defended by certain sections of the clergy, and especially the monks of the Escorial, who could not countenance the censure on their founder which these attacks implied. Two quotations from this controversy will explain better, perhaps, than a lengthy description could do, why this painter of "dreams" could exert so profound an influence on Goya.

In the third part of his *Historia de la Orden de San Gerónimo,* published at Madrid in 1606, Fray José de Sigüenza, prior of the Escorial, included a long digression on Hieronymus Bosch[6] which has remained to this day one of the most penetrating appreciations of that artist's work. Defending Bosch against the charge of heresy, Sigüenza writes that his works, far from being "absurdities," are a profound moral sermon. Moreover, "while others have aspired to represent the external appearances of man, he alone has dared to paint man as he is within." The monsters, demons, and composite beasts which haunt the pictures of Bosch (Sigüenza is referring in particular to the Escorial *Hay Wagon*) are the embodiments of man's own vices and evil impulses. It was Sigüenza who was quoted by Ponz[7] and by Goya's friend Cean Bermúdez,[8] when they discussed Bosch in their art-historical works published during Goya's life.

The second quotation comes from the *Dreams* (*Sueños*) of Quevedo (1627), who was himself attacked as a "pupil and second

[6] It is quoted in full, together with references to Bosch by other Spanish sixteenth- and seventeenth-century writers, by Tolnay, *Hieronymus Bosch.*

[7] A. Ponz, *Viaje de España*, Madrid, 1772–94. Bosch is mentioned in volumes ii and iv, where Ponz describes the art treasures of the Escorial and Valencia Cathedral respectively.

[8] J. A. Cean Bermúdez, *Diccionario de los más ilustres profesores de las bellas artes en España,* Madrid, 1800. Cf. the article "Bosch."

edition of the atheist painter Hieronymus Bosch." In this work El Bosco appears as one of the condemned souls in hell, and when he is asked why he made such a "hash" of us in his *Dreams* he replies, "because he never believed in the existence of devils." [9]

Goya, who had made an inventory of the royal collections in his capacity of Painter to the Royal Chamber, was, of course, intimately acquainted with some of the best works of Bosch. But he had been prepared for this influence ever since his early studies in Madrid. The fantastic element which the Tiepolo expressed in their *Scherzi* and *Capricci* had come to them, by way of Brueghel, Callot and their followers, from Bosch. But while the influence of Bosch's great moralities on the conception of the *Caprichos* is self-evident (even the arrangement of the set seems to reflect that of the Escorial *Garden of Delights* with its profound opposition between sensual pleasure and the torments of hell), Goya could nevertheless truly claim that he had not imitated any existing models in the style of his work.[10] He achieved an entirely new synthesis of reason and fantasy, as adequate both in content and form to the age of the French Revolution as that of Bosch was to the Reformation era.

Goya's new style, as first embodied in the *Caprichos,* placed him beyond the reach of his most advanced contemporaries. The Spanish painters of his own generation adhered to the Mengs tradition. The younger artists, born in the 1770's and working from about 1800, adopted the more rigorous classicism of the David school, and, indeed, the most talented among them were sent to

[9] I am quoting from Justi's article.

[10] Certain formal similarities may be discovered between the strongly caricatured heads in some of Bosch's paintings and in a vast number of prints directly or indirectly inspired by his work (including the *Heads of Peasants* attributed to Brueghel and illustrated in Nos. 235–78 of van Bastelaer's catalogue) on the one hand, and the heads in certain *Caprichos,* in the *Betrayal of Christ* (Toledo Cathedral, 1798), and in a Goya drawing with sixteen caricatures (also 1798, cf. the illustration in F. Boix, *Esposición de dibujos originales 1750–1860,* Madrid, 1922) on the other. But such similarities are insufficient to prove direct derivation. The same is true of the curious "conceit" of the girls with chairs on their heads (*Capricho* No. 26) which may have been inspired by the figure with a chair on his head in the *Wrath* segment of the *Seven Deadly Sins* (Escorial). Goya was too great an artist to copy, even when he was inspired by the work of a predecessor. When he did adopt a certain formal detail, he completely remodelled it to fit his own aims. It should be noted, however, that this is not true of some of the religious works Goya painted on commission.

Paris by the Spanish government to be trained in the studio of that master. . . .

MONSTERS OF OPPRESSION

REACTION

In his manifesto of 4 May Ferdinand had promised to in-augurate a régime of benevolent moderation. His conception of moderation is revealed by the series of decrees culminating in the re-establishment of the Inquisition on 21 July 1814. Following the restoration of the old despotic system of local government (4 May), of the monasteries and convents (20 and 23 May), of the Council of Castile with its fantastic agglomeration of bureaucratic and juridical functions (27 May), of the grotesque tangle of feudal taxes and monopolies (23 June), and the liberation of the clergy from all taxation (24 June), the edict reviving the Inquisition demonstra-tively completed the resurrection of Spanish despotism. It was in a real sense a triumph of the most fanatical section of friars and con-fessors in the camarilla. Only two days before its publication the Prime Minister San Carlos had given his word to Wellesley that nothing of the sort was contemplated. When the ambassador com-plained after the event, San Carlos excused himself by stating—probably quite truthfully—that neither he himself nor the Minister of Justice had known of the edict until they had read it in the news-paper.

The manner in which this enactment was engineered, evidently against considerable opposition, illustrates perhaps better than the decree itself the atmosphere then prevailing in Spain. Early in July the officers second in command in Cadiz, Seville, and Valencia received orders signed by the Minister of War for the immediate arrest of their superiors, the Captains-General of those provinces. After these arrests they were to open a second letter with further instructions which were to be carried out instantly. Strange as these orders were, the surprise of the officers to whom they were ad-dressed was as nothing compared with the shock received by the only one of them who actually arrested his chief. For the second note contained the command to execute the Captain-General on the spot. Now even this officer considered it his duty to write to Madrid, as the others had done, for confirmation of so extraordinary

a command. The three enquiries came as a bombshell to the minister Eguia, who disclaimed all knowledge of the proceedings, and on 12 July an official manifesto informed the public of the horrible plot which had been hatched against the Serene Majesty of the King. The clerical party were not slow in exploiting this sensational incident. Pulpit and press vied with each other to persuade the people how necessary for their protection was the strong arm of the Inquisition. A reward of 200,000 reals was offered for the discovery of the wretch who had misused the name of the King's minister. But, once the excitement had died down, the petty official, who was implicitly convicted of the forgery, was not only released, but remunerated with a liberal pension.

The country was now at the mercy of the camarilla. "The committee reigns supreme," wrote the new Prussian ambassador von Werther; "It issues decrees and orders the arrest of all whose opinions it suspects. The countless victims, who are jailed indiscriminately with robbers and murderers, include many men distinguished both for their talents and for their services to the nation. This despotism is so much the more revolting because it is exercised by fanatical, avaricious, and revengeful priests, equally lacking in ability and in moral sentiment. The finances are in a state of hopeless confusion. Yet the King gives everything that comes into the exchequer to the friars." [11]

The exultation of the clerical party in those days is expressed in a refrain which they had the effrontery to spread among the masses:

Vivan las cadenas,	(Long live our chains,
Viva la opresión;	Long live oppression;
Viva el rey Fernando,	Long live King Ferdinand,
Muera la Nación!	Death to the nation!) [12]

It would serve no purpose to follow the ceaseless intrigues and the abrupt changes of personnel in the camarilla or to describe the squalid details of its misrule. For although Ferdinand gave his creatures full licence to exploit his subjects in the most shameless man-

[11] Dispatch of 25 August 1814; cf. H. Baumgarten, *Geschichte Spaniens vom Ausbruch der franzoesischen Revolution bis auf unsere Tage*, Leipzig, 1865–72. The moral indignation expressed by the representatives of all the great powers little accords with their actions, which were dictated by a strict policy of "non-intervention."

[12] Baumgarten, *Geschichte Spaniens*.

ner, he took good care to remind them that he alone was the ruler of Spain. Abruptly and without any apparent reason he debased all whom he had raised from the gutter. After a brief spell of power ministers, lackeys, confessors, and police spies (whose duty it was to amuse the King with the unsavoury details of the Madrid *chronique scandaleuse*) would suddenly find themselves in some remote jail or monastery, with ample leisure to meditate on the blessings of arbitrary despotism. . . .

Although he retained his rank of court painter, Goya now disappeared from the public scene. He had retired, even before the return of Ferdinand, to a small country seat he owned on the opposite bank of the Manzanares, and he buried his grief behind the walls of the cottage which the people called the "Quinta del Sordo" (the deaf man's house). Except a few intimate friends, none of his contemporaries ever saw the works which we cherish to-day (with the *Caprichos*) as the finest fruits of his genius: the *Disasters of the War*, the *Disparates*, the *pinturas negras*, and the treasures of his sketch-books. To the rising generation of Spanish artists, versed in the polished classicism of the David school, he had already become a legend. . . .

MONSTERS

To appreciate the terrible conflict which tormented Goya in this period one must turn to the "private works" which he created without regard for the market. Foremost among these nightmare visions are the *pinturas negras*—the Black Paintings—of the Quinta del Sordo. These paintings, now in the Prado, originally covered the walls of the two main rooms in Goya's country retreat. In the ground-floor diningroom Goya painted a *Manola*, a bearded old man with a monster shouting into his ear, a visionary *Pilgrimage to* San Isidro, a *Witches Sabbath, Judith and Holofernes,* and the terrifying figure of *Saturn devouring one of his Children.* A haunting landscape with the head of a dog, the *Fates* suspended in mid-air, two men fighting with clubs as they sink into a bog, grinning women, men mocking a reading figure, two old people eating soup, the miraculous *Font of San Isidro,* and a fantastic vision of soldiers shooting at figures who float in the air of a gloomy landscape filled the room on the upper storey.

Ghost-like apparitions of towering dimensions, massed faces distorted by terror, or bodies without gravity, emerge from spaceless

gloom or float in sombre landscapes with huge rocks in this grue-
some nightmare. For the most part only half life-size, they give the
impression of a superhuman scale. The same breadth distinguishes
their treatment: all superfluous details are eliminated, and the
colouring is reduced to a macabre harmony of black, brown, and
white.

Equally macabre are twenty-two monumental etchings, eight-
een of which were first published in 1864 by the Madrid Academy
under the title *Proverbios*. Although they may not have been etched
until 1820, they were certainly conceived in the same period as the
pinturas negras, i.e. some time between 1814 and 1819. The title
Proverbs chosen by the Academy is a travesty of Goya's intention.
He himself called these enigmatic fantasies *Disparates* (his original
captions, *Disparate feminino, Disparate de miedo, Disparate furioso,
Disparate pobre*, etc., were discovered on contemporary proofs of
a number of the plates). The term *disparate* means "folly," "vagary,"
"something without rhyme or reason"; its significance is thus similar
to that of "*capricho.*" But what makes its adoption by Goya espe-
cially significant is the fact that it is the term generally used by the
older Spanish writers to describe the works of Hieronymus Bosch:

> Bosch, the Flemish artist celebrated for the "disparates" of his
> painting. . . . [Argote de Molina, *Libro de la monteria,* Seville,
> 1582.]
> Although people generally call his pictures the "disparates" of
> H. Bosch, he cannot be accused of heresy. [Fray José de Sigüenza,
> *Historia de la Orden de San Gerónimo,* Madrid, 1605.]
> He painted themes and objects which are extremely unusual and
> were never seen before, so that it has become the custom to call
> Bosch "el disparate." [J. Martinez, *Discursos practicables del no-
> bilisimo arte de la pintura,* mid-seventeenth century.][13]

This use of the word persisted in Goya's time. In his article on
El Bosco in the *Diccionario* of 1800 Cean Bermúdez paraphrased
Sigüenza's critique, but he retained the term *disparate.*[14]

Additional evidence that Goya consciously chose the title
disparate to indicate the affinity of his visions (the ghost-like quality
of which must not blind us to their deep moral intent) with the

[13] Tolnay, *Hieronymus Bosch.*
[14] Two other favourite terms of Goya occasionally applied to Bosch are
sueño (*e.g.* by Quevedo) and *capricho* (by Ponz).

dreams of Bosch may be found in a curious drawing of the Prado collection. It also shows in a striking manner in what sense one may speak of "influences" in Goya's imaginative work. One of the paintings by Bosch in the Prado, which was undoubtedly known to Goya, is the *Cure of Folly.* A pompous-looking doctor is cutting a stone out of the forehead of a man who is seated at a table; two other figures watch the operation. The satirical impression produced by this scene is heightened by the large funnel which is incongruously placed on the doctor's head, instead of a hat. Goya's drawing, which he significantly entitled *Gran disparate,* shows a decapitated man spoon-feeding his own head placed on the table at which he is sitting. A man behind him is pouring a liquid out of a jug into the funnel, which has been inserted into the severed trunk, in place of the head. A third figure watches these strange proceedings. *Formally* Goya's freak is a completely new invention. But in view of his title it is not unreasonable to assume that Goya was struck by the incongruous use of the funnel in El Bosco's *Folly* and that it was this *detail* which inspired the invention of his own *Disparate.* By retaining the detail of the funnel, Goya stuck closer than would appear at first sight to the hidden *motif* of Bosch's painting. In Bosch's days the funnel was widely used in popular satire as a symbol for the lifeless, purely mechanical learning of the scholastics. The "Nürnberger Trichter," for example, is a miraculous device through which the indolent student has knowledge poured into him without any effort on his part. In Goya's drawing knowledge, *i.e.* the official view of things, is poured straight into the trunk of the man, who does not even need his head to absorb the dope. Nor is this all; Goya has reinforced the "funnel" symbol with the synonymous one of "spoon-feeding"—the trunk spoon-feeds its own head and thus passes on the dope it has absorbed—and it was this latter symbol which he had used some twenty years earlier in the *Chinchilla* plate of the *Caprichos.* Thus Goya's *Gran Disparate,* like the disparates of Bosch, conceals a profound meaning under a mask of folly, and the same is true of all the fantastic images we are now considering.

The twenty-two plates of the *Disparates* are not, therefore, morbid essays in "satanism" for its own sake. But they are the most dream-like of all Goya's etchings,[15] and their symbols are conse-

[15] This applies even more to the preliminary drawings, not all of which were engraved. Blamire Young, *The Proverbs of Goya,* London, 1923, is an unconventional attempt to interpret the *Disparates.*

quently more personal and elaborate than those of the earlier prints. Nevertheless, some of them can be traced back to the *Caprichos* and even to the tapestry cartoons. Indeed, two cartoons reappear entirely, the *Pelele* and the *Game of blind-man's-buff*. To appreciate the road Goya had travelled one should compare the original conceptions of 1791 with the nightmare visions into which he transferred them a quarter of a century later. Other details of the *Disparates,* such as the repeated introduction of figures on stilts or the plate of the sack-race, strengthen the impression that the series as a whole is in some respects a sardonic revival of Goya's main theme in the cartoons: the portrayal, "in pleasing style, of the manners, customs and games of his country."

One of the most striking of the *Capricho* symbols revived in the *Disparates* is that of the double-faced woman who represents the Duchess of Alba in the suppressed plate known as the *Dream of Lying and Faithlessness*. In the eleventh plate of the *Disparates* a similar young woman with two separate heads is running away from the shadowy figure of an adoring lover towards a dark gateway in which four other women are waiting for her. Three are lined and crippled with age, the fourth, somewhat younger than her companions, looks up in despair. With one of her heads she looks back tenderly towards her lover and she beckons to him with her raised hand. The other head is bent low towards the human wreckage in the gateway; its face is deeply shaded and rigidly set, with the blank stare of a person obsessed. Beneath it appears a second, more sharply defined image of the lover, now reduced to the state of a raging madman, with dishevelled hair and gaping eyes and mouth. Even more horrifying is the way in which the *Capricho* symbol of the married couple has been intensified in the *Disparates*. The man and woman tied together have been fused into a single monstrous being, a gigantic nightmare image of Plato's primordial man-woman, before the separation of the sexes.

Personal feelings and experiences thus play a crucial part in the *Disparates,* and there are repeated examples of sexual symbolism, as in the plate with the stallion who has seized a woman with his teeth and is raising her from the ground, or in the various illustrations of flying. But all these allusions to the "vices and follies of private life," or even to Goya's own personal experiences, are again, as in the *Caprichos*, linked with meditations on the "frauds of public life." Once again Goya was attempting to show, in an even

profounder way, how both spheres transfuse and distort each other.

The Quinta paintings and the *Disparates* are the supreme embodiment of Goya's "satanic" expressionism. They are *Caprichos* on a gigantic scale. "Black-wingéd demon forms"—

> Like animated frenzies, dimly moved
> Shadows, and skeletons, and fiendly shapes,
> Thronging round human graves, and o'er the dead
> Sculpturing records for each memory
> In verse, such as malignant gods pronounce,
> Blasting the hopes of men, when heaven and hell
> Confounded burst in ruin o'er the world:
> And they did build vast trophies, instruments
> Of murder, human bones, barbaric gold,
> Skins torn from living men, and towers of skulls
> With sightless holes gazing on blinder heaven,
> Mitres, and crowns, and brazen chariots stained
> With blood, and scrolls of mystic wickedness,
> The sanguine codes of venerable crime.[16]

> The Fiend whose name was Legion: Death, Decay,
> Earthquake and Blight, and Want, and Madness pale,
> Wingèd and wan diseases, an array
> Numerous as leaves that strew the autumnal gale;
>
> Fear, Hatred, Faith, and Tyranny, who spread
> Those subtle nets which snare the living and the dead.[17]

There is no more striking resemblance than that between the visualised anguish of the lonely old artist, who retained his faith in the cause of liberty even at a time of catastrophic defeat, and the imagery of the young poet, whose very being breathed revolt. Both had discovered the cause of their agony in the concrete social evils of their day. Like Goya in the donkey sequence of the *Caprichos,* Shelley even went to the length of identifying the demoniac visions of his dreams with living politicians:

> I met Murder on the way—
> He had a mask like Castlereagh—
> Very smooth he looked, yet grim;
> Seven blood-hounds followed him:

[16] Shelley, "The Daemon of the World," 1815.
[17] Shelley, "The Revolt of Islam," 1817.

All were fat; and well they might
Be in admirable plight,
For one by one, and two by two,
He tossed them human hearts to chew
Which from his wide cloak he drew.

Next came Fraud, and he had on,
Like Eldon, an ermined gown;
His big tears, for he wept well,
Turned to millstones as they fell.

And the little children, who
Round his feet played to and fro,
Thinking every tear a gem,
Had their brains knocked out by them.

Clothed with the Bible, as with light,
And the shadows of the night,
Like Sidmouth, next, Hypocrisy
On a crocodile rode by.

And many more destructions played
In this ghastly masquerade,
All disguised, even to the eyes,
Like Bishops, lawyers, peers, or spies. . . .[18]

Shelley clearly understood the significance of the "romantic agony"
in Restoration art and literature:

Methinks, those who now live have survived an age of despair. . . .
The revulsion occasioned by the atrocities of the demagogues, and
the re-establishment of successive tyrannies in France, was terrible,
and felt in the remotest corner of the civilised world. Could they
listen to the plea of reason, who had groaned under the calamities
of a social state, according to the provisions of which, one man riots
in luxury, while another famishes for want of bread? Can he who
the day before was a trampled slave, SUDDENLY become liberal-
minded, forbearing, and independent? This is the consequence of
the habits of a state of society to be produced by resolute per-
severance and indefatigable hope, and long-suffering and long-
believing courage, and the systematic efforts of generations of men
of intellect and virtue. Such is the lesson which experience teaches
now. But on the first reverses of hope in the progress of French

[18] Shelley, "The Masque of Anarchy" ("written on the occasion of the
Massacre at Manchester"), 1819.

liberty, the sanguine eagerness for good overleaped the solution of these questions, and for a time extinguished itself in the unexpectedness of their result. Thus many of the most ardent and tenderhearted of the worshippers of public good have been morally ruined, by what a partial glimpse of the events they deplored appeared to shew as the melancholy desolation of all their cherished hopes. Hence gloom and misanthropy have become the characteristics of the age in which we live, the solace of a disappointment that unconsciously finds relief only in the wilful exaggeration of its own despair. This influence has tainted the literature of the age with the hopelessness of the minds from which it flows. Metaphysics, and enquiries into moral and political science, have become little else than vain attempts to revive exploded superstitions, or sophisms like those of Mr. Malthus, calculated to lull the oppressors of mankind into a security of everlasting triumph. Our works of fiction and poetry have been overshadowed by the same infectious gloom. But mankind appear to me to be emerging from their trance. . . .[19]

Shelley, an ardent admirer of Spanish literature, especially Calderón, was deeply stirred by the events in Spain. His "Ode to the Assertors of Liberty" ("Arise, arise, arise!—There is blood on the earth that denies ye bread . . .") was "written October 1819, before the Spaniards had recovered their Liberty." The Revolution of 1820 itself he glorified in his "Ode to Liberty," and the revolutionary wave it inspired in other countries in the "Ode to Naples" and the poem "Liberty" (all 1820). The following passage from a letter to Leigh Hunt, dated Pisa, 5 April 1820, also reveals Shelley's attitude to the Spanish liberal movement:

Much stress is laid upon a still more southern climate for my health, which has suffered dreadfully this winter, and if I could believe that Spain would be effectual, I might possibly be tempted to make a voyage thither, on account of the glorious events of which it is at this moment the theatre. You know my passion for a republic, or anything which approaches it.[20]

Both Goya and Shelley belonged to that band of inspired intellectuals whose art was the clarion call of militant democracy. But while Shelley deserted his class to join the ranks of the revolution,

[19] Shelley, Preface to "The Revolt of Islam," 1817–18.
[20] *The Letters of Percy Bysshe Shelley,* ed. by Roger Ingpen, London, 1914, vol. ii.

Goya rose from the people. Moreover, Goya, born in 1746, grew to manhood with the tide of bourgeois rationalism as it surged towards its revolutionary climax. Himself in the thick of the struggle, he saw his people in action. And although he shared their defeat, he never wavered in his militant materialism. Shelley, on the other hand, was born in 1792. He grew up in the backwash of the revolution, when the upper middle class, having attained its aims, had cast aside its democratic pretensions and a wide rift had appeared in the structure of hope built on the foundation of bourgeois rationalism. Moreover, he died too young to experience anything but the first storm signals of the renewed rising of the people in the Reform Bill agitation. His brief span of life was confined to a single epoch of fierce repression in the history of his country, to a period when the people, as yet only dimly aware of their true aims, remained on the whole inactive, and fervent hope could be the only solace of "the generous few."

> The system of society as it exists at present [Shelley wrote to Hunt on 1 May 1820] must be overthrown from the foundations with all its super-structure of maxims and forms before we shall find anything but disappointment in our intercourse with any but a few select spirits. This remedy does not seem to be one of the easiest. But the generous few are no less held to tend with all their efforts towards it. If faith is a virtue in any case it is so in politics rather than religion; as having a power of producing a belief in that which is at once a prophecy and a cause.[21]

Because Shelley's revolutionary fervour could find an outlet only in the imagery inspired by his faith, and not in action, he could never wholly master an inclination towards philosophical idealism. Although he confessed, in 1819, that he had "founded much of his persuasions regarding the imagined cause of the universe" on the principle that "mind cannot create, it can only perceive,"[22] he was nevertheless increasingly fascinated by Plato's metaphysical speculations.

[21] *The Letters of Percy Bysshe Shelley.*
[22] *The Letters of Percy Bysse Shelley,* Letter to Hunt, Livorno, 27 September 1819. See also the selection from the Shelley-Hunt correspondence and from Hunt's *Examiner* articles edited by R. Brimley Johnson, *Shelley—Leigh Hunt,* London, 1928.

Goya's sober materialism, on the other hand, is evident even in the *Disparates*. He repeatedly went out of his way to prove how little he had succumbed to the satanic mysticism which seems to pervade that work. In one of the *Caprichos* he had used a barren tree on which an empty cowl is spread to symbolise the material roots of established religion. He employed a similar device in two plates of the *Disparates*. In the *Folly of Fear* (No. 2: *Disparate de Miedo*) a gigantic phantom faces a group of soldiers. Some have fallen, terror-stricken; another is running away. In the middle distance their comrades are preparing for a desperate night action. They are training a gun at the enemy, who is rendered invisible by the dark range of hills in the background. But on closer inspection the "ghost" turns out to be a commonplace contraption of sticks and winding-sheets, from one of the sleeves of which there leers the revolting face of an impostor: by playing on the superstitions of the people, the "fifth column" of reaction attempts to demoralise the rear of the army which is fighting for the real values of life.[23]

Plate 19, *Disparate conocido* (*Folly exposed*), reveals a more truculent mood. A crowd is facing two similar contraptions of wood and cloth, one of which is flourishing a sword. A respectably dressed figure on the left of the group still exhibits signs of fear, but the leader of the crowd, a man of the people, drastically reveals his contempt for the sabre-rattling scare-crows of despotism.

The *pinturas negras* and the *Disparates* are moving manifestations of Goya's struggle to preserve his faith in a moment of deep despondency. Hence the difficulty of tracing their *specific* inspiration. In the last eighteen plates of the *Disasters of the War*, on the other hand, Goya was far more open in his social criticism (these plates, too, were produced at various dates between 1814 and 1820). If we neglect the somewhat enigmatic plate 65 (weeping women running from a table at which an officer is sitting: "Why all this clamour?"), the sequence opens with two quite unambiguous comments on the benighted fanaticism which still blinded the Spanish people: plate 66, *Strange devotion*, shows a donkey bearing a glass coffin with a mummified saint past a devout multitude; in plate 67 (*This is no less so*) statues of saints are carried on the backs of men. *What madness!* is the caption of the next design, which shows a

[23] See also Young, *The Proverbs of Goya.*

grotesque monk sprawling among piles of masks, puppets, and other symbols of superstition. **. . .**

THE PRISONER'S CHALLENGE

The spirit of Goya's Quinta paintings, the *Disparates,* and the later *Disasters* is reflected in many of his contemporary drawings. Some are preliminary sketches of those works,[24] others are additional manifestations of Goya's agony. In the words of Felix Boix,[25] they are a new set of *Caprichos,* but more tendentious and bitter than the earlier series. Apart from the "daemonic" fantasies, two groups are particularly important. The first consists of variations of the "prisoner" theme. As we have noted, this theme already appeared in the *Caprichos* and it was revived by Goya in the historical form of "famous prisoners of the Inquisition" during the Josefino period. Since the restoration of that tribunal by Ferdinand made the latter theme even more horribly topical after 1814, it is probable that Goya continued the series in the years of reaction. But he also returned to the wider theme of imprisonment as such, and the majority of the drawings of this period are not directly related to the Holy Office. Some are dungeon scenes in which the victim's hopeless anguish is smothered in darkness. More often they show single figures, whose brutal shackles brand the fiendishness of a prison system inherited from the days of the torture chamber: "The fetters are as barbarous as the crime"; "One need not torture a prisoner to secure him"; "If he is guilty, let him die quickly"; "What cruelty!" "Because their ancestors were Jews"; "They gagged her, because she spoke, and beat her face with sticks. This I saw near Orioso Morena in Saragossa." Nor are the victims of political persecution forgotten in this gallery of unfortunates: the drawing of a woman chained by her neck to a pillory, her feet secured in a heavy block, bears the caption: "Por Liberal."

Goya made etchings of three of these designs, and the importance he attached to their theme is shown by the fact that he added them to the proof set of the *Disasters* which he asked Cean

[24] Most of these are reproduced in P. d' Acchiardi's monumental work, *Les Dessins de F. Goya au musée du Prado,* Rome, 1908.

[25] *Los Dibujos de Goya,* Madrid, 1922; cf. also F. Boix and F. J. Sánchez Cantón, *Goya: Cien dibujos inéditos,* Museo del Prado, Madrid, 1928.

Bermúdez to edit in 1820. Countless are the haunting folk-songs inspired since immemorial times in Spain and elsewhere by the prisoner's anguish.[26] When, as in the Restoration period, a dying system seeks to perpetuate its rule by mass arrests and terrorism, the inarticulate cry of the oppressed becomes a challenge. Like the "prisoners' chorus" in Beethoven's *Fidelio* (first performed 1805, final version 1814), Goya's drawings voice the challenge of this age-old folk-theme in the "universal idiom" of grand art.

The second outstanding group among Goya's drawings of 1814–20 are scathing attacks on the clergy (especially the monastic clergy) and thus related to many of the later plates of the *Disasters*. Their significance must be considered in relation to certain contemporary paintings with religious themes which we must now examine.

CHRIST IN HIS AGONY

Ferdinand's policy of enriching the clergy enabled the Church to celebrate its victory with lavish building schemes, despite the poverty of a country ravaged by war and economic chaos. In Madrid alone more than twenty churches and monasteries were built or refitted during the 1814–19 period. Goya, too, was given certain ecclesiastical commissions. The first, which came from Seville, appears to have been an extensive project, for a number of sketches dealing with the legends of various saints associated with that city have survived. Only one of these was executed, the life-size altar-piece of Saints Justa and Rufina of 1817 (Seville Cathedral). Its derivation from Murillo's version of this theme (Seville Museum) has been pointed out by Sánchez Cantón and other authorities. But Goya's indebtedness to a seventeenth-century model appears to have been closer than this. The Witt Library contains a reproduction of another version attributed to P. de Moya (1610–66; Coll. Sánchez del Campo, Aznalcazar). Whether this attribution can be accepted or not, the painting undoubtedly dates from the seventeenth century, and it is of great interest that its composition is much more similar to that of Goya than to that of Murillo. Both the "Moya" and Goya versions are more baroque and melodramatic in feeling than the

[26] For modern prisoners' drawings see Hans Prinzhorn, *Bildnerei der Gefangenen*, Berlin, 1926.

Murillo. In the latter the Saints are standing before a neutral land-scape background and holding a model of Seville's Cathedral Tower between them. Their connection with that city is thus indicated in the traditional form of the attribute. But in the other two paintings, the local tie is emphasised more directly and realistically, for the figures are placed in front of a picturesque view of Seville with the Cathedral as the most prominent feature. Goya's main innovation, compared with the "Moya," was to place the tower, not between, but to the right of the saints, whom he could thus move closer together. It is of course impossible to tell whether Goya saw this particular specimen of what is, after all, a typical baroque solution of the theme, but it is difficult to escape the conclusion that he took his composition almost literally from a seventeenth-century model.

Copying of this order was wholly foreign to Goya's conception of art, and the few similar examples we have had occasion to note were almost invariably early ecclesiastical paintings. One is probably justified, therefore, in regarding the fact that he did not take the trouble to invent a new composition for the Seville picture as proof that he approached the theme in the spirit of a conventional Church commission.

It is difficult to imagine a greater contrast than that between the Seville altar-piece and two pictures with religious themes which Goya painted two years later. *The Communion of St. Joseph of Calasanz* [Fig. 4] and the *Christ in the Garden* [Fig. 5] of 1819 are generally placed among the most significant of Goya's later works. Technically they have been compared with the styles of the late nineteenth, rather than of the seventeenth, century. Their genuine feeling is beyond dispute. It is this sincerity which has induced cer-tain authorities to claim that in his old age Goya experienced a revival of religious feeling. Sánchez Cantón, for example, calls 1819 "l'heure religieuse" in Goya's life.

Goya's attitude to religion has been hotly disputed for almost a century. Personal conviction, rather than a dispassionate historical approach, has distinguished many of the contributions to this con-troversy. Romantics, like Théophile Gautier or Matheron, interpreted the *Nada* plates in the *Disasters* and similar works as proofs of Goya's philosophical nihilism; while devout Catholics, like Zapater, sought to vindicate the artist's orthodoxy. Although recent writers have, on the whole, adopted a more cautious line, it has not been sufficiently emphasised that for Goya, as for most of the Spanish

intellectuals of his generation, the problem of religion appeared in an entirely different light. To appreciate their attitude we must return, for a moment, to the pamphlet *Pan y Toros*.

The religious programme of the Spanish reformers, as defined in *Pan y Toros*, may be summarised briefly as follows. They demanded that "the plain simplicity of the word of God" be restored to the people and that the "eternal edifice of the Gospel" be cleansed of the "temporal and corruptible supports" added by those who have erected upon it "the idol of tyranny." They also demanded that the clergy should direct the people "by ways of peace, and not of legal process."

For Goya and his friends the problem of religion was not, therefore, primarily the abstract philosophical contest between Christianity and Theism or Atheism. They were mainly concerned with the more practical and immediate problem whether the Spanish Church should express the genuine feelings of the people and minister to their needs, or whether it should remain—what to a large extent it manifestly was—an instrument of oppression. Hence they bitterly attacked all those sections of the clergy and those institutions which embodied the flagrant elements of corruption in the Spanish Church. But they were equally zealous in supporting those forces within the Church who strove to make it an instrument for the enlightenment of the people. Their attitude could scarcely have been otherwise in a country which was still so completely under the influence of the clergy as was the Spain of Goya's time.

That this was also Goya's own attitude no one familiar with his work will deny. Virulent attacks on clerical corruption occur, as we have seen, not only in the *Caprichos*, but also in the *Disasters*. The finished plates do not, however, reveal the full length to which Goya was prepared to go. As already noted, the preliminary drawing for plate 77 of the *Disasters* identifies the mountebank priest of that design as the Pope, and this is not the only example among Goya's contemporary drawings in which he ridicules the head of Catholicism. In the last plates of the *Disasters*, which we shall presently discuss, and in a number of related drawings, priests are branded as the enemies of truth and justice. Most of the anti-clerical drawings of 1814–23 are, however, directed more particularly against the friars. Goya never wearied in depicting them as lazy scoundrels battening on the sweat of the people. His indignation is most graphically expressed, perhaps, in a drawing which shows a fat monk rid-

ing on the shoulder of a peasant who is tilling the soil (Prado). It is clear, moreover, that Goya did not simply regard the monks of his day as the corrupters of a noble ideal: he despised the whole conception of personal salvation through retirement from life. This is indeed a point in which Goya's outlook was radically opposed to that of Bosch and other popular artists of the late medieval period. The Prado collection contains at least one drawing of a hermit which might be interpreted as a direct parody of his predecessor's grand fantasies of St. Anthony in his desert retreat. Even in the calmer mood of the last Bordeaux years Goya's anti-clericalism is evident, as we shall see, from a number of drawings showing old people in various attitudes of devotion.

Quite distinct from the polemical aim of all these works is the genuine feeling not only in the two paintings of 1819, but also, significantly enough, in another scene from the Passion Cycle, the Toledo *Capture of Christ* of 1798, which we have mentioned in an earlier chapter. Between these two extremes range Goya's Church commissions from the conventional baroque histories of his youth to the gay *Caprichos* of San Antonio de la Florida [Figs. 7 and 8].

In spite of such concessions to the religious traditions of the people—which compelled even the constitution-makers of 1812 to proclaim Catholicism the only legal faith in Spain—Spanish liberalism of the Goya period was nevertheless a genuine offspring of eighteenth-century rationalism. Its programme was based on a belief in the inherent perfectibility of man, rather than on a plea of divine inspiration. Hence its zeal for education and the general enlightenment of the people.

Goya's religious pictures of 1819 were both painted for San Antón Abad, the church of the Madrid *Escuelas Pias*. The life-size altar-piece shows St. Joseph of Calasanz [Fig. 4] (1556–1648), the founder of the order which maintained that school and many similar establishments in Spain and other countries. Calasanz is one of the most remarkable figures in the history of education.[27] Although he was a Spanish nobleman by birth, his outlook was strikingly democratic. His legend abounds with visions similar to those of St. Francis of Assisi; according to one of them he was married to "Poverty" by

[27] The following details are taken from the articles "Escuelas Pias" and "José de Calasanz" in the *Encyclopedia Universal Ilustrada* (Barcelona, n.d.) and W. E. Hubert, "Der Heilige Joseph Calasanz," *Lebensbilder katholischer Erzieher,* Mainz, 1886.

that saint. This did not, however, prevent him from regarding the poverty of the people as the ultimate cause of their sins. The poor, he argued, have no time to educate their children, hence their degradation is the inevitable result of ignorance and neglect. Thus convinced, he devoted his life to the struggle for free and universal education.

The story of his struggle has the dramatic flavour common to all great reform enterprises. It is interesting that he did not, apparently, at first regard the direct participation of the Church as essential for the success of his scheme. He began by trying to persuade the *secular* teachers of Rome, where he was then living, to admit poor scholars free of charge to their classes. Only when his further plea that the Senate should subsidise free places in the schools had failed, did he turn to the religious orders famous for their educational work. Both the Jesuits and Dominicans, however, rejected his scheme. Undaunted by these refusals, St. Joseph at last decided to carry out his plan himself. With three devoted followers he founded the first "pious school" in the autumn of 1597 in Rome. Hounded by ceaseless intrigues and even arraigned before the Inquisition, he fought for his aims and kept up the work of his school, until, twenty years later, he was able to consolidate his cause by founding the order of the *Escolapios*. After another two decades, in 1637, his organisation embraced 27 schools with 372 teachers, and before Calasanz died its work had been extended to his native Spain and other Catholic countries.

Judged by the standards of his age, Calasanz's educational principles were advanced. He divided his pupils into age grades, each with a separate class-room and teachers, and he prepared curricula for primary, secondary, and higher education, in which religious teaching was combined with secular and practical instruction. Above all, he insisted that a teacher "must not only know *what* he teaches, but also *how* to teach."

The work begun by this great man was continued by his followers even through the darkest periods of his country's degradation —during the later seventeenth century and also in the period of reaction after 1814. It is not difficult to understand why Goya should have felt deeply moved, when he paid tribute to one whose inspiration was so profoundly akin to his own. Nor is this all: Calasanz, like Goya, was a native of Aragón, and no one familiar with the latter's intense local pride—or indeed with the whole

spirit of Spanish regionalism—will under-estimate the importance of this fact in the present context; finally, Goya himself had received his first tuition at the "pious school" of Saragossa, founded in 1732. Tradition reports that he charged only a nominal fee for his altar-piece and that he made a present of the small *Agony,* which is an entirely separate work, to the good Fathers of the Escuelas Pias.

Goya chose as the subject for his altar-piece, not some conventional miracle, but the act of Communion, the solemn moment when the great teacher returned to the roots of his inspiration to draw from them the strength he needed to continue his battle. He is kneeling on the raised platform of the altar, facing the priest who is placing the wafer into his mouth. His limp body and half-closed eyes express that ultimate concentration in which the self is wholly abandoned to a greater cause. The nave below is filled with the boy-ish heads of his pupils and the apostolic figures of their teachers— a silver treble and solemn base accompanying the main theme of the saint's devotion. A ray of light, falling from above onto the head of the saint, barely penetrates the gloomy expanse of the vault [Fig. 4].

Well might Goya ponder on the theme of moral courage at the time which Sánchez Cantón calls his "hour of religion." He received his commission from the Fathers of the Pious School[28] on the day before the fifth anniversary of that night of terror, 10–11 May 1814, when the leading liberals had been arrested in their beds and dragged off to the jails in which many of them were still languishing, that night which gave the signal for the restoration of oppression. 1819 was, as we have seen, the year in which the hideous corruption of the régime revealed itself in utter lawlessness and chaos; the moment when Garay's failure had made it clear for all that only a rising of the people could restore peace and order to Spain. 1819 also witnessed the last and most sensational of the many unsuccessful attempts at revolt. Before Goya delivered his altar-piece the Cadiz mutiny of July had been betrayed by La Bisbal.

In this lurid atmosphere of terror and treachery, rent by the distant flashes of the approaching storm, the theme of the great reformer seeking courage for his struggles assumed the force of a

[28] The altar-piece was commissioned on 9 May 1819 and completed by 27 August, the festival of the saint, when the altar was consecrated.

universal symbol in Goya's mind: "Father, if thou be willing, remove this cup from me: nevertheless, not my will, but thine, be done." The dark vault has become the desolate night on the Mount of Olives. The kneeling figure is Christ, spreading his arms in His agony and raising His eyes to the angel who is approaching with the cup in a beam of light [Fig. 5].

Less than six months had elapsed since Goya delivered the altar-piece of St. Joseph and his minute gloss on its meaning (the *Christ* measures no more than 47 x 35 cm.)[29] to the good Fathers of the Pious School, when D. Rafael de Riego and his Asturians again unfurled the banner of revolt (1 January 1820). Their famous march through Southern Spain (27 January–11 March) gave the signal for the overthrow of despotism. On 9 March Ferdinand swore the oath of loyalty to the Constitution of 1812, and on 4 April Goya attended a meeting of the Academy convened for the same purpose.[30] He expressed his exultation in a number of drawings, one of which is of great significance in the present context. It is a literal translation of the *Christ in the Garden* into a mood of ecstasy. The same broad beam of light traverses the scene, banishing all but the last traces of the preceding gloom. Leaning back to gaze with radiant joy into the light is the same kneeling figure. Halo and gown are replaced by the ordinary hat and great-coat of the period. On the ground before him are an inkstand with pens and paper, and below is written: "Divina Libertad."

If we now look back to the other works in which Goya expressed his grief in the days of darkness, we shall find yet a fourth version of the "kneeling man" image. He is again, of course, a "man of sorrow," and he may have been the first of the series to have taken shape in Goya's mind, although one is tempted to date him between the *Christ* and the *Divina Libertad* drawing. The kneeling figure now faces the spectator. He is emaciated and clothed in rags. The darkness of the rocky desert in which he kneels is haunted by dimly discernible monsters. His arms are half-raised in a gesture of helplessness, and his brow is clouded by the "sad presentiments of things to come," for he represents the people of Spain in Goya's frontispiece to the *Disasters of the War*.

[29] [Slightly over 13 by 18 inches. —Ed.]

[30] It was the last of the 81 meetings of that body which Goya attended. The first had been that of 14 July 1781, at which Jovellanos read his "Elogio de las bellas artes."

It is thus evident that even in his "hour of religion" Goya did not abandon the theme which was the mainspring of all his imaginative creations: the hopes and struggles of his people. In the periods of oppression which cast their shadows over his later life the Spanish people no longer appeared to him in the gay disguise of the *majo*, symbol of confident youth and vitality, but in the image of the "man of sorrow." In a moment of supreme agony[31] and in the context of a religious commission for which Goya felt deep sympathy, that image fleetingly assumed the likeness of Christ. By expressing his credo of life and action through the symbol of Christ, Goya struck a chord to which his people had long been attuned. Because Goya's religious pictures do not, like so many later works, express the despair of an artist seeking to escape from his social isolation, because, on the contrary, they are profoundly "popular" and democratic, Goya may justly be regarded as the last great religious painter. He was the final link of the tradition which ran from Cimabue to Rembrandt, its modulations ranging from Dürer's imagery of spiritual conflict to the grand moralities of Bosch and Grünewald. Nevertheless, the religious symbol was but a momentary choice for Goya. When, for a brief instant, the black night of reaction was dispelled by the dawn of freedom, he proudly proclaimed the social meaning of his image.

There is a beautiful drawing in the Prado which summarises Goya's attitude to the traditional faith of his people more succinctly, perhaps, than any of his other works. A monk is crouching on a stone, raising a crucifix in his right hand and pointing with his left to a skull on the ground. He is looking sternly at a peasant boy who is standing before him and raising his mattock in a defiant gesture. The opposition between the *vita contemplativa* and the *vita activa* is the theme of this design. And the symbolism chosen—on the one side agile youth raising the instrument of creative labour towards the sun, on the other the crouching monk pointing downwards to the symbol of death—can leave no doubt which of the two Goya,

[31] It is interesting to note that in this period of social stress, as in the similar circumstances of 1792, Goya again experienced a physical breakdown. When he recovered, early in 1820, he painted a portrait of himself on the sick-bed together with his doctor Arrieta, whom he thanks, in the dedication, "for saving his life in the grave and dangerous illness he suffered at the end of 1819 in the seventy-third year of his life" (Coll. Lucas-Norman, Paris).

whose vitality neither old age, nor deafness, nor disease could crush, had made his own. . . .

None of the romantics was more deeply influenced by Goya's art than Baudelaire. It is reported that a small book on Goya (it must have been Matheron's published in 1857) and the works of Edgar Allan Poe were constantly at his side.[32] As this combination shows, it was the "satanic" element in Goya's style that fascinated the author of *Les Fleurs du mal*:

> Goya, cauchemar plein des choses inconnues,
> De fœtus qu'on fait cuire au milieu des sabbats,
> De vieilles au miroir et d'enfants toutes nues,
> Pour tenter les démons ajustant bien leur bas.[33]

Increasingly isolated, as they were, from the people, the mid-nineteenth-century romantics were fascinated by Goya's macabre imagery without perceiving that it is but the foil which offsets the radiant essence of his genius: his profound optimism, faith in reason, and heroic affirmation of human dignity and freedom. But it is highly significant that the attitude of those artists who remained in touch with the people, *i.e.* of the cartoonists, who carried on the struggle for the cause of democracy, was precisely the reverse. They retained the spirit, even when they abandoned the form of Goya's art. This is strikingly apparent in the present context. Realising the continued hold of religion over a section of the people, especially in the country districts, the French nineteenth-century cartoonists, like Goya, occasionally adapted themes from Christian iconography for their ends. In doing so they took up the thread, however, where Goya left it, not in the Mount of Olives painting, but in the *Divina Libertad* drawing of 1820. That is to say, they showed not Christ, but a symbolic figure of Liberty or France suffering the agonies of the Passion. "Parodies" of this kind modelled on the Mocking of Christ, Christ before Pilate, and similar images appear fairly frequently in *La Caricature* of 1830–35, and one of the most moving series of cartoons published during the Paris Commune of 1871 is

[32] The authority for this statement is Troubat; see Jean Adhémar's essay in the catalogue of the Bibliothèque Nationale Goya exhibition, Paris, 1935.

[33] *Les Fleurs du mal*, vi: "Les Phares" (1st ed. 1857). The essay, "Quelques caricaturistes étrangers," also dates from 1857.

entitled *La Grande Crucifiée*.[34] It consists of nine naïve prints by
E. Courtaux showing "Liberty" or "Paris" in various stages of the
Passion. On the title-print she is crucified before a map of France,
while another plate shows her on her own Mount of Olives—the
Paris city wall—receiving the cup—a Prussian helmet—filled to the
brim. An even more recent example of this type of symbolism is
George Grosz' noble design of suffering humanity crucified, wearing
a gas-mask and soldier's boots, with the famous caption "Maul halten
und weiter dienen!" This was the drawing for which Grosz was con-
victed of blasphemy by the same tribunal which later became no-
torious through the Reichstag Fire Trial of 1933. . . .

GOYA'S ARTISTIC TESTAMENT

To understand the final phase in the development of Goya's art
we must retrace our steps to the last years before the Revolution of
1820. We have already noted that among the visions of fear and
horror which haunted the artist at that period, there emerged one
type of image with an opposed significance: the allegorical female
figure Truth, Reason, Justice, or Liberty. At the same time Goya's
creative fantasy also gave birth to another image, ultimately even
more profound in its antithesis to the dominant mood of terror.
This we must now examine.

We have noted as a general feature of all Goya's visions in the
period 1814–19 their vastness of scale. The unspeakable disaster of
brutal reaction after the sacrifices of the war of liberation took shape
in Goya's mind in the form of gigantic monsters—whether beasts,

[34] Britannia crucified is the subject of an English caricature of 1762
(B.M. Catalogue No. 3964). But this is not really an anticipation of
the French prints here discussed, since the symbolism is anti-Scotch
(*i.e.* anti-Bute) rather than religious, the cross being the St. Andrew's
Cross. This is also true of one of the details in Paul Sandby's "Satire on
Lord Bute" of 1762 (B.M. No. 3910), where Bute is shown in the guise
of the Angel (wearing a Scotch bonnet) appearing to the Shepherds
(*i.e.* the Scotch place-hunters). Such instances are, however, excep-
tional. Where the English caricaturists of the 1760's used religious im-
agery at all (always excepting the Apocalyptic imagery, already men-
tioned), they generally took it from the Old Testament, as, *e.g.*, in the
numerous prints representing Bute and the Princess of Wales as "Gisbal
and Bathseeba," or in certain cartoons (B.M. Nos. 4031, 4055), where
Wilkes appears as Daniel in the Lion's Den.

such as those in plates 1, 40, and 81 of the *Disasters,* or semi-human and human forms as in the Quinta and the *Disparates*—whose super-human proportions dwarfed and utterly crushed mankind. But, probably about the time when the ethereal figure of Hope first appeared in Goya's dreams, the irrepressible vitality of the people also began to reassert itself in his imagination in a more elemental form. The very scale of his horror visions brought about this release. For inhuman, monstrous, as were the torments of reaction, the body politic was even vaster. Kings, priests, jailers, torturers must die— the people are eternal. It is this conception which Goya embodied in a series of monumental designs some of which, at least, must date from before 1820.

The main stages in which this new type of image emerged from its satanic opposite can be traced without difficulty. The two paint-ings in the Quinta with huge figures poised in mid-air above sombre landscapes are transitional in character. The former shows the *Fates,* aloof, but still predominantly hostile in mood. In the latter, two figures are crouching in the air above what appears to be a battle-field. One is pointing towards a vast, strangely shaped mountain[35] in the distance; the other, apparently a female, is looking backward. The prevailing mood is no longer so ferocious, although it is heavy with mystery and still by no means confident.

Goya's release from the mood of gloom is expressed with tri-umphant abandon in plate 4 of the *Disparates.* A youthful giant dances wildly, laughing and shaking his castanets; behind him are the heads of two other shouting giants, facing him the half-crouch-ing figure of a man hiding behind a doll-like, shrouded female figure (possibly, as Young suggests, the wooden statue of a saint) which he is holding up towards the giant. In mood and conception this design is Rabelaisian: Gargantua, embodiment of the people's pris-tine virility, terrifies the upholders of established superstition and rises with triumphant laughter above their fears.[36]

From the exuberant joy of release to the confidence of assured conviction was but a small step for Goya. The next stage is a return

[35] Mountains play a striking role in Goya's imagery during this period. They occur in a number of designs and paintings, and in two landscape etchings with vast rocks.

[36] I am not, of course, suggesting any direct link between Rabelais and Goya. Unfortunately there is little documentary evidence regarding the books he read (although both Don Quixote and Gulliver appear in his drawings).

to the scheme of the two Quinta paintings: the huge form of a giant rising about the clouds in a landscape which again contains a war-like scene below. The giant makes a gesture of defiance; confidence and power are the dominant moods of this picture (Prado) [Fig. 6].

But the design most perfect in its simplicity and tranquil force is the famous etching of the *Giant*, of which only a few prints were made before the plate was broken. The immense figure is seated on a gently rising incline before which minute villages appear in the middle distance. Seen from behind, the titan turns his head and looks back towards the sky. The shadow of the earth darkens the greater part of his body, but the first rays of the rising sun fall on his face and shoulders. (Carl Neumann has published two variants of a print after a lost drawing by Brueghel which show a striking formal resemblance to Goya's *Giant*.[37] Brueghel's giant differs in spirit from Goya's, for he represents the power of wealth before which all mankind abase themselves. Yet it is suggestive that the change in mood from the terror designs of the *Disparates* to the *Giant* should be accompanied by a change in affinity—if not in influence—from Bosch to Brueghel, a change, in other words, from the artist who expressed the haunting terrors of the period immediately *before* the revolution to his successor whose art was inspired by the people's cause *in* the revolution).

In this context a drawing which shows the gigantic head of Gulliver as he lies asleep on the shores of Lilliput also assumes additional significance: the "grand colossus" need only awaken and stretch his limbs to shake the swarm of petty parasites, who are crawling all over him, into the dust (*Gran coloso dormido*—Berlin, Collection Gerstenberg).

Lastly, we must note a variant of this theme in which the people are no longer represented by a gigantic human form but by a beast. It is plate 21 of the *Disparates*, the *Disparate de Bestia*. An enormous hump-backed elephant is standing outside a white, semi-elliptical arena and faces a group of magicians. One of them is holding an open codex of the laws towards the suspicious-looking beast, another a belt of jangling bells, a third seems to be addressing it with honeyed words, while the fourth is turning, as if about

[37] C. Neumann, "Drei merkwürdige Anregungen bei Runge, Manet und Goya," *Sitzungsberichte der Heidelberger Akademie der Wissenschaften*. Philosophisch-historische Klasse. 1916.

to escape. *Other laws for the People* is the title given to the print, when it was first published in the periodical *L'Art* in 1877. Although probably apocryphal, it expresses its essential meaning, except for the sense of imminent revolt implied both in the posture of the elephant and the expressions of its keepers.[38]

It is unfortunately uncertain at what date Goya returned to a style of documentary realism to express his reassured confidence in the people. But this return to realism is the most striking result of the heroic recovery of his social outlook at the height of the pre-1820 reaction period. There exists a group of three closely related paintings which, with Daumier's paintings and groups of working people, Courbet's *Roadmakers*, a few of the more objective Millets, and some early drawings by van Gogh, belong to the most important pictures of manual workers produced during the nineteenth century. One shows a *Forge* with three men at work at an anvil (Frick Collection, New York), the other two a *Knife Grinder* and *Girl carrying water* respectively (Museum, Budapest). They are wholly documentary paintings of workers at their tasks. The theme which Goya first approached in the *Fallen Mason* and the *Muleteers* of 1786–7, and to which he fleetingly returned in the *Tapestry Workshop* of c. 1808–1810, now re-emerges in its most mature form. For in their style also these three groups of works mark three outstanding phases of Goya's artistic development. From the first assertion of realism within the framework of the rococo tradition, through the tense expressionism of doubt and dismay, to the vigorous objectivity of calm conviction—such was the course of a creative struggle which finally enabled Goya to give adequate expression to the theme of the people. On technical grounds the three paintings we are considering are usually dated 1818–19.[39] If this is correct, Goya had

[38] Among the Bosch paintings taken to Spain in the sixteenth century was his *Elephant* (C. Justi, *Miscellaneen aus drei Jahrhunderten spanischen Kunstlebens*, Berlin, 1908). Although it may have already disappeared by Goya's time, he may well have known Bosch's print of the same subject: a gigantic elephant standing, a tower of strength, amidst the turmoil of a fantastic battle scene.

[39] All three pictures are evidently contemporary; the *Forge* and the *Knife Grinder* contain the same model. It is tempting to date them from the Constitutional period. This is impossible, however, in view of the fact that the two Budapest pictures were purchased for the Esterhazy Collection from that of Prince Kaunitz on 3 April and 19 October 1820 respectively. Nevertheless they cannot have been painted much before 1819.

defeated the monsters of reaction in his own mind even before the collapse of political repression. For it is the spirit of freedom, the spirit of the dignity and joy of labour, as both Goya and Shelley understood it, which emanates from these pictures.

Goya's sense of confident assurance, his noble triumph over the monsters of despair, was shaken neither by the weaknesses and disappointments of the revolution itself, nor by the renewed horrors of the second restoration. It is to his drawings and last prints that we must turn for his artistic testament. A large number of the drawings[40] date from the artist's last years, although it is not always possible to distinguish those drawn in Bordeaux from the last Madrid designs.

We have already noted a number of drawings which obviously allude to the revolution of 1820. To these must be added a further group of designs of monks and nuns disrobing, an illusion to the secularisation of the religious houses.

Of the later drawings Paul Lafond writes: "Goya, less extreme than in his youth, more contemplative, wiser, more master of himself and of his thoughts, has here in part forsaken the fantastic and the macabre so frequently employed in the *Caprichos*. . . . This suite of drawings combines something of everything, of philosophy, of morals, of ecstasy, scenes of popular life, and simple incidents found through happy accident.[41]

In this last and most moving cycle of dreams and observations the old master has again traversed the whole range of his creative experience. They are a last version of the *Caprichos*,[42] but *caprichos*, imaginative follies, in a calmer, more benevolent, sometimes humor-

[40] Several hundreds of these drawings are preserved in the Prado and in various other collections. A set of 38 is illustrated in Paul Lafond, *Nouveaux Caprices de Goya*, Paris, 1907; many others in *Goya: los Caprichos*, No. 3 of the series *Los Grandes Maestros de la pintura en España*, Madrid, 1909; in F. Zapater, *Goya, Collección de reproduciones . . . etc.*, Madrid, 1924; in Boix and Sánchez Cantón *op. cit.*; in P. d' Acchiardi *op. cit.*; and in H. Rothe, *Francisco Goya, Handzeichnungen*, Munich, 1943.

[41] Paul Lafond, "Les Dernières Années de Goya en France," *Gazette des Beaux-Arts*, 1907.

[42] In 1825 Goya's friends in Paris apparently tried to persuade him to issue a new edition of the *Caprichos*, for Goya wrote in December of that year to J. M. Ferrer that he could not do so since he had ceded the plates to the King. He continues: "I would certainly not copy them, since to-day I have got better works, which could be more usefully sold . . ."; cf. Paul Lafond, "Les Dernières Années de Goya."

ous, but always fundamentally confident mood. It is true that the old monsters still occasionally appear, but more often than not they are now objective studies of idiots (*locos*). And sometimes there is a flash of the old ferocity, as in the design in which a man is sawn in two, while bespectacled lawyers watch the ordeal. Again, there is a group of drawings, deeply moving in its mood of pity rather than of ridicule, in which benighted old men or women are counting their beads or praying. One of these might be regarded as a faint echo of the "man of sorrow" image. And the same is true of another drawing, also in the Prado collection, in which the kneeling figure appears, at first sight, to be an old devil. But Goya's caption quickly dispels the illusion by tracing the old man's horns to a more worldly source: "He says he was born with them and he has them all his life"—a sardonic allusion to the trials of matrimony. In the serene mood of his final years Goya could make light both of the religious and of the satanic imagery of his troubled past.

But occasional reminiscences such as these scarcely affect the character of the concluding phase of Goya's art. It throbs with the life of the people, their work, troubles, quarrels, and amusements.

Roaming through Bordeaux, Goya observed the life of its streets and public places in all its vividness. Many scenes are from circus and fair-ground: the magnificent *Elephants,* the "living skeleton," the man in the peep-show, the man with the camel, the crocodile, performing animals, and similar marvels. There is also the guillotine performing its gruesome work. But most of the drawings show ordinary folk at their everyday occupations: women at work in their homes, or tending their children; men working or having a drink; children, courting couples, and old people.

Some of these drawings stand out as triumphant manifestations of Goya's faith in the people. Such is the drawing showing a rugged peasant in tattered clothes pulling with all his might at a rope. Such is also the lithograph[43] of the *Vito*; a girl moving in the measured ecstasy of the dance, surrounded by the uncouth figures of a watching crowd. All the confidence and joy, the unshakable certainty of a better future which inspired the old master, is expressed

[43] In 1819 Goya took up this new technique; his lithographs are similar in style and spirit to the last drawing. The same applies to the curious miniatures he painted in Bordeaux, when the infirmities of old age rendered work on a large scale difficult for him (though here the fantastic element is rather more in evidence than in the drawings).

in this fervent portrayal of Spain, uncouth and barbarous, but triumphant in its irrepressible vitality.

In another form this spirit inspired the last of Goya's imaginative paintings, the *Milkmaid of Bordeaux*. With its brilliant brushwork and exquisite colouring it is technically one of his best productions. A simple peasant girl seated in contemplation. Serene and beautiful, she is Goya's last tribute to those who spend their days in toil.

We have now followed the inspiring course of Goya's creative development to its conclusion. Many important aspects of his art, notably the technical attainments of his supreme craftsmanship in many different media, have been neglected in this study, and whole categories of his work, particularly his portraits, have not been considered. Their exclusion was necessary, since it has been my aim to indicate the underlying rhythm in the development of Goya's outlook and to trace its origin, and the origin of Goya's style, in the social history of his time. In order to pursue this aim and to prevent the main conclusions from being obscured by a multitude of subsidiary details, I had to confine my attention primarily to the theme which links all his productive activity: the people. Yet Goya's work forms a complete and indivisible whole. The portraits, with their majestic progression from his first attempts to get away from the formalised aristocratic portrait of the baroque, through the brilliant works of the 1790s, to the ever more analytical, yet at the same time monumental, portraits of his old age, reveal an integral part of Goya's social and artistic personality. They are a true gallery of the men and women who made the history of his time, both statesmen and intellectuals. In a deeper sense they are documents of that liberation of individual personality which began, though it was not completed, with the bourgeois revolution. In that sense they are the necessary complement of Goya's main theme, the emancipation of the people.

In its formal aspects the development of Goya's art revealed itself as a succession of clearly demarcated phases. It started with the artist's attempt to escape from the baroque tradition and to attain a style of truthful simplicity and naturalness, schooled in the heritage of Spanish realism. The crisis of 1792 led Goya to a more profound formulation of artistic truth. Thenceforth his personality expanded through the creative conflict of its chief elements: reason

and fantasy. The cycle completed its course in a sequence of oscillations characterised by the predominance of one or the other of these two creative forces. Tempered by suffering and its mastery, their conflict was at last resolved in the serene but virile harmony of Goya's last works.

And the content of this cycle of creation? I can do no better than return to Shelley who, in describing the theme of his poem "The Revolt of Islam," [44] has unconsciously epitomised the message of his great comrade-in-arms:

> It is a succession of pictures illustrating the growth and progress of individual mind aspiring after excellence, and devoted to the love of mankind; its influence in refining and making pure the most daring and uncommon impulses of the imagination and the senses; its impatience at "all the oppressions which are done under the sun"; its tendency to awaken public hope, and to enlighten and improve mankind; the rapid effects of the application of that tendency; the awakening of an immense nation from their slavery and degradation to a true sense of moral dignity and freedom; the bloodless dethronement of their oppressors, and the unveiling of the religious frauds by which they had been deluded into submission; the tranquillity of successful patriotism, and the universal tolerance of benevolence and true philanthropy; the treachery and barbarity of hired soldiers; vice not the object of punishment and hatred, but kindness and pity; the faithlessness of tyrants; the confederacy of the Rulers of the World, and the restoration of the expelled dynasty by foreign arms; the massacre and extermination of the Patriots, and the victory of established power; the consequences of legitimate despotism—civil war, famine, plague, superstition, and an utter extinction of the domestic affections; the judicial murder of the advocates of Liberty; the temporary triumph of oppression, that secure earnest of its final and inevitable fall; the transient nature of ignorance and error, and the eternity of genius and virtue.

[44] Preface to "The Revolt of Islam," 1817–18.

GOYA—THE SECOND OF MAY AND THE EXECUTIONS

Enrique Lafuente Ferrari

THE BREAKTHROUGH OF MODERN ART

If one is to discover the significance of two paintings by Goya, *The Attack on the Mamelukes in the Puerta del Sol on the 2nd of May* [Fig. 2] and the *Executions of the 3rd of May* [Fig. 3], one must take a moment to imagine the impression that they convey to a visitor of average sensitivity visiting the Prado Museum.

Moving from room to room, our hypothetical visitor observes the development of the various schools of Western painting reflected in the canvases and panels produced during four centuries of European art. He is attracted by the ingenuous and delicate compositions of the Primitives—the minutely exact, keen observations of the Netherlandish painters, the severe and decorative Spanish style, and the precision of the Italians, who adhere to a classical idea of beauty. He passes on to the works of the Renaissance masters, observing the dignity and nobility of Raphael, the penetrating analysis of Dürer, the brilliance and coloristic opulence of Titian. Then he comes to the baroque masters; he delights in the licentious, orgiastic figures of Rubens, the elegance of Van Dyck, the noble proportions and the integrity of Velazquez. He notes the affectations and the evanescence of the 18th-century painters, including Goya himself, in some aspects of his work.

"Goya—The Second of May and the Executions." From Enrique Lafuente Ferrari, *El dos de Mayo y los fusilamientos* (Barcelona: Editorial Juventud). Reprinted by permission of the author and the publisher.

71

Our visitor's attention is still fresh; his eye responds to the mental exercise of the smooth transitions and he is pleased by the elasticity of his comprehension and the joy experienced during his tour. Then he enters the room where Goya's two great war paintings are hung and, without warning, an emotional storm erupts inside him. The hitherto tranquil lake of his impressions becomes rough and agitated and disturbs his placid spirit; he realizes with startling immediacy that he has arrived at a turning point, not only in the history of art but in the soul of European man.

These two paintings represent a radical departure from the quiet assemblage of the other works in the Museum. They are a discordant cry, desperate and plaintive, amidst a choir of voices that are always in perfect harmony, though they may vary in timbre and key. These two canvases are obviously the product of grave and fundamental changes in the way man confronts his world—for art always reflects such changes in the same prophetic manner with which it customarily reveals man's innermost thoughts.

This is the first appearance in the museum of what is termed "modern art"—"modern" standing for an explosive and concrete way of looking at the world that man then begins to apply to himself.

The tradition of Christian art derives from the need to convey ideas symbolically. Throughout the Middle Ages, the artist's task had been to present ideas, dreams, and human fantasies in plastic form, with persuasive force. Man as a natural being was the subject of figurative art from the fifteenth through the eighteenth centuries. The humanists translated into human form—entirely convincing as far as formal truth is concerned—those symbols, dreams, and fantasies that inhabited the art of the Middle Ages. Renaissance art humanized everything, including the vision of the hereafter. When those human forms were achieved with convincing plasticity, it was felt that a work of art had been created.

Human form and the interpretation of the emotions that give expressive value to man's ideas became the artist's essential concern. He worked with these elements in terms of his cultural repertory of religion and mythology. With the Renaissance, man became the essential pictorial subject. The portrait returned as an important genre. Feats which elevated or dignified man and his achievements came to be worthy of representation. Thus, historical painting was born. These representations of history were still within the human-

istic conception of art; undue importance was given to the dignity of the individual, a Christian concept, and to the heroic exaltation derived from the writers of antiquity. These two limitations—dignity and heroization—created a barrier to the objective appraisal of those deeds, emotions, and sentiments considered worthy of representation in the figurative arts.

Goya overcame these barriers with the two paintings we are discussing; he boldly crossed those frontiers beyond which lay modern art. As a result of these two works, painters began to depict historical events without attempting to dignify or heroize man. The conventions formerly used by man to present his own image were discarded.

The modernity we observe in Goya has two aspects that are not easily separated: not only is his vision of the world new and original, but his technique is similarly unique and unfamiliar. A world-view as the focus of a figurative theme and the manner in which it is translated into pictorial form are dynamic, new elements —a dual innovation representing a total spiritual and artistic transformation.

A new and revolutionary approach to subject matter is evident. Contemporary historical events are portrayed anonymously: that is, without the glorification of the protagonists, without that homage to the heroic concept paid by Renaissance and baroque painters alike, despite differences in their formal compositions.

On the other hand, events are depicted with passionate immediacy, with a total and unadorned surrender to a pure impression of observed or imagined truth not present in art until Goya wielded his brushes. The artist breaks with all reverence for tradition and boldly ventures into the unknown. His paintings are an outcry, a scream of exasperation characteristic of "modern" man's expression of his feelings and opinions. This new man, like Rousseau, feels the need, for the first time, to display his ego blatantly; he feels an impulse to create art out of his misery and anguish, without clothing them in traditional garb or diminishing their effect by employing intellectualized forms. That immediacy of artistic expression, that sensitivity to plastic form can now transcribe instantaneous impressions and emotions, highly personalized conceptions—in other words, the swiftness of the interpretation sweeps away the need for symbolic ideograms. The very canvas of Goya's two war paintings

seems to vibrate with psychological impressions; they signal unusual and striking innovations, the opening of new fountainheads, the breakthrough of modern art.

HISTORICAL ACCOUNT

Ignoring those critics who reject consideration of subject matter in the masterpieces of a genius, we must go back to the historical events that inspired Goya to create these two great paintings if we are to understand them fully. Their significance lies not only in the manner in which they were executed but also in the choice of the subjects.

It is undeniable that the crisis that began for Spain in 1808 with the very events immortalized in these paintings—events that occurred during Goya's lifetime—exerted a decisive influence both on his life and on his artistic development.

Let us recall the essential historical facts: Napoleon's troops, falsely posing as allies, enter Spain. From Paris, Bonaparte initiates a complex intrigue to deepen existing dissension in the Spanish court and provoke some action or public disturbance that will offer him a pretext for intervention. On March 17th, in Aranjuez, events occur that lead to the abdication of Charles IV two days later. On the 23rd of March the French troops, under Murat, reach Madrid; the citizens receive them with a sullen and sombre air; Ferdinand VII is acclaimed the following day as he makes his entrance into the Court. Ominous forebodings and threats mark the incidents of those days.

Napoleon is alert to the situation; he invites Ferdinand to meet him in Bayonne. King Charles IV and his queen set off for France immediately; Murat frees Godoy and he follows the king to France. Bonaparte has in the meantime offered the Spanish throne to his brothers and demands the presence in France of the remaining members of the Spanish royal family. Struggles ensue between Murat and the remnants of the Spanish government still in Madrid under the supervision of the clumsy and easily frightened Infante, Don Antonio.

Early in the morning of the 2nd of May, the Infanta Maria Luisa, Queen of Etruria, leaves Madrid with her children. The city is seething with rumors, full of suspicion and amateurish plots; the

patriots are on their guard. When an attempt is made to remove the Infante Don Francisco de Paula from the palace (he is the child dressed in red in the portrait of the family of Charles IV painted by Goya eight years earlier) his screams unleash the latent fury—the townspeople block the coach and attack the French. The first shots are fired by the occupation troops and insurrection spreads through the streets. Murat and his staff are attacked in the Puerta del Sol.

The cry goes up "To the palace"—the Puerta del Sol fills with citizens from all over Madrid. The French cavalry tries to disperse the crowd and fails three times to enter the square, which is packed with exasperated, enraged people.

The first victims fall. A group of Mamelukes is chased by the people. The French prepare for a full-scale attack; artillery is readied and a cavalry force of some three thousand tries to clear a passageway from the avenue of San Jeronimo. Led by Grouchy, they are aided by the musketeers of the Guard, who make their way into the Square by way of the Calle Mayor. Two generals and the company leaders Daumesnil and Valence repeatedly attack the inflamed mob which is armed only with hatchets and knives and very few firearms. This is not a battle between two equal forces but between trained army units and an angry disorganized multitude. The fighting breaks up into small skirmishes. Groups of civilians attack the cavalrymen; their weakness is compensated for by that Spanish fury that Goya captured and to which he bore witness in his work.

The ferocious battle lasted for two hours. The Emperor's Mamelukes and the Polish cuirassiers led the action on the French side; Daumesnil lost two horses and Grouchy's own charger was wounded in the fray. Then the cannons roared; this swept away the last resistance, and the badly mauled French troops took possession of the Calle Mayor and the area around the Puerta del Sol. Madrid was split in two.

The reprisals and executions began just where the battle had been fought. Gunfire announcing the first execution was clearly heard at three in the afternoon. The only organized action carried out by the Spaniards that day was a defensive move against the French at the Artillery Park of Monteleon, led by a handful of Spanish officers. With this spark of resistance extinguished and the Puerta del Sol occupied, the French military commissions appointed by Murat went into action.

In the afternoon an anguished silence hovered over the anxious

city—a silence broken only by the shots of the firing squads. Executions were held at the Prado, in front of the Convent of Jesus, in the Buen Retiro, along the banks of the river, at the Casa de Campo park, in Leganitos, Santa Barbara, the Puerta de Segovia, the Buen Suceso, and the Montana del Principe Pio—the last executions were here; at four in the morning, the sunrise of a typical spring day in Madrid, forty-three patriots fell here. Goya chose the incident in the Puerta del Sol, the first tumultuous event of that bloody day, to immortalize in one of our paintings; this final execution at the Montana del Principe Pio served for the other.

That day left an indelible impression on all of the Spanish survivors. The Napoleonic wars, a consequence of the French revolution, initiated this kind of bloodshed on the battlefields of Europe. Although unforeseeable at that time, mankind has since broken all records for inhuman horror and bloody tragedy. For peaceful, traditional Spain, that drama disrupted a century of internal that and progress under the Bourbon dynasty; it stirred up atavisms and passions which had lain dormant during the tranquil eighteenth century, the period glorified by Goya in many paintings and particularly in his tapestry cartoons. Madrid, once light-hearted and secure, was splashed with blood on the 2nd of May. This was only the first in a long series of devastating conflicts that were to break out time and time again. It was a major turning point in the history of Spain.

CRISIS IN GOYA'S WORK

Goya was an exceptional interpreter of the tragic events that followed the Napoleonic aggression. He poured into his work all of his violent spiritual reaction to the outbursts of disorder and bloodshed he had seen, things that accompany all war and revolution. The self-made painter who climbed successfully the social ladder of the Spanish court now found himself, at the age of sixty-two, faced with a void. The world around him had collapsed and his inner world was crumbling but he was not a passive man—he could not remain selfishly on the fringes of such a catastrophe.

The war and the revolt that began in 1808 marked a crisis in Goya's life and in his work—a crisis for his mighty spirit, so sensitive to everything human. Goya had been a courtier, captured by the enchantment of color and of life; this was the man Beruete called

"the eighteenth-century Goya." Still, in all of Goya's work, as in Beethoven's, there is an ominous tone that echoes over and over. It underlies the most placid melodies of his art and warns us that, for all of his early optimism and beyond the apparent euphoria of his delight in the world, there beats a pulse of the sense of tragedy.

This aspect of his art, fed by his afflictions and his deafness, was already visible in the *Caprichos*, where it appears as sarcasm and social criticism, expressed with bold humor. His role as a solitary critic of vice and mortal sin must be considered as the counterpoise to his career as a successful society portraitist. His critical outlook was strengthened by the ideas and the philosophical climate of his circle of intellectual friends, influenced by the spirit of criticism and social revision that existed in France. In his own manner, Goya saturated himself with the illusions of the *encyclopaedistes*, the first manifestation in the modern world of a desire to control and rationalize life; man no longer feared upsetting the delicate machinery of the social organism by his rude manipulations and innate clumsiness. But dreams of utopia are always followed by tragedy: the utopia of the *encyclopaedistes* was followed by revolution—Napoleon's nationalistic utopia ended in devastating wars.

Today we can trace a rapid trajectory of the ideas of the eighteenth century; for the contemporary Spaniard, the brutal consequences of that historical process were felt in a very different way. They were experienced with the intolerable immediacy of a reality that bore no logical connection to what had been anticipated. This was, above all, the drama of the *afrancesados* (Spaniards who sympathized with and imitated the French) who belonged to Goya's circle; within Goya himself there existed a dichotomy that was present in many Spanish intellectuals of this and the following periods.

To illustrate that dichotomy we can select two figures who are well known as friends of Goya: Jovellanos, on the one hand—Moratin on the other. To which group did the artist belong? Let us drop simple classifications and answer with a Barojian aphorism—less precise but very true. Goya was always *against stupidity and cruelty*. He was able to paint physical courage with intensity. Few painters have infused their images with the same degree of strength and life —and Goya, for all that intensity, never succumbed to overemphasis or rhetoric. He rightly saw that while war breeds the admirable trait of heroism, the heat of belligerency also breeds vicious passions and grave sins. He understood, moreover (see the last plates

of the *Desastres*), that the *favorite child* of all political upheaval is falsehood. These lies are smothered in propaganda then resurrected by men of sound mind and heart who believe them with incurable naivety.

THE NOVELTY OF GOYA'S ART

If an artist is to succeed in giving us a realistic image of life, it is imperative that his sensibility be finely tuned and that the image not be distorted by prejudice or idealism. Both conditions are fulfilled in Goya's work. An observer with uncompromising insight, he was in direct contact with the people of Spain during the war years, and he compiled a vivid documentation of human misery from which he extracted a new, original art—an art that best suited his specific mission. The evil and bestiality of man revealed under the flag of war reach far beyond the social satire of the *Caprichos*. To Goya, cruelty and tragedy were unbound cosmic forces. The Four Horsemen of the Apocalypse are not seen as embodiments of dream images, as Dürer had interpreted them; Goya, in his profoundly Spanish manner, presents them as concrete reality, raising the art of pictorial narrative to an impressive height, far surpassing the level of simple anecdote. Goya's eyes were fed by the reality he had personally seen, heard, and remembered. He felt it would betray his experience if he invented allegories or created academic machines. Never before had scenes of war been given pictorial form with such intensity. It is this force which gives novelty and modernity to the etchings of the *Desastres* and to the two paintings which we are discussing.

Print #44 of the *Desastres* depicts a scene of flight from the approaching peril of war. Goya established the authenticity of his testimony with an exclamation that sprang from his pen—"This I saw" is inscribed at the bottom. Goya felt the necessity to proclaim that this work had been created to preserve an unforgettable impression, lodged in his soul, which he was able to uproot by transferring it, through an uncontrollable impulse, onto the copper plate. Herein lies the profoundly radical difference that distinguishes his interpretation of war from all others. If we recall Callot, for example, we observe that the savage scenes of his *Misères de la Guerre* appear distant, made unreal by the artificiality of the compositions, the virtu-

osity of the drawing, and the miniscule dimensions of his figures. This reduction and controlled elaboration separates us from the tragedy and we see, instead, the expression of a purely studio interpretation that falls far short of reality.

Before Goya, paintings of battles tended to be small in size; even in larger dimensions, the paintings were steeped in deification or heroization, essential elements at that time for rendering the subject matter acceptable to the mentality of a humanist-oriented society. Goya discarded all these pretenses; his artistic concepts are not concerned with the traditional formulae of the past; they require new and direct treatment, based on personal experience, without half measures or conventions. Art is now the translation of the personal impression, the externalization of an intimate first-hand experience stripped of any cultural artifice that comes between it and us, without normative conventions that restrict its pictorial form. This is the revolution that is achieved in Goya's art—a revolution unsuspected by his contemporaries and not fully comprehended until many years later. The barriers are broken down and art moves toward new goals—just as the thought of the social critics of the eighteenth century moved beyond its limitations to conceive of the problems of modern man. The artistic expression of the revolutionary way of interpreting the world is not to be found in the work of David, the official artist of the French revolution, but in the work of Goya, the Spanish artist who inaugurated modern art.

"This I saw"—Goya also saw, or rather intuited with his genius, the pictorial vocabulary and artistic viewpoint that were needed to treat the themes of his era. This is what makes him the genius of his century—the precursor who opened new doors to a new spirit, struggling to manifest itself in art.

Since the paintings of the 2nd and 3rd of May are the very embodiment of this new artistic interpretation, we may be justified in concluding that the inscription "This I saw" was indeed the literal truth. Although the paintings were executed six years after the events occurred, they remain fiery interpretations of personal impressions, experienced with extraordinary intensity; they were imprinted in his mind with the emotional impact that creates obsessive memories. They heralded the tragedy in which his nation and countrymen were involved long after the war ended.

Goya perceived all this as he perceived everything—with avid eyes and spirit embittered by shattered illusions about man's hu-

ı the *Caprichos* man appears as merely ridiculous in his
at court and in the vanities of his artificial existence; in the
ι man has sunk to such a low level of savage bestiality that
ı forth from Goya the heartfelt exclamation, "Rabble."

NOTES AND TESTIMONY

Everything leads us to believe that Goya was an eyewitness
to those first two acts of the Spanish drama of the War for Independ-
ence that had the city of Madrid as its theatre—and that he had no
need for clever interpretations or second-hand accounts. At that time,
Goya was living in room #2 at 9 Puerta del Sol—this address is
listed in a Madrid register of Heads of Families, compiled by order
of Napoleon in December, 1808. We do not know exactly where his
building was located (or if it was damaged in the battle), but the
most probable site is the corner of Calle de Carretas and the Puerta
del Sol.

Regarding the executions, we might think that Goya had in-
vented the scene if it were not for the existence of a valid and ex-
ceptional testimony that forces us to believe that he did indeed have
the right to entitle his print *This I saw*. The author of the testimony
not only presents his facts with unimpeachable objectivity, unem-
bellished by literary, imaginative flourishes, he also provides a de-
tailed account of the source, leaving no room for doubt about their
accuracy. Don Antonio de Trueba, author of *Cuentos de Color de
Rosa*, was a Basque writer whose simple prose won him immense
popularity in Spain during his lifetime. In 1873 he published *Madrid
por Fuera*, a collection of youthful memoirs, written in simple and
humble prose and focused on his walks through the rural outskirts of
Madrid in 1836. During these walks, the writer had occasion to visit
Goya's home, La Quinta del Sordo as it was popularly called, and
to talk with the gardener Isidro, raised from boyhood by Goya, who
told many facts and stories about his master to Trueba and his
companions.

Trueba relates that he heard the story direct from the lips of
Isidro one "Sunday . . . at dusk" (which happened to be the 1st of
May, the eve of Spain's national holiday commemorating the begin-
ning of the War of Independence). According to Trueba, the old
gardener said that Goya had been at the Quinta while the executions

at the Montana de Principe Pio were taking place. Acting on an uncontrollable impulse, the painter had gone to the hill afterward to saturate himself with the horror of the sight of the cadavers and had made sketches of the shocking spectacle.

Trueba transcribes the entire story told by Isidro:

"Did you see those horrors of war which my poor master painted so marvellously?", Senor Isidro asked us.

"The bell that tolls in the church of La Florida reminds me that on tomorrow's date, years ago, my master, wild with anger, got the idea of painting those horrors. From that window up there he watched the executions at the hill of Principe Pio, with a telescope in his right hand and a blunderbuss and a fistful of bullets in his left. If the French had come by, my master and I would have ended up like Daoiz and Velarde. As midnight approached, my master said, " 'Isidro, take your gun and come with me.'

"I obeyed him and where do you think we went?—To that hill where the bodies of those poor people still lay. I remember everything as if it happened yesterday. There was a moon that night but as the sky was filled with huge black clouds, we were often in total darkness.

"My hair stood on end when I saw that my master, with a gun in one hand and his portfolio in the other, led the way toward the bodies. He saw that I hesitated.

" 'Are you shaking, Otelo?', he asked.

"Instead of answering that my knees were trembling, I almost burst into tears, thinking that my poor master had gone mad, since he was calling me Otelo instead of Isidro.

"We sat down on a mound: bodies lay beneath us. My master opened his portfolio, put it on his lap and waited for the moon to come out from behind the large cloud that was hiding it. At the foot of the hill you could hear rustling noises and growling. . . . I admit I was shaking like a leaf . . . but my master calmly continued to prepare his materials, almost completely by touch.

"At last the moon shone so brightly that it seemed like daylight. Amidst the pools of blood, we could make out some of the corpses —some lying on their backs, others on their bellies; this one in a kneeling position, that one with his arms raised toward heaven, begging for vengeance or mercy. Some starving dogs were preying on the bodies, growling at the buzzards that were circling overhead, wanting their share of the spoils.

"While I stared at that terrible scene, filled with dread, my master drew it. We returned home and the next morning my master showed me his first print of *La Guerra,* which I looked at in horror.

" 'Sir,' I asked him, 'Why do you draw these barbarities which men commit?'

"He replied, 'To warn men not to be barbarians ever again.' "

Let us render unto Caesar that which is Caesar's; let us admit that thirty-eight years elapsed before the story made its way from the gardener's lips to Trueba's pen. It is possible that some element of literary ornamentation may have slipped into Trueba's transcript; the possibility is inevitable, even considering the Basque author's simple style. Even if there is some amount of fantasy or inaccuracy in the details, the story remains a testimony of great interest, wholly compatible with what we know and imagine about the painter's character. Above all, Goya's gloomy and somewhat terse final remark throbs with the emotion that he was compelled, both by background and temperament, to inject into his paintings of war and into the *Desastres*: the violent sense of repugnance and revulsion that is inevitably experienced by honest men whose misfortune it is to live in an era of violence.

GOYA AND THE WAR

With Spain defeated and his emotions aroused by the harsh tragedies of the 2nd and 3rd of May, Goya undoubtedly lived through the drama of the ensuing war in great anguish.

Subdued by the bloodshed, Madrid suffered alternately from illusion and despair during the six years that the war lasted. José Bonaparte was established as regent; after only a few days his reign was interrupted when the Spanish victory at Bailen forced him to withdraw to Miranda de Ebro. Then Napoleon arrived with his troops to secure the throne for his brother; except for efforts of small *afrancesado* parties, the capitol was silent and subordinate.

The changing tides of war forced José I to abandon Madrid once more after the battle of Arapiles, in August 1812. He returned in March 1813 but left Spain for good after the battle of Vitoria put an end to the ephemeral Napoleonic dynasty.

In addition to the calamities generated by the war, Madrid experienced, from 1811 on, a famine that was the cause of terrible epidemics. An atmosphere of anxiety was created by rumors that spread from mouth to mouth about the efforts of guerrilla parties,

military skirmishes in the country, and the activity of the government in Cadiz—the Court, the battles raging far from Madrid, English aid, and Napoleonic intervention in other countries.

Goya, witness to the outbreak of war in the Madrid he had known as a light-hearted and happy young man, now found himself cut off from his world. His life as a successful court artist had come to a halt. Moreover, he was at that stage in life in which the biological changes of old age naturally incline one toward pessimism. His broad understanding of human nature, his critical spirit, and his misanthropy—exacerbated not just by old age but by loneliness and deafness as well—all turned him inward. Enforced professional idleness did not extinguish his ardent desire to create; on the contrary, his genius was stimulated by the convulsions that the world was experiencing. He was moved to express his feelings. In an earlier moment of crisis and spiritual discomfort he had allowed the monsters of his imagination to surface in the *Caprichos*; now he immortalized the various aspects of the war—but not as history painting, for this was a genre beyond Goya's artistic realm, it was not adequate to express the bloody and vivid reality he had experienced. War, as he presented it, was neither an elevated conceptual vision nor an idealized falsification; rather, it was pared down to its essential truths—robbery, pillage, rape, useless cruelty, ferocious retaliation, fire, and flight—the whole desolating vision of man reduced to his lowest, most brutal passions. The need to create stimulated Goya to return to graphics and transform the sketches of the Montana de Principe Pio, the product of an uncontrollable impulse, into a fully realized series of engravings.

It was during the war years that he executed most of the plates for the *Desastres*. Direct contact with a hallucinatory world and his overwhelming need to express personal experience also led him to paint scenes of the unfair and unspeakable war on canvas and small panels. Conceptually, these works bear an affinity to the scenes selected for the engravings. There is a certain ambiguity in some of the subjects; it would be difficult to determine whether they were directly connected with the war or whether they present more ordinary scenes of robbery and crime. With the constant intervention of irregular armed bands, even the major battles on Spanish soil often took on a rather ambiguous aspect. Furthermore, Goya may have felt it unwise to be too specific, since that might have aroused French suspicion. We must also remember that there were earlier examples

of this kind of subject matter in Goya's *oeuvre;* he was attracted to themes dealing with highwaymen, bandits who attacked coaches, and priests outside the towns.

When dealing, however briefly, with Goya's life and work during the war years, it is pertinent to refer to a trip that he is supposed to have made to Zaragoza in that very year 1808—although the information available to us is imprecise and confusing. . . .

His visual curiosity made even more acute by his deafness, Goya seems to have witnessed scenes filled with bloodshed, terror, and fright over vast areas of Spain. We must assume that he visited ravaged fields and burning villages—perhaps even devastated Zaragoza. No aspect of this dramatic chapter in Spanish history eluded his memory as he created his imposing works. Because he was always able to transcend anecdote, his paintings and prints do not have the character of chronicle or narrative. He took his material from vivid and direct impression—the only kind that could possibly have provided him with an impetus strong enough for his agitated and terrifying creations. We should not seek the documentation of his war paintings—this would belittle the significance of his work. We should look, rather, for the impression, elaborated and transformed into art by the genius of brush and engraver's tool, the inescapable imprint of experienced reality, undeniable and vibrant in Goya's battle scenes. Therefore it is not strange that in the two paintings we are considering, the events of the 2nd and 3rd of May, experience and training blend into a complete harmony, into works of vast dimension.

COMPOSITION, EXPRESSION AND TECHNIQUE

Whether observed or imagined, Goya's vision of war—attacks, executions, heroism, and revenge—was deep in his soul in 1814 when he translated the motifs of the copper plates and small paintings (easily hidden from the search parties of the occupation troops) onto huge canvases. Although the small war paintings, especially those owned by the Marques de la Romana, are charged with emotion and executed in intense tonalities, they still bear a resemblance to more traditional art—to certain delicate Dutch paintings of the seventeenth century.

When Goya finally begins the two large war paintings—im-

pressions indelible in his memory, brushes well-trained, his vision of the war still fresh—his execution stays in step with his emotion. Because of the uniqueness of the subject matter, he cannot refer to traditional painting to express what he feels in his soul, he cannot employ techniques previously utilized; he is compelled to forge a new concept, opening a new era in the history of painting.

Goya does not portray the attack in the Puerta del Sol as a narrative but as a total episode. In this history painting, Goya's intuitive approach presents us with a battle that has no hero. Goya saw the obverse of the Napoleonic epic, as Tolstoy was to see it years later in *War and Peace*. Opposed to Bonaparte—the hero steeped in Plutarch's writings, filled with the classical concept of heroic grandeur, nurtured by Roman history—stands a new protagonist, who dominates the nineteenth-century stage. Goya, as no one before him, felt the immediacy of this faceless and shapeless figure, already present in the wildly imaginative paintings that hang in the Academia de Bellas Artes. As the artist himself revealed in a letter, these paintings "expressed a spontaneity, an originality that could find no place in commissioned works." The anonymous masses, enigmatic and frightening, are already there, marching in the ceremonial processions, following the grotesque banner of the *Burial of the Sardine*, seated in the tribunal halls of the Inquisition—just as we see them in the frescoes of San Antonio de la Florida, a heterogeneous crowd witnessing the miracle of St. Anthony. Now, even more strongly than during the French Revolution, we find the masses reacting spontaneously and violently, with furious impetus; now they emerge as a multiform historical character.

It is interesting to make a detailed analysis of the unusual composition of the *2nd of May* [Fig. 2]. Some critics, Beruete for example, speak of its lack of unity, implying that its composition is defective. This observation underscores its unique character; it does not adhere to the rules of classical composition, to fixed laws of balance and contrast, precisely *because* of the radical innovations that Goya introduced. It is a painting of history without a hero. Goya wanted to depict an event in which the masses, rather than the individual, were the real protagonists. His painting avoids hierarchical composition and records an impression of confused and blind conflict in order to achieve a realistic representation of battle in pictorial form. A balanced and formal composition would have falsified this purpose. All the customary techniques of the academic tradition were

useless to Goya if he was to escape from outmoded conventions. His object was to capture the amorphous and thunderous impact of the tragic even within the rectangular boundaries of the picture frame.

Mayer was better able than Beruete to appreciate the particular, fresh character of the painting. "It was," Mayer writes, "the vision of an entire event, the image of a totality—what Goya had seen passing before him and what he intended to immortalize. The figures do not move by their own impulse, but are directed by fate, a demoniacal and powerful being. They appear not only to be moved by external forces—they also seem to be agitated by an almost supernatural power. Everything contributes to a dramatic emphasis of the action; at the same time each incident is narrated in a clear and profound manner. It was in this way that Goya created a new kind of history painting."

The apparent confusion mentioned by some critics reflects an inner cohesion, solid and logical in itself. Even if we were to define the painting in terms of traditional composition, we would find that the groupings do adhere to basically triangular forms. The dominant one is in the middle of the painting, slightly off center; a secondary one is near the first, in the left portion of the canvas. The directional lines and subordinate centers of these two forms are indicated with a mastery that unites the entire mass.

The painting, thus, has an overall compositional pattern that, while it differs from those of classical compositions, still possesses essential patterns and an effective rhythm of its own. Goya was primarily concerned with rhythm of movement; the linear construction of the scene was secondary. . . .

The masses are the true protagonists of this battle and the French are the only victims—the masses that Goya had portrayed in his earlier paintings, having sensed their presence and force. They appear in his bull rings, in the *Burial of the Sardine,* in the witches' sabbaths, and in the hallucinating festivities in the Quinta del Sordo. The masses are obsessive; we see them in the *2nd of May* in a thicket of heads with vengeful stares, mouths half-opened, faces blurred, haphazardly modeled by violet patches of light, emphasizing the confusion—driven by a torrential collective force, possessed of a blind thirst for blood. There is an overwhelming sense of threat emanating from this multitude in the background. We can read it in the terrified expressions of the soldiers who are trying to escape their savage claws. . . .

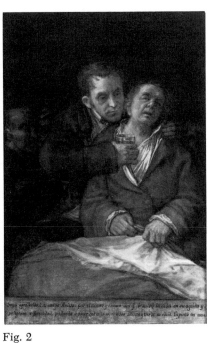

Fig. 1
GOYA:
Self-Portrait with Dr. Arrieta.
The Minneapolis Institute of Arts.

Fig. 2
GOYA:
Battle with the Mamelukes in the Puerta del Sol, May 2nd, 1808.
Madrid, Prado. *(Photo Scala.)*

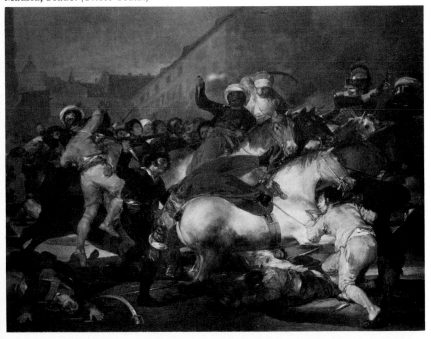

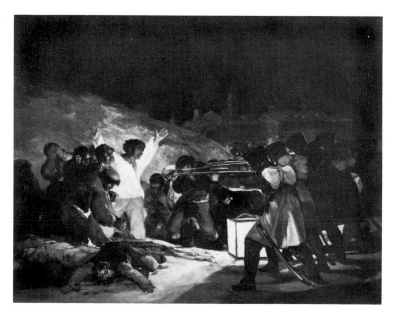

Fig. 3
GOYA:
Executions at the Mount of Prince Pius, May 3rd, 1808.
Madrid, Prado. *(Photo Scala.)*

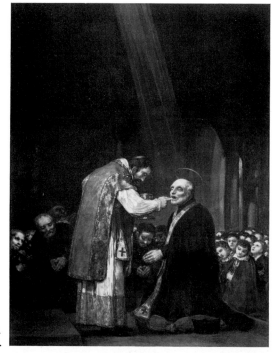

Fig. 4
GOYA:
*The Last Communion
of St. Joseph Calasanz.*
Madrid, Prado. Manso.

Fig. 5
GOYA:
Christ in the Garden of Olives.
Madrid, Prado. Manso.

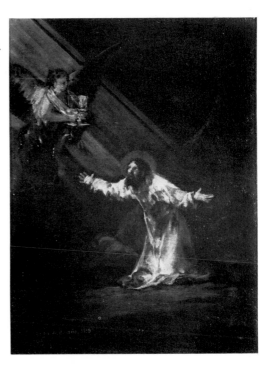

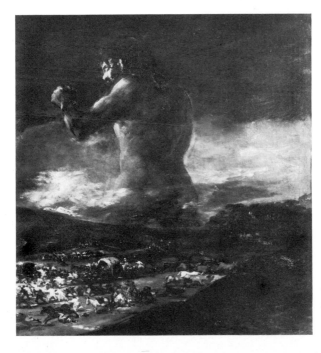

Fig. 6
GOYA:
The Giant.
Madrid, Prado.

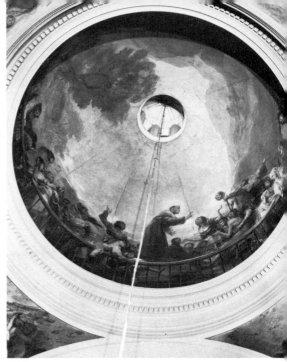

Fig. 7
GOYA:
Miracle of San Antonio, Cupola.
Madrid, Prado. Manso.

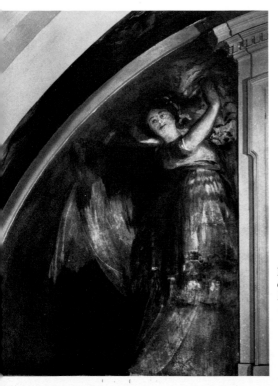

Fig. 8
GOYA:
Detail of Angels in Vault.
Ampliaciones y Reproducciones Mas.

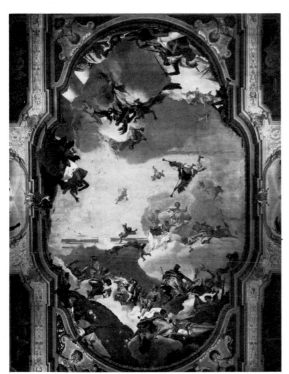

Fig. 9
TIEPOLO:
Detail of Frescoed Ceiling.
Art Reference Bureau.

Fig. 10
GOYA:
Naked Maja.
Madrid, Prado. *(Photo Scala.)*

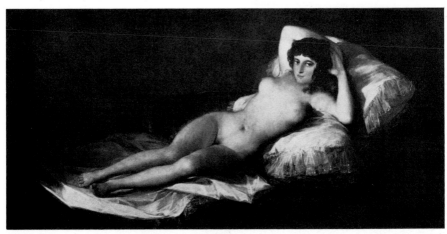

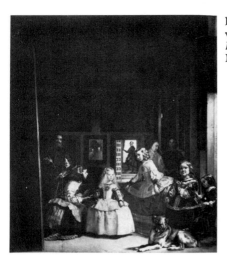

Fig. 11
VELAZQUEZ:
Las Meninas.
Madrid, Prado. *(Photo Scala.)*

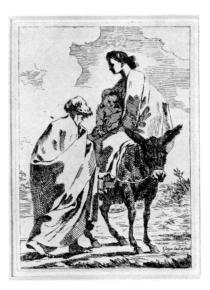

Fig. 12
GOYA:
Etching after Velazquez' Meninas.
Staatliche Museen.

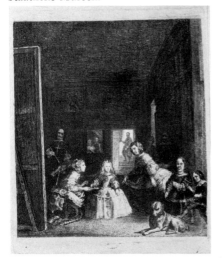

Fig. 13
GOYA:
Flight into Egypt.
Staatliche Museen.

Fig. 14
TIEPOLO:
Rinaldo and Armida.
Staatliche Museen.

Fig. 15
GOYA:
Winter.
Madrid, Prado. *(Photo Scala.)*

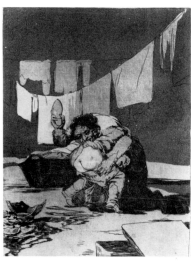

Fig. 16
GOYA:
Caprichos, Plate #25.
Ampliaciones y Reproducciones Mas.

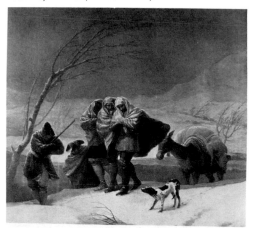

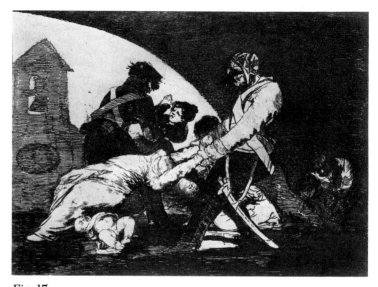

Fig. 17
GOYA:
Desastres, Plate #11.
Ampliaciones y Reproducciones Mas.

Fig. 18
GOYA:
Drawing of Woman before Reflection of Serpent on a Scythe.
Madrid, Prado.

Fig. 19
GOYA:
Drawing of A Constable before Reflection of a Cat.
Madrid, Prado.

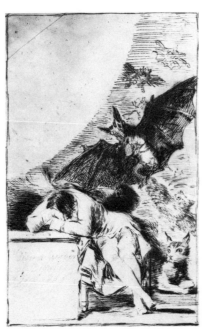

Fig. 20
GOYA:
Preparatory drawing for *Capricho* #43
with writing.
Madrid, Prado.
Ampliaciones y Reproducciones Mas.

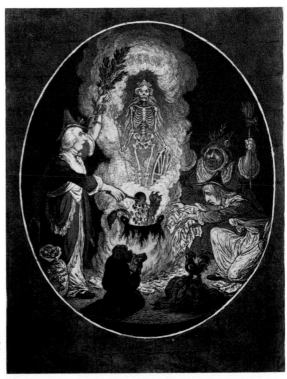

Fig. 21
GILRAY:
*A Phantasmagoria: Scene
—Conjuring-up an Armed
Skeleton,* 1803.
British Museum.

Fig. 22
WOODWARD:
John Bull and his Family taking Leave of the Income Tax, 1802.
British Museum.

Fig. 23
WILLIAMS:
A Naked Truth or Nipping Frost.
British Museum.

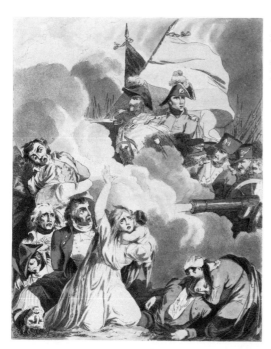

Fig. 24
PORTER:
Buonaparte massacring 1,500
persons at Toulon, 1803.
British Museum.

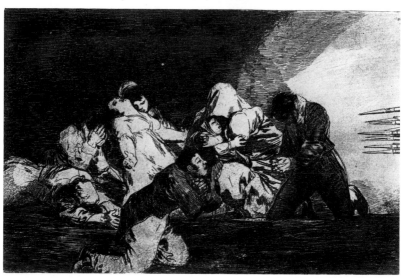

Fig. 25
GOYA:
Desastres, Plate #26.
Ampliaciones y Reproducciones Mas.

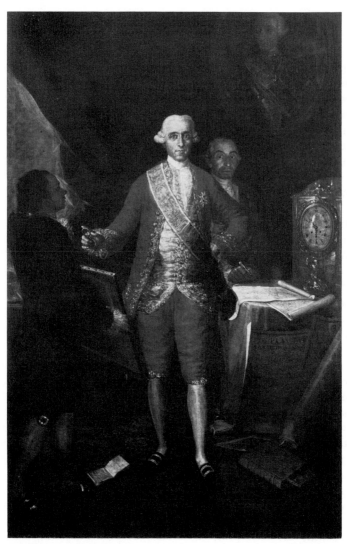

Fig. 26
GOYA:
Portrait of Count Floridablanca.
Madrid, Banco de Urquijo. *(Photo Scala.)*

Goya is able to portray this horrible scene and still create a surface of chromatic delicacy, opulent materials, subtle values, and attractive colors—this is the miracle of his art. It brings to mind Maurice Denis' definition: "Every painting, before it becomes a warrior's horse, a nude woman or any kind of narrative, is essentially a plane surface covered with colors that are arranged in a certain order." The definition is true of paintings from every period; it is realized beyond measure in Goya's work, especially in the two paintings we are analyzing. For Denis, and especially for the Italian critics who form the "school of visibilita," if a painter respects his chosen or imposed subject matter, he must make the plastic quality of his work completely harmonious with the theme. Rejection of the theme is convenient since it frees the artist from all obligation. The difficult task is to express the theme without renouncing the essential artistic values. The achievement of expressive movement by linear or chromatic rhythm, appropriate both to the theme and to the desired final effect, is a supreme triumph granted to great artists and denied to those who believe that the function of a painting is about the same as that of wallpaper.

Goya's palette, as Beruete noted, is not extensive. He achieves chromatic richness by combining few tonalities: greys, dark ochres, light earth colors, rose carmines, delicate greens, and silvery blues. The primer he uses is reddish in color, with a base of Sevillean earth, but, as Beruete noted, it is finer and better blended here than in Goya's other canvases. Over this preparation, he executed delicate passages with strength and superb mastery—he created whole areas with broad strokes of the brush, daubing the color on without insistence, at times using impasto with the boldness of genius, with swift execution and frequent use of his palette knife. The forms emerge, delineated by a thin black outline drawn with the brush.

The setting is deliberately imprecise; we can neither identify the background nor Goya's supposed vantage point. Surely geographic fidelity was not Goya's first concern; although he vaguely suggests the shape of a building, a dome here and there, a spire in the background, he prefers to envelop the urban scenery in a haze formed by the dust and smoke. In this greyish, storm-like atmosphere, the silhouettes of the buildings are barely discernible. . . .

The vibrant polychromy, the fine touches of the colorist, contribute to the painting's vigorous and extraordinary imagery, visible through the dusty sunlight of a day in May. By contrast, they

heighten the dreadful effects of the execution scene, the *3rd of May* [Fig. 3]. The dominant colors here range from earth tonalities to black, passing through subtle gradations of grey. The large area of dark sky and the ash-colored buildings (whose exact distance is uncertain) fill more than one-third of the painting; they seem to bear down on the human figures—all of whom, executioners and victims alike, seem the embodiment of tragic fate. The figures seem flat, as if reduced by a superior force, an unavoidable doom. The beam of light from the lantern cuts through the darkness. It serves as an artificial means of infusing life into the scene, which emerges from the shadows with striking clarity, a physical presence that is its own justification.

The composition is totally different than that of the *2nd of May*. Here the horizon is low; there it is high. There one finds vague masses, tight and confused composition—a dynamic whirlwind of action and battle; here, two groups of figures are contrasted—there is clarity of action and careful delineation of every figure and line. On the right, the firing squad—five figures who form a compact unit performing an automatic synchronized action. The relationship between Spanish and French is reversed here. The French, the victims at the Puerta del Sol, here become the vengeful executioners. The small group of soldiers, leveling its guns, becomes the "masses," uniformed and anonymous, impersonally carrying out a senseless order. To emphasize this depersonalization, Goya conceals the faces of the soldiers from us. He emphasizes the uniformity of their movements, the deliberately exaggerated position of their legs to accentuate their deed; the curve of their silhouettes, the tension of stance, the parallel lines formed by the barrels of the guns, the tilt of their heads—all emphasize the concentration on the instantaneous dramatic moment that the shots are fired.

The Spaniards, the angry masses of the Puerta del Sol, are now an articulated group. While the battle was raging, the juxtaposition of wills welded the people into a mass; when aggressive tension ends, mass emotion dissipates or is dispersed—the bond snaps, the mass becomes individualized. Freed of collective anxiety, face to face with death, the individual reappears.

The tense and bewildered victims in this painting display the most diverse reactions, emphasizing the unique quality of each. Observe the five figures who are the immediate targets of the musket fire: one figure covers his face with his hands in the tragically in-

fantile reaction of hiding from the inevitable; another victim, whose face we can barely make out, sinks down in hopeless resignation, as if seeking refuge within himself; a priest is on his knees, his head bowed, his hands clasped as if in prayer; behind him, another man raises his eyes toward heaven, tightening his fists in mute protest— an expressive plea for vengeance. The main figure of the painting, who is both symbol and protagonist—the man with the white shirt and bulging eyes—reacts forcefully, raises his arms to the sky in a gesture that seems to signify a final invocation to a supernatural power, a protest against an unjust death—the courage of a valiant being who faces death with defiance, demanding that posterity affirm the justice of his cause. All these emotions are embodied in his supreme gesture of invocation, summoned in the moment of greatest peril. Total submission to fate can be found in the reactions of others: a child pleads for his mother's protection; a defeated man bows to brute force, to an insuperable menace; one figure, over- whelmed by the tragedy, senses the helplessness and the insignifi- cance of an individual before the avalanche of cosmic or social forces —he appears to discover the revelations of the absolute in a moment of supreme rapture. . . .

The man with upraised arms represents both personal aware- ness and an unconquerable will—symbols of Spain's spirit of inde- pendence in 1808, unextinguished by the river of blood that flowed from the executions at the Montana. Try to imagine the painting without this figure—it would be void of meaning, reduced to a mere narrative. He embodies the whole significance of the painting. Goya illuminates him with the brightest colors, directs the beam of light from the lantern at him; moreover, the focus sharpens as we get closer to him. It is by all these means that the central figure is con- verted into a symbol. The use of line and color confront us with this dark man, whose bulging eyes and tense, open hands express rebel- lion and protest.

There are many differences in the compositions of these two paintings—the similarities are fewer. They do exist, however. Al- though the mass of buildings in the background and the spatial rela- tionships are more dominant in the execution scene, there is a funda- mental similarity to the *2nd of May*—the parabolic structure. This parabola or arc is delineated by a line that moves in a similar man- ner in both paintings. The oblique grouping of the three men who attack the French on the right side of the *2nd of May* perform the

same function, from a compositional viewpoint, as the firing squad in the execution scene. Each group, obliquely arranged, is like the chord of an arc whose foreshortened perspective creates a parabolic line. In the execution scene, the group of those waiting to be executed and those already shot, bleeding on the ground, form the essential lines of a curve that extends towards the background. Two horizontal contrasting curves meeting at the apex perform the same function in the center of the painting. One of these is formed by the undulation of the earth that serves as a parapet for the execution; the other is formed by the slanting line of the soldiers' headgear.

Technically, the canvas of the execution scene is painted with greater emotional freedom and more masterly assurance. The unity of the tonalities of earth colors and greys helps to focus our attention on the subject matter. The color is applied with such energy that certain areas appear to have been painted with something other than brushes. An artificial beam of light, serving to create contrasting light and dark areas, assists the overall composition; the legs of the soldiers break the repetitious rhythm and delineate the boundaries in this portion of the painting. Figures and faces are modeled in a *grisaille* of grey and ochre—but the tones are rich, ranging from ashy leaden greys to warm earth colors. The greyish-green of the kneeling man's breeches reminds one of the color Velazquez used for the clothing of the gypsy-like Wise Man in the foreground of the *Adoration* in the Prado, painted in 1619.

Superb details can be found in the group of men in the background, who await execution: the foreshortened head above the lantern; the young, robust worker who pulls at his hair; the roughly sketched figure beside him who has a white handkerchief on his head—and, most important of all, the man whose eyes are painted a ghostly white, who appears to be biting his fists while contemplating an inner abyss. He brings to mind that unforgettable figure in a painting at the Quinta del Sordo entitled *Romeria de San Isidro*— the figure who stares at us from out of the background, amidst a pyramid of heads. The boldest and most astonishing figures in the execution scene are the mound of dead bodies in the foreground; the hasty, rough-sketched quality of the figures gives strength, in its simplicity, to portions that hardly seem painted. The impression achieved with such economical means makes this section of the painting outstanding. It is precisely in this group of cadavers, lying in pools of blood, that Goya's extraordinary delicacy and technical

achievement are most evident—that hand still twitching near the edge of the canvas, the fallen man in the foreground whose forehead is perforated by bullet holes, whose arms seem to embrace the earth. I advise the observer to examine this section closely, forgetting for a moment the subject matter, in order to enjoy the exquisite achievement of a superb colorist: there are delicate greys, pinks, earth colors, carmines, and bluish patches that enhance the forms they describe, creating captivating patterns, inherently beautiful.

The boldness of the technique of this painting prompted Théophile Gautier to comment that Goya had used unorthodox techniques—that he had painted with a spoon. It would be possible to paint with a spoon; perhaps Gautier had seen one used by some eminent contemporary master of his acquaintance. There are portions of the painting that justify this assertion—the splashes of red on the fallen man in the foreground and, above all, in the patches of color that extend from the knees of the man in the white shirt towards the lantern; Goya has piled on layers of paint that form an almost viscous surface. The red is stroked on gently, then is scratched and covered with greys and whites that do seem to have been applied in an unusual manner, perhaps with the fingers, possibly with a palette knife—maybe with a spoon. Certainly in this and other segments of the painting the brush was used very little.

The tonalities of both paintings suggest comparison with the paintings of the Quinta del Sordo [the so-called Black Paintings—Fig. 6]. There is a certain resemblance, especially evident in the section of the *Romeria* where a man is dealing blows with a cudgel—or in the fantastic dream scene of the *Aquellarre*—not only in the *palette* but in the way in which the colors have been applied. These paintings, probably executed during the war with all of the inner violence and technical freedom that Goya felt at that time, reveal the technique that he used in painting these scenes of the 2nd and 3rd of May—a new and daring technique, unequaled in the history of painting.

FRANCISCO GOYA AND THE CRISIS IN ART AROUND 1800

Theodor Hetzer

Today's subject links up in a certain sense with the lecture I delivered on Giotto last summer. On that occasion I attempted to show how Giotto created a form of art that was, over the years, to predominate not only in Italy but throughout Europe. It was destined to remain the foundation on which painting was based until the end of the eighteenth century, in spite of many changes and transformations. My present aim is to show how this form of art was disrupted by the crisis that rocked Europe around the year 1800 and to trace the consequences of that crisis and the possibilities that they offered to painting throughout the nineteenth century. I do not intend to discuss this crisis and its inherent novelty in general but from the viewpoint of its influence upon one particular painter, Francisco Goya.

Goya, a Spanish contemporary of Goethe, was born in 1746 and died in 1828. I have my own strong reasons for singling Goya out in this way. He is the only painter of that period who was, in fact, a genius. Because of his achievements—not just his dreams or aspirations—he may be compared to the great artists of the past. If we glance at the art of Germany, France, and England during this period—Italy was in a state of total eclipse—we encounter a wealth of striking ideas; the artistic achivement, however, did not prove adequate to express these high-flown ideals.

Many of Goya's paintings hang in the Prado—more of a testing-ground for a painter than most other museums. He has to stand comparison with Titian, Velazquez, and Rubens, who appear here in all their serried might and splendour. I would not presume to say that Goya stands at the same level as these great masters—but he holds his own, and that is saying a great deal. He can surely be placed in the same class as Tiepolo, the last great painter of the pre-ceding period. If we look at the paintings by David in the Louvre we do find some beautiful portraits, important in concept; at the same time we are confronted with his kind of historical paintings, which, to our eyes, border on theatricality and contain more than a hint of what will later be known as academic "machines."

Any comparison with earlier paintings seems highly question-able; with works of this period we find ourselves in a world that is so totally different that it even seems desirable to separate early nine-teenth-century art from that of earlier periods. In Italy, if one hap-pens to stroll heedlessly from rooms full of earlier works into those of the nineteenth century one either hastens to turn one's back on them or remains in order to be amused. Goya is the only painter of that period who maintains the continuity of the great masters. His paintings interest us not only because they document a crisis or because they are examples of classicistic or romantic tendencies—or because they are expressions of noble and pure ambitions; they interest us because they have presence and vitality—as does every work that is born of creative fantasy.

For all these reasons Goya appears to me to be the symbol of all that was new, topical, potent, and, at the same time, really art in the nineteenth century. I do not wish to be misunderstood; I make no claim for Goya as the point of departure for the vital cur-rents of nineteenth-century art. He did influence some of the best painters of that period—Daumier, Manet, Degas—but his influence can in no way be compared with that of the great Renaissance masters. Influence of that magnitude was not to be found in fragmented nineteenth-century Europe, where we find a Ludwig Richter next to a Daumier, a Boecklin next to a Renoir. We may say, however, that Goya, who destroyed the baroque tradition just as radically as did David (although in a different way), discovered a new form of art—not derived from external influences but springing from his own creative genius. This David was unable to do. The problem of paramount interest in any discussion of the nineteenth

century is this, the main theme of my lecture: how did the genius of the nineteenth century manifest itself in art, following as it did the collapse of a centuries-old tradition?

II

I believe that Goya's art is initially striking because of the novelty and unexpectedness of his fantastic subject matter. The new and ingenious sensibility we perceive is also a contributing factor. Traditional content—religion, mythology, genre scenes, landscape—plays a very minor role. Whenever these subjects do appear they are reinterpreted in an uncanny way. In their place he offers a world that is sombre and fantastic, crude and gruesome—a world that borders on the satanic and the haunted. He gives us the reporter-like realism of his terrifying *Desastres de la Guerra*—the startling, stirring, varied scenes of the Spanish national sport and passion, the bull-fight. At this point one might say that his discovery of a new body of subject matter was the point of departure for his genius. Later on in this discussion I shall try to show, by referring to his early works, that this was indeed the case. Certainly something similar had occurred in the seventeenth century with Caravaggio, but at that time the new content merely implied a transformation of forms inherited from the High Renaissance—whereas with Goya these forms were destroyed. One of the characteristics of the crisis throughout Europe about the year 1800 was the strong emphasis laid upon content: we find this emphasis in the *Sturm und Drang*, in classicism, in romanticism, in the manner in which Goethe speaks of art when he describes Ruysdael's landscapes or Mantegna's Triumphs. We also find it, if I am not mistaken, in Beethoven's music, which becomes a means to *awaken* emotion in us—an emotion that is not *in* the music itself.

What singles Goya out, at least as far as pictorial art is concerned, is the fact that he stands alone with his new world. His *Caprichos, Proverbios, Tauromaquia* are unique—as is his fury, or *Furor*, along with the more sinister and coarser aspects of his genius. This is what makes him a forerunner both of the individualistic painters of the nineteenth century and of those who limited themselves to personally chosen themes—I need only mention Daumier and his vehement tribunal paintings and Degas with his subjects

drawn from the ballet and the race-course. But the premise on which such a coarse and violent world, such naked realism, was based was Goya's Spanishness.

One must always bear in mind that Spain, compared to Italy, France, Germany, and the Netherlands, was a land poor in artistic stability and tradition. In addition—and I think this is very important—it never succeeded in fusing the real with the ideal, cultural inheritance with present fact, as the rest of Europe had done since the Renaissance. This fusion was the very basis of European art. Velazquez was incapable of painting mythological or religious pictures: his *Mars* is the only baroque painting that makes us think of Corinth[1]—and there is surely some definite reason why Manet could imitate Velazquez but not Rembrandt. Even painters of religious subjects, such as Murillo, failed to transform the religious theme into art—which is, after all, the supreme achievement of Rubens and the great Italian masters. What the Spanish painter gives us is the religious fact as such—the end effect being either sentimentally sweet or grim and forbidding. In the seventeenth century Zurbaran was already painting figures of female saints who can hardly be recognized as such.

Spanish realism does not admit of aesthetic distance; objects are palpably near. This situation must be kept in mind if we are to understand Goya's Spanish premises. The baroque tradition that he rejected was far weaker in Spain than it was elsewhere. For this very reason the revolution in his art did not have the same radical character as David's. Goya was not aiming at producing any new theory. He was a man, unbridled and intractable by nature, who broke bonds that offered very little resistance. It often happens in the history of art that a great artist arises out of relatively poor cultural traditions just at the moment in which the dominant national tradition exhausts itself.

Even after all this is taken into consideration, Goya's art remains decidedly revolutionary. The revolution, however, is that of an individual rather than of a theory. The personal nature of his revolution is especially strong in his religious paintings—particularly in those cases in which the commission grew out of accepted baroque traditions, that is, the frescoes of the cupola, pendentives and adjacent arches in the church of San Antonio de la Florida

[1] [Lovis Corinth (1858–1925), German expressionist painter. —Ed.]

[Figs. 7 and 8]. Masterpieces of this kind of painting were produced in Madrid during the late baroque period by Tiepolo, Corrado Giaquinto, Luca Giordano. Late baroque ceiling painting is the last phase of an art in which creative imagination combined with religious conception to form a living whole. The means are no longer the most spiritual or the noblest—indeed, they at times appear somewhat dubious. The vision of Divine offered us is fleeting, sensuous, intoxicating, and self-indulgent—but it is, nevertheless, a genuine and convincing other-worldliness. The heavens open to reveal a beatific host of angelic choirs in exultation. This Heaven, these figures, these colors flooding down upon us do not partake of that abstract and transcendental quality that characterizes medieval mosaics and stained glass; they are natural. But what, exactly, is this natural quality? It is not that of the commonplace, everyday world in which we live and of which we are hardly aware—but neither is it a world of natural realism based on scientific observation. On the contrary, it is inextricably bound up with the rhythms and the intuitive experience of the marvelous and the visionary in the artist's own mind. While contemplating this kind of art we are led to believe in the existence of another world that is the correlative and heightened, transfigured image of the terrestrial sphere. We live between two worlds, the temporal and the eternal, and we suffer the artist to give sensuous form to the transcendental. The hereafter is not dark and forbidding—it is filled with light, life, form.

This belief—or rather, this union of belief and artistic imagination, is not to be found in Goya. Goya's figures loom up, silhouetted against the void. The darkness in his works is that of despair; it is terrifying. No mysterious gleam of light appears as a solace, as it does in Rembrandt's painting. This is even more apparent in Goya's graphic works; the effect is obtained technically by the sharp contrast achieved between the tone of the aquatint and the stroke of the burin. Goya's technique is no longer homogeneous, and this shortcoming reveals a deeper one: namely, that what Goya creates does not have its origin in a universal principle to which it returns but is lost, isolated in the horror of infinity. The martyrdom of a saint in a baroque painting represents the threshold to a better life; Goya's *Executions of the 3rd of May* [Fig. 3] represents an end. Because of his point of view, it was impossible for Goya to continue to paint religious pictures. What strikes us in the paintings at San Antonio de la Florida [Figs. 7 and 8] is their utterly terrestrial quality—and

their resultant blasphemy and banality. Let us take the dome as an example: here we find that Goya has rejected the characteristic expression of transcendence, as it were—has rejected the hovering and soaring angelic choirs, the merging of man with clouds and sky. His figures *stand* around the bowl of the dome; behind and above them appear trees and sky. The figures stand behind a balustrade, just as they might in a real scene—and this impression of a reality within our own reach is heightened by the fact that the balustrade is an ordinary kind of balcony rail, common in Madrid (cf. Goya's *Majas on a Balcony*). We are not introduced to a heavenly throng—but to a crowd of excited, ecstatic human beings. We do not shed the bonds of our earthly existence when looking at these figures. Baroque painting transports us, physical creatures though we are, into an unearthly sphere. The artists of the Middle Ages achieved transcendency by rejecting natural conditions; between 1500 and 1800 artists achieved the same result by transforming the natural, the realistic, into the celestial. Not only human beings but everything visible underwent the same transformation—the trees and clouds in a baroque religious painting are certainly realistic, but at the same time they convey an impression of another and higher sphere; together with the figures they form one single whole, whose compact unity is seen against the foil of the everyday world.

With Goya, all that is left of this baroque conception is a summary form of decoration; the inner relationship springing from an imagination open to the suggestions of religion has vanished. Not even the purely celestial apparition of the angels is spared this reduction to ordinary reality. The angels neither soar nor mingle with the clouds; they stand in pairs at the springing of the broad arches that carry the dome—they are cinema angels, to use a vulgar term, pretty girls decked out in long floating robes with wings stuck on to their shoulders! Brilliant footlights pick them out and render their faces as garish as that of the most earth-bound actress. The patterned draperies hanging behind them are far from celestial. If we compare these figures with Tiepolo's angels [Fig. 9]—who wear their robes girded high about their hips and who are, in some cases, rather daring—what do we find? A large dose of impudence, a troupe of celestial ballet-dancers—but they remain celestial!—whereas Goya gives us decently clothed actresses who merely play at being angels. The creative imagination behind all baroque painting, including Tiepolo's, presents us with a new type of reality. In

Goya's work, however—and here we are on the brink of the nineteenth century—we are given only that reality with which we are familiar. In baroque art we believe the illusion; in nineteenth-century art we see through it. A secret voice whispers "It's all a trick." Nothing can be more trivial than to approach the gospel with the criteria of historic truth.

III

When the heavens no longer open, when the relationship between near-and-present and far-and-future is no longer an article of faith, reality itself takes on new meaning. How does Goya view the world and mankind?—because for Goya the world *is* mankind more than anything else. Here again those concepts that had been valid for centuries are pitilessly rejected and destroyed. Let us begin with the nude. Goya's *Maja* [Fig. 10] challenges us to a comparison with the classical *ignuda* as the Renaissance conceived it. I do not propose to discuss here the extremely interesting question of the significance of the nude form in Christian art after the fifteenth century; neither shall I dwell upon the fact that during the Renaissance (a period that was not addicted to the cult of the body) the nude must have been viewed with eyes different from those of classical antiquity. In a general way the nude figure was regarded with respect and was depicted as beautiful; it was the most perfect object in creation, the highest form of organic life. This concept was heightened by ancient examples and by the role the nude figure played in religious and mythological themes; the nude might represent Adam or Eve, a martyred saint, Venus, Diana, Adonis, Narcissus. Even the erotic element in its boldest form became grandiose and divine (sometimes even satanic). The nude appears as the quintessence of the creative forces of nature. The permeation with classical form leads to a broadening of the concept of the nude that embraces everything that is generally admissible. We no longer see one particular, unique, and transitory nude figure but the whole gender of mankind. The nude figure is presented in its relationship to the whole of nature—as a concentration of all the forces inherent in nature. This is as true of Giorgione's *Venus* as it is of Rembrandt's *Bathsheba*—and it is equally true of the so-called "frivolous" paintings of the French eighteenth century. Even an engraving such as

Baudoin's *Evening* is imbued with the same exalted feeling for beauty that we find in the painting of a saint by Guido Reni. It shows us the harmony that exists between the nude and clothed figures and their erotic *ambiance*. Every dubious bedroom scene is associated with hallowed myths relating to the loves of the gods. All representations of this kind are endowed with a higher meaning; they contain a serious underlying note and we give them a positive and optimistic evaluation because of the religious, mythological, or organic concept that inspired them.

 None of this is true of the *Maja*. She belongs to the type of painting that Giorgione originated with his *Venus*, but she might almost be considered a parody of it. The *Maja* is the first visual example of the mental attitude expressed in the phrase "épater le bourgeois" that later became typical of so many artists. Venus and the mythological content have vanished; a naked Spanish girl, pert, lascivious, indecent, lies before us on an ordinary blue-green sofa. There is no trace of classical idealization. On the contrary, her vulgarity is emphasized and every trace of poetical charm is derided. A glaring light floods her pinkish-white body, which contrasts strongly with the background of the sofa—the colors contribute nothing to link the two. Boucher's nude figure of a girl lying on her belly is by no means a chaste picture, but it has charm; it is filled with the rhythmic movement of line, color, planes. Goya will have nothing to do with such distracting elements; he forces us to concentrate on the reality of the naked female figure. One cannot deny—and this is true of everything Goya produced—that the painting possesses vigor and vitality. Above all, it illustrates Goya's most decisive quality—his ability to see the human figure with new eyes. What is particularly striking is that in about the year 1800 two factors split apart that had previously been united; the Renaissance, and the periods based on it, combined the strongest and most vital forces with beauty and classical form. After 1800, on the one hand we find the anaemic, smooth, and frigid beauty of classicism and on the other a cult of the ugly, the forceful, and the demythicized. The most potent and positive values of the nineteenth century are once more on Goya's side. Matters have gone so far in this direction that the very word *beauty* becomes suspect because it is so often associated with a saccharine sweetness and with *kitsch*.

 Goya does away with all the classicizing rhythm adopted in depicting the nude—with all the classicizing harmony and contour.

He has nothing of the academic painter about him. Instead of trying to avoid the ugly and the repulsive, he deliberately sought them out. He sought the violent, the shocking, and the expressive—he sought everything that is overwhelmingly natural. He cast overboard the whole vast system of formal order that had regulated pictorialized life in previous periods. Goya achieves his form directly from the motif—from the appearance of objects and from their motion. Emphasis is deliberately laid on all that is ugly, vulgar, provocative.

One may certainly say that even before Goya there had been some rebellion against the cult of classical beauty. The first painter who comes in mind is Rembrandt, who certainly did not shun the ugly and may even have set himself deliberately against classical art (think of Jacob Burckhardt's angry outbursts!). It would be well worth while to study Rembrandt's influence on the eighteenth century from this point of view—to determine to what extent his acceptance of the ugly was worked into the extremely complex polyphony of the late baroque theory of beauty. We might then come to the conclusion that the ugly as such was welcomed as a means of heightening the appreciation of beauty—much as salt is added to a sweet dish in order to bring out the flavor. Perhaps a link could be found between Rembrandt and Goya via the late Venetian school of painting; but Goya also concerned himself directly with Rembrandt. Still, there is a vast difference between Rembrandt's inclusion of the ugly in his view of life and that of Goya. Rembrandt's is positive, whereas Goya's is negative. Rembrandt makes us realize that even the ugly—all that which has not been transfigured by the light of the classical world—is nevertheless the creation of God. Goya sneers with a fiendish grin; for Goya's figures are not merely ugly—their hectic activity masks a vast emptiness. The striking vitality they possess does *not* lead us to think of an organic structure—and therefore does not lead us to the Creator Himself. Their vitality has something uncanny about it; his figures are sometimes reminiscent of puppets or trolls. His works lack the firm principles of previous centuries. In their place we often find provocation, a kind of exhibitionism. This is particularly true of Goya's portraits. The King, the Queen, the royal family [Fig. 25] are painted in such a manner that one is driven to ask whether Goya was deliberately caricaturing them. There is a touch of vulgarity in many of his portraits even when it is hard to imagine that he intended a caricature. When Goya does present us with all the apparatus of a monumental, offi-

cial, baroque portrait—as in that of Godoy—the result is something unresolved and unedifying; Godoy sprawls without dignity.

At this point I have two observations to make—one, that Goya is the first great painter in whom genius is coupled with a delight in the commonplace, the first for whom strength and vitality rank on the same level with brutality and unscrupulousness. Time and again during the nineteenth century we see nobility coupled with a kind of weakness—and this juxtaposition arouses feelings of sympathy. That which is not conducive to sympathy, however, is on the side of the great talents—Wagner, Strindberg, Manet. Time and again we encounter the figure of Mephistopheles, who could only be meaningful at this time—the spirit of negation, which is also a part of Goethe's spirit; that is to say, an intelligent devil, not an obtuse one. On the other hand, we must ask ourselves whether the pitiless quality of the ugly and repellent aspects of Goya's work is not a symptom of despair. Is there not a certain pathos in his negation, in his criticism of society, his doubt concerning the divine order of the universe? Obviously the creative, the God-given artist, is tormented mercilessly when he cannot praise the Creator by means of his works. Perhaps his very torment consists in his yearning for a renewed union with the Divine. Throughout the nineteenth century one problem recurs again and again: what kind of harmony can the great masters attain if the world itself is no longer a matter of certainty? I shall answer this question at the end of my lecture. Before I can do so, I shall have to discuss Goya's third destructive contribution: the destruction of the image or picture as it had developed from Giotto's time. With this problem we touch upon the most fundamental matter of art.

IV

In his early period Goya made several engravings after Velazquez's paintings. If we compare these engravings with the originals we shall have a clearer and more precise touchstone by which to discuss the problem of the image or painting.

Let us begin by comparing Velazquez's portrait of Don Sebastiano de Morra to Goya's copy. First, Goya has accentuated the bestial quality of the facial expression. Velazquez's melancholy face has been turned into something stupid, somber, staring. Once more

we find Goya emphasizing and distorting the content, as he so often does. But how does he achieve this effect?—by isolating the figure against its background, by dissolving Velazquez's sense of order, by creating tension between the figure and its surroundings. In both Velazquez's portrait and Goya's copy, the figure stands out against a dark neutral background. In Velazquez, it gives the impression of being a natural background, in harmony with man's physical and spiritual being; it is his natural habitat, his refuge. In Goya, the background does not evoke a sensation of shelter but is turned into something inimical; lacking compositional coordinates, it suggests an engulfing infinity. This sense of the infinite heightens the desolate character of the buffoon. How does Goya achieve this impression? By means of the sharply accentuated contour that isolates the figure and by the contrary and contrasting strokes of the burin. The contour is more movemented and more sharply defined than in Velazquez; it is more descriptive. There is a contrast between the detailed figure and the utterly monotonous background. The figure is more plastic than in Velazquez but the background is less clearly defined spatially. Velazquez insists on more light behind the figure and gives firm pictorial structure to the painting by increasing the darkness of the background toward the edges of the canvas. Goya uses an even darkness; his image stops at the edges without coming to a conclusion achieved through the inner logic of the composition. Although his picture is bounded by its frame, it gives a sense of infinity—we find this again in the *Maja* [Fig. 10]. Furthermore, Velazquez integrates his figure into the axial and orthogonal functions of the canvas surface—but Goya fails to do so. In Velazquez the line marking the point where the jacket is buttoned lies exactly along the central vertical axis; Goya deliberately moves this line out of alignment with the central axis. At the same time he accentuates the buttons. In Goya this line is part of the figure alone; in Velazquez it is, at the same time, part of the composition and of the entire picture surface. In Velazquez the human figure is subordinate to a higher order; the painting represents universal harmony.

But this one line does not constitute the whole problem. It is but the outward and visible sign of a sense of reigning order that Goya no longer recognized or perceived. The vertical line meets the horizontal (the horizontal line is equal to one-third of the height) in the lap of the seated figure and in the background on the right. The seated figure serves to accentuate the static-architectonic

principles governing the composition; it harmonizes with the treatment of space, just as the treatment of space harmonizes with the planes. The human figure, the planes, and the spatial quality still form the kind of unity that Giotto established. In Velazquez we also see that all the contours are related to the general composition; they are related, that is to say, not just to the figure but to the whole. The single detail is subordinate to the composition as a whole and, no matter what form it takes, is linked with it throughout. The superior reality to be found at the heart of experience is expressed in Velazquez's painting by means of a mathematically-based composition.

None of this is to be found in Goya—neither the horizontal line drawn through the lap of the seated figure and the background nor the abstract relationship between contours and planes. Note in particular the change that the base-line undergoes on the right, where the emphasis is placed on a strongly-marked diagonal line leading up to the figure. Goya refuses to tolerate a composition based on an order that merely includes the seated figure. On the contrary—this line, as well as the gleam of light on the left, is made to serve the purpose of isolating the figure. What matters to Goya is the striking urgency of the human figure—and that alone.

Let us take another example: Goya's copy of Velazquez's *Aesop.* We might make the same remarks. Once again we find a distortion of the face; it has become smaller, ugly, less confident. Velazquez's figure is imbued with classical calm. Goya, on the other hand, has disrupted the beautiful relationship between the figure and the format, which gave Velazquez's work its monumental character. Disorder has usurped the place of order. The reduction of the bucket is very important in this connection. In Velazquez we find the genuine and generous baroque concept that harmonizes man and his surroundings. The impagination is chosen to serve the dignity of the figure. In Goya, the bucket becomes an irrelevant accessory—as so often happened in nineteenth-century painting; it does not articulate the harmonious relationships of the picture. If we examine the figure itself the changes appear at first sight to be minor—but they are typical. The jagged effects in the lighter parts of the work as well as in those in shadow (here the eighteenth-century style is still evident) and, above all, the break in the line cutting along the central axis through the figure; the slurring of the contour at the throat; the shifting of the line at the waist and the same hesitant shifting and bend at the foot—all these are to be noted. Observe how the line,

which should spring from the figure and reach beyond it to en-
counter the limits set by the frame, has been abandoned.

Finally, let us consider the *Meninas* [Figs. 11 and 12]. I shall
not attempt to discuss the extent to which a comparison is unfavour-
able to Goya. What interests us are the changes that indicate an
essentially different outlook. Once more we find Goya dispensing
with a composition based on mathematical proportions between
planes and space. By doing this he is no longer master of that de-
tached calm that, in Velazquez, was based on unshaken principles.
The transformation of the relationship between the height of the
figures and the height of the painting is extremely important. In
Goya, the figures are smaller and the female dwarf on the left no
longer rises above the maid-of-honour on the right. This fact destroys
the harmony between figures and space; space is no longer filled with
human beings but has become a threatening cloud hovering over
them. The reduction of the dwarf and the foreshortening of the dog
deprive us of the scale in the right-hand corner that served as a
steady point of reference by which we could orient ourselves in rela-
tion to the figures in space. The relation to the vertical wall on the
right and to the horizontal base-line has been abolished. Goya dark-
ens the room—the paintings in the background can hardly be dis-
cerned; the contrast between light and shade is exaggerated. This
makes the engraving even more uncanny. The disruption of the rela-
tionship between the human being and his surroundings implies the
disruption of something even more profound—that is, the mathe-
matical principle on which the whole is based. It is important to
understand the extent to which Velazquez, the *colorist* Velazquez,
took this mathematical order into account. If we compare the two
works we find that in Velazquez the core of the composition lies in
the relationship between the little princess and the painting as a
whole—the lower part of the princess' body is proportionate to the
two large pictures in the background; her face is the only one that is
in proportion to the format of the painting itself. Furthermore, in the
figure of the princess the major coordinates are made dominant; the
profile of the maid-of-honour on the left lies exactly along this golden
section; the door-frame is in the center. Goya has changed all this!
The main lines in his figure of the princess have been disrupted by
the diagonal stream of light—how typical of Goya's figures is this
faltering quality! The door is no longer exactly in the center; the
maid-of-honour is no longer set in the line of the golden section. Even

the relationship between man and dog is disturbed; the dog is as irrelevant as was the bucket in the case of *Aesop*. In Velazquez the figure dominates in the general composition of planes and space. In Goya the figure must be deliberately emphasized in order to assert itself against its surroundings and to attract our attention. This is the beginning of advertisement and poster art. Goya has destroyed all sense of sociability; human beings together, human beings with animals, the space in which they live and have their being, objects— all have nothing more to do with one another.

V

These examples have taught us something—namely, that for Goya the baroque order was no longer valid. He refused to admit or acknowledge a painting as expressive of that order. Here, too, Goya is destructive and does not stand comparison with Velazquez. One may also say—and fairly—that his genius does not rank with that of Velazquez, which is tantamount to saying that even the best artists of the nineteenth century cannot compete with the great masters of the past. In this case, however, we must ask whether there was a lack of genius in the nineteenth century or whether the indifference of that century denied to genius the bliss of being able to develop itself happily to the full. We prefer not to dwell on this negative aspect—for Goya is a true artist and he could not have been one had he been merely destructive. He bequeathed to us an imposing mass of work; he lived on into old age. He did not just revolutionize—he developed, in a positive sense. At the end of his life he was a far greater artist than he was at the beginning. He attained clarity and completeness (even if it was not perfection) and a certain kind of classicism. We must therefore ask ourselves what Goya's artistic form really was. What did he set up to take the place of traditional pictorial composition? Subsequently, we shall have to ask what it was in Goya's art that was symptomatic, in a positive sense, of the nineteenth century. The graph of his development becomes clear if we compare his early work *The Flight into Egypt* [Fig. 13] to the late lithograph *The Dagger Thrust*. The former recalls Tiepolo; the latter, Manet. In the early work we still find the network of strokes that premise a composition based on geometrical laws; in the later work, the stroke is completely random—Goya is

aiming only at obtaining a striking effect and renounces any attempt to fill the page. The early tapestry-cartoons, too, in which he adopted the technique and the content of eighteenth-century tradition, have an obvious link with that century and with Tiepolo in particular. This tie is not without significance. The fascination and the artistic quality of Goya's work may be explained by his peculiar dislocation of the baroque composition. Goya does not oppose the eighteenth century—as Mengs and David did; he develops new artistic potentialities within that tradition. He knows what to do with Tiepolo's wit and impudence. This transformed baroque is highly evident in the *Caprichos*—less so in the *Desastres*. In the later work the baroque vestiges have been absorbed into a new pictorial form.

Any analysis of these matters is extremely difficult—and this brings us to the most intricate part of this lecture. A painting such as *The Couple with a Sunshade* is still conceived in the manner of the pastoral scene, the porcelain statuette, and it may well be compared with Tiepolo's *Rinaldo and Armida* [Fig. 14]. The traditional composition based on parallel lines balanced by others running contrary to them, the repertoire of charming attitudes typical of late baroque art, the playfulness and philandering, the accentuation achieved by the use of strong color—we find all these elements in Goya. And yet the beginning of the transformation may be glimpsed even here. If we stroll past the whole series of cartoons in the Prado or look at the tapestries themselves in the Escorial it is even more obvious. The great charm of tapestries, as they developed in the seventeenth and eighteenth centuries, lies in their decorative quality. I do not mean to say that one is indifferent to their content; in earlier periods this was never the case. We find logical sequences carried out—historical and mythological scenes, scenes of the chase, the seasons—but the main purpose is to "delight the eye." The eye gazes upon a broad expanse and sees variations and repetitions of colour and form. We skim lightly over the individual scenes and embrace at a single glance the whole surface into which the episodes are interwoven. The very technique of a tapestry makes obvious the ideal framework on which the whole conception is based.

Now, if we wander through the rooms in the Escorial where Goya's tapestries are hanging, the impression we receive is not unmixed. Why is this so? Because the decorative surface, the interweaving of scenes with the general composition, does not answer to Goya's intention. Goya does not repeat the form—he isolates it

(as he does color) and concentrates upon the episode itself. He takes the content too seriously. His tapestries do not adorn the room— because we linger before each individual scene. He can even fill us with sensations of melancholy, as in the representation of *Winter* [Fig. 15], which has something desolate about it. Goya illustrates —he does not embellish. If we go back to *The Couple with a Sunshade* and compare it with Tiepolo [Fig. 14], this fact strikes home. In Tiepolo we see the figures actually dissolving into the composition to form part of it—lines and colors, light and shade—all harmonize; the diagonal is repeatedly emphasized. The human element, the landscape, and the objects depicted stream together to synchronize in form. Goya, on the contrary, draws far more attention to the group itself; the colors are concentrated upon this point; he introduces concentric circles (note the dog, the sunshade—compare it to Tiepolo's sunshades in the frescoes at Villa Valmarana!). The physical consistency of the figures stands out in opposition to the background. What is even more striking, however, is that the diagonal scheme taken over from the baroque is no longer adopted in order to situate the group in the composition as a whole or to underline the fact that the movement of the figures is synonymous with the movement of the spheres. Not at all! It is used to attract our attention to the figures themselves! Stage direction has replaced order; the particular has usurped the place of the general; the interpretive artist has given way to one who wants to give shape to his own inspiration and personal impressions. This change is fundamental and its consequences must not be underestimated. It is the ground on which the self-sufficiency of the artistic imagination is based. This change explains the ever-widening distance—at times, the hostility —between the artist and the public. It would be interesting to show how the artistic imagination and power of invention increased from the seventeenth century on, even though it was always kept within the bounds set by the order established by the great masters of the sixteenth century. By the eighteenth century the artist had come so far that he began to trifle with order. He was so certain of it that he no longer needed to proclaim it as such or to represent it. Indeed, he sought to give himself and his compositions a random and casual air—at the same time keeping strictly within the bounds set him. We find a host of fantastic figures, witty spirit forms, bold contrasts, and daring effects—and Goya inherited his share of this wealth. So it was that this one aspect of late baroque life was carried over into

the nineteenth century and continued to inspire those very artists who were most vital. But the underlying and binding principle, the correlative aspect they rejected; the artist now followed only his own laws. Thus can the cleft between good and bad art in the nineteenth century be explained—for in earlier periods it had never gaped so wide. Thus, also, we can explain the unpleasant element that crept in—the inability to collaborate with one another, the trend to stridency in order to call attention to oneself. In fact—the beginnings of poster art! Goya's art definitely has something of the poster about it—the essence of this kind of production being the ability to concentrate attention so sharply upon one object that everything else is ignored. We must note, in this connection, that both Goya and the neoclassicists saw in late baroque art only the play of an unfettered imagination. They ignored the order within whose limits it was contained and expressed. Goya judged what he saw as positive and therefore remained in touch with its living, artistic force. The neoclassicists condemned it and strove to fashion a new order and severity. But since this severity was directed against the imagination and not born of it, the only result was the tyranny of rule without the establishment of a new order.

I would like to show you what connection Goya has with this one aspect of vital baroque art—how the impressions he got from it became more and more his own until they were transformed. In the end he contrived to fashion a system of order out of himself, *the order of his own being*, the only form of order remaining to the great artist of the nineteenth century. At the same time I shall discuss how the nineteenth century tackled the problem of the plane surface.

Some echo of baroque composition may be found in many of the *Caprichos*. They are chiefly devices that go back, in essentials, to painting since the time of Caravaggio: diagonal lines running to meet, strongly contrasted grouping in which the figures are combined to form a system or a whole. This grouping makes the most varied possible use of every potential orientation of the plane surface. Goya interprets the baroque according to the meaning that the term originally had—something bizarre, striking. But he has not entirely abandoned the old unifying principle that held the picture together. We still find the basic coordinates making themselves felt by bringing each single, restless detail or motif within the frame into harmony. Meanwhile, however, the emphasis has shifted—and in

no uncertain manner. What concerns Goya is not the inclusion of each single motif in a whole that is subject to a universally applicable rule; his main preoccupation is to concentrate upon the motif itself —on the unprecedented inspiration of his own genius. Every detail in the baroque is significant because it derives from the general conception of a significant whole, embracing religion, mythology, society. A picture—that is, a plane surface enclosed by a frame within which the order is unchanging—represents this general concept in its most self-contained form. Each painting is a self-contained world. But what happens in Goya's work? Just the contrary! He intensifies the single, isolated motif until it becomes significant in itself. The means he adopts to achieve this result for his own special purposes are those of baroque art—with which we associate elevated themes. This is what transforms his occasionally commonplace or trivial scenes into something gigantic, uncanny, incalculable. They are *in fact* incalculable, because they no longer form part of a self-contained order; they know no boundaries.

One of Goya's genre scenes is so characteristic that it may serve as an illustration [Fig. 16]. It shows an old woman thrashing her son on his naked behind because he has broken a bowl. A laundry basket stands in front of her to the left and washing hangs from two lines behind her. A genre scene—but not as the seventeenth century understood it—not as the bad genre painters of the late nineteenth century did, either. In the seventeenth century, all genre scenes, everything that was burlesque, loutish, or base, had its place, too, in that order that was valid for the most elevated themes. They, too, were among the manifold aspects of the world. The genre painters of the nineteenth century make such scenes harmless, insipid, and arch. But in Goya even a scene of this kind becomes terrifying and nightmarish—and for what reason? Because the great factors of composition—light and shade, basic lines and repetitions—do not regulate the details and order them according to one universally dominant principle. On the contrary, all these technical devices stream together into the details; they are used to accentuate each single item.

At this point we have reached an important conclusion—the characteristic of the great artist of the nineteenth century is revealed. The period that began about 1500 was established by men of genius. But their genius, the specific artistic force working in them, realized itself as an expression of divine order in the universe.

Genius was not absolute: by means of the creative power that genius possessed, it symbolized the Creator Himself. The relation between form, color, light and dark planes, the inner rhythm of a great master-piece, sprang from the individual's aesthetic sense. What the artist expressed with these technical means was the profound coherence at the heart of the universe—its divine order. Goya is the only one of his generation to possess the intensity of a great master. His paintings are based on the relationships between all these elements and it is this that differentiates his work from that of lesser painters. With Goya the artist's genius becomes absolute and responsible to no one. The inspired artist no longer carries out the will of God. He creates a world without God. The baroque artist finds dignity and beauty in things in themselves because they bear testimony to God. For Goya the human figure, the washing, and the basket are all trivial in themselves and become significant only in so far as he concerns himself with them. The artist becomes exalted—but homeless. Every talent needs some subject-matter, some content that it can realize; this subject is henceforth to be chosen by the artist himself and what he chooses is his concern alone.

In the *Caprichos* we see that Goya had not yet found his own form. As his inner coherence increased, the baroque configurations became superfluous. The *Desastres* have no touch of the bizarre; the only echo of baroque fantasy is to be found in the urgency and conviction with which he formulates his themes, in the sureness behind the striking contrasts. Goya frees himself from the old convention that a picture should not extend beyond the limits set by the frame. It becomes obvious that a frame can no longer enclose a world. Its only function is an artistic one; it is there to create a painting out of something that is, in fact, only a segment of a wider view. Once more we find that the artist's handwork, his *metier,* is losing the philosophical grounds on which it was based and now summons us to admire genius in and for itself alone. This marks the beginning of the relationship between artist and public that is best summed up by the exclamation: "Fabulous!" One admires the artist's achieve-ment in itself; one is in conflict, torn between the ghastliness of the content and the aesthetic achievement.

We now begin to find drawings that do not even extend to the edge of the frame but only fill the center of a sheet of paper. This is enough in itself to prove that the earlier function of the frame, that is, to indicate the rule of order in the picture, has been superseded

—but I do not mean that it signifies the end of the frame's aesthetic function. It is not a matter of indifference to see how the motive is impaginated. The frame also implies a heightening of the desired effect by means of the contrast obtained to the void outside it. Goya's artistic form progresses. The sense of coherence in his work is drawn logically from the motif itself, that is, no longer from the motif combined with the articulation of the planes. The plane itself remains unarticulated. Number 11 of the *Desastres* [Fig. 17] is a particularly good example of this point. The similarity of form of the bridge, saber, and bandolier is fortuitous; no articulating function, no ulterior meaning is to be derived from the circumstance of their similarity. The similarity conveys no metaphysical truth—it is nothing more than a purely aesthetic intensification and elucidation of a given fact. We see Goya's aesthetic unity and his sense of composition becoming ever more intense. His aim is to achieve harmony among all the various facets of his picture; at the same time we perceive that the only result of this emphasis is to admit the particular, the individual, the peculiar—that is to say, it does not serve to transform the particular into part of the general or make the detail part of the whole. Let us examine Number 70 of the *Desastres* with this in mind. The theme of the procession has been mastered to perfection: the curves of the hill, the contours of the figures, the coils of the rope—all harmonize. The greatness and conviction inherent in Goya's art make the scene unforgettable. On the other hand, nothing consoles us. There is no trace of any contact with a universal sense of order, no trace of a law that gives us something to rely on or leads us to believe that destiny, even in its most horrifying aspect, is, nevertheless, God's will. Goya's aesthetic ability does not emancipate us. On the contrary, it increases our sense of oppression, of horror. The art of the later Rembrandt, of Titian or Velazquez, leads us from the naked fact to its transfiguration—but Goya leads us to nothing but darkness. A great artist, a master, transports us from contact with a variety of objects to the visionary. But Goya's vision is no longer transfigured by the light of eternity. Its only background is the void.

The three etchings of the prisoners are no less masterly. If we compare them to the title-page of the *Caprichos* [Fig. 20], the degree of artistic perfection attained, the masterly unity of form, leap to the eye. There is no single stroke that does not harmonize with the others, that does not spring from the theme itself. This fact ex-

plains the incredible concentration to be observed in the two series. But to what purpose does Goya use this concentration? To make the hopeless, tormented, terrible aspect of the scene as striking as possible. All meaning is in the figure—the background is either amorphous or antagonistic to the figure. Goya's aesthetic form does not integrate man into the surrounding universe—it emphasizes his isolation.

Goya's greatest achievement as an artist—and it is also, in its form, his most original work—is to be found in his late etchings of the *Tauromaquia* and the *Toros de Burdeos,* made when he was an old man. Here, too, the striking novelty of the content is what attracts our attention. But this is no longer so important as a point of departure. There is no criticism of the social order, no troubling topical reference. He has shed all this. What interests us so keenly is no longer the bizarre configuration, the impact of the theme itself —but its pictorial effect. In order to obtain this effect, Goya takes advantage of all those means he had made his own in emphasizing the single detail. But what is the result? Something entirely different from the result obtained by artists of the previous epoch. The key to this difference is the juxtaposition between a concentration of attention upon the central motif and the void surrounding it. Take Number 21 of the *Tauromaquia* series as an example. In the lower part of the scene, on the right, we have a host of figures and a number of complex, contrary rhythms. The rest of the seemingly huge picture remains empty. The bull that has gored a man and caused the heedless flight of spectators is drawn parallel to the base-line and proportionate to the whole scene. The woman hastening away on the right follows the same line as the balustrade, whereas the figure flooded with light on the left serves to remind us of the whole breadth of the picture. The light thrown upon this figure echoes the light shed upon the whole of the left side of the composition. Here, too, as in every masterpiece, the effects—from the aesthetic point of view—have been exactly calculated. However, the effects that stream from Goya's later works are quite different from the harmonious unity he had overthrown. Even now the work of art is not intended as a realization of a timeless order and of the laws governing this order. It is only a skillfully chosen theme in isolation. What is fleeting and unique, that is, the theme itself, is even more sharply accentuated. The fact that the facetious and cruelly accurate aspect of the episode is constrained within a given framed space makes it

even more impressive—as does the fact that it is silhouetted against the void. Whereas in earlier periods the theme was subordinated to the picture as a whole, this plate shows clearly that for Goya it was the theme or motif that inspired the picture—and the theme became the whole object of his concentration. The shadow lying across the arena, its curve—all these details serve only to accentuate the contest between the bullfighter and the bull.

Goya does not give us a complete and self-contained world; he only fixes one point, one situation. The public is undefined; it has become the mass. His aim is a subtle one: to make us realize the boundlessness, the disharmony in the world by means of one detailed episode traced by the artist's hand within a circumscribed space. Life is made up of a number of simultaneous and coexistent moments, among which we choose those that appeal to us. The delight in emphasizing chance and random details and yet creating a coherent work of art can be carried so far that we look upon the artist as a wizard or conjuror who sets himself the most difficult problems just in order to prove that he is capable of solving them. Number 4 of the *Toros de Burdeos* shows one section of an arena drawn diagonally across the surface of the picture—nevertheless, it is a perfectly unified work of art. Solutions of this kind made an enormous impression on Manet and Degas. Degas, in fact, excels in making the task he sets himself as complicated as possible; at the same time he achieves a state of cohesion whose perfect balance and extraordinary precision astound us.

The challenge implicit in selecting a random slice of life and mastering it as an artist attracted the genius of the nineteenth century. We cannot help but admire this kind of art—and what we admire is definitely artistic. The great artist of earlier periods concealed himself behind his work and offered us a view of the unity and order reigning in the universe—the great artist of the nineteenth century offers us the spectacle of his capability. Virtuosity plays an enormous role. Only with Cézanne do we return to an artist who concerns himself with the principles of our world instead of questioning them.

GOYA'S *Caprichos*: BEAUTY, REASON, AND CARICATURE

José López-Rey

As we pause here and there to see men and women acting out their passions, entangled in the fabric of the society they themselves have made, or changed into caricatures of themselves under the weight of their vices or errors, we may perhaps better realize that the world of moral and physical malformity was not congenial to Goya. Though he does take us through such nightmarish scenes, he does so firm in his conviction that man can conquer the monsters of error, prejudice, superstition, passion and the like which he so masterfully depicts. As he took care to state in writing, those monsters are "impossible"—that is in terms of reason. It is true that in the 1850's Charles Baudelaire found Goya's monsters *vraisemblables* and was fascinated with their truthful appearance. Nevertheless, if Baudelaire's own creative vision has overshadowed the understanding of the *Caprichos* for a long time, we should not today fail to realize that in that work Goya did not intend to assert the reality of his strange visions, but rather their absurdity. Indeed it is Goya's confidence in reason which admits a hope for beauty into his caricatural rendering of man as a mummer who constantly disgraces his high role.

"Goya's Caprichos: Beauty, Reason, and Caricature." From *Goya's Caprichos: Beauty, Reason, and Caricature* (Princeton: Princeton University Press, 1953), two paragraphs of Foreword, 57–72, 75–86. © José López-Rey. Reprint edition brought out by Greenwood Press, Westport, Conn., 1970. Reprinted by permission of the author.

CARICATURE AND MAN'S NATURE

Goya's caricatures must be linked with the contemporary interest in the physiognomical characterization of human passions. Though this approach to the understanding of man dates back to Aristotle and Galen and had brilliant adherents in the sixteenth and seventeenth centuries, it was in the eighteenth that the interest in Physiognomy became widespread among cultivated people. In 1764 so critical a mind as that of Voltaire answered the question, "Can one change one's character?" with the qualified affirmation, "Yes, if one changes one's body." [1]

The importance of physiognomical knowledge to the artist reached back into the centuries. Leonardo had endeavored to acquire it, and put down his observations both in writing and in a number of drawings. In the 1660's, the painter Charles Le Brun posed the problem in a fashion both learned and empirical, with a marked tendency toward didacticism, and pointed out analogies between certain human and animal physiognomic traits.[2] Antonio Palomino—the author of an art treatise widely read in Spain throughout the eighteenth century—stated as a constant principle of natural philosophy that the formation of the human body and its artistic configuration are infallible indications of man's emotions and inclinations. He illustrated his point by describing the characteristics of a number of temperamental types such as the wise, the witty, the courageous, the pious man, the coward, the miser, etc.[3]

In England, Hogarth endeavored to analyze and determine the line of beauty, while at the same time expressing by means of caricature the reality of human passions and behavior.[4] As we shall see presently, there was no contradiction between such an interest in the comprehension of beauty and the parallel rendering of man's malformations; in fact the first was a prerequisite for the second.

In 1767 a book containing fifty engravings after Leonardo's drawings was published in France. M. Mariette, who wrote the

[1] *Dictionnaire Philosophique*, article on *Caractère*.
[2] See, Pierre Marcel, *Charles Le Brun*, Paris, n.d., pp. 123 ff.
[3] Antonio Palomino y Velasco, *El Museo Pictórico*, Vol. II, *Práctica de la Pintura*, Madrid, 1724, Book VIII, Chapter II. A second edition was published in 1797.
[4] William Hogarth, *The Analysis of Beauty*, London, 1753.

introduction to this *Recueil de charges et de têtes de differens caractères,* used the French word *charges* to convey the original meaning of caricature; for, according to his explanation, Leonardo in those drawings rendered the characteristics of the passions by "loading" those parts of the human figure which were most open to ridicule. Underlying the procedure was the conviction that "peculiar physiognomies contribute more than anything else to the characterization of passions," and that "there are certain physiognomies which express certain vices." "A petulant, haughty or stupid man has, in most instances, his character painted on his face." [5]

The belief in a relationship between moral or mental qualities and physical traits was shared alike by the eighteenth century exponents of revolutionary philosophies and their religious opponents. For example James Beattie, who won great notoriety in England for his *Essay on Truth*—directed against Voltaire and his followers—considered that a lack of proportion in the members of the human body was indicative of moral or mental weakness.[6]

It was a minister from Zurich, Johann Kaspar Lavater (1741–1801), who sketched physiognomical notions into what, despite certain objections, was widely accepted as a scientific system, a task in which he was aided by Goethe, at least for a while.[7] Lavater's aim

[5] *Recueil de charges et de têtes de differens caractères gravées a l'eau forte d'après les dessins de Leonardo da Vinci. Precedés d'une lettre de M. Mariette sur ce peintre Florentin,* Paris, 1767, pp. 16–17.

[6] James Beattie, *An Essay on the Nature and Immutability of Truth, in Opposition to Sophistry and Scepticism,* First ed., Edinburgh, 1770.

[7] The first edition of Lavater's collected papers, or "fragments," appeared in 1775–1778. Several editions in the original German as well as in French and in English were made late in the eighteenth and early in the nineteenth centuries. Goethe's "fragments" on Physiognomy, several of which were included in Lavater's book, date from 1774–1775. See: *Goethe's Samtliche Werke, Vol. xxxiii, Schriften zur Kunst* with introduction and notes by Wolfgang Oettingen, Stuttgart and Berlin, n.d., pp. 294–297.

Goya may have read one of the editions in French, a language he learned in 1787. I have chosen to quote from the folio English edition, translated from the French by Henry Hunter, *Essays on Physiognomy,* which seems to have been reprinted more than once. The publication dates of the set I have consulted are as follows: Vol. i, 1799; Vol. ii (two parts with consecutive page numbers), 1792; Vol. iii (two parts with consecutive page numbers), 1810. In a couple of instances, however, I quote from Thomas Holcroft's translation made from the German (London, 1804).

Since Goya was not probably a thorough student of Lavater, even

was to study the moral life of man which "discovers itself principally
in the face—in the various changes and transitions, or what is called
the play of the features." Physiognomy was to him "a source of
sensations: an additional, delicate and sublime sensation," "a new
eye which perceives in the creation a thousand traces of the divine
wisdom and goodness." [8] Convinced that the new science could be-
come "the terror of vice," Lavater admonished: "Let the Genius of
Physiognomy awake and exert its power, and we shall see those
hypocritical tyrants, those grovelling misers, those epicures, those
cheats who under the mask of Religion are its reproach, branded
with deserved infamy." [9] Hence one of the vignettes illustrating
Lavater's *Essays* represented the nude figure of the physiognomist
with a lighted torch pursuing a vicious character, dressed in an
ample habit, running from an altar into the darkness.

For Lavater there was "a natural union between physical and
moral excellence," and to suppose the contrary would have been to
question "the existence of infinite Wisdom and Goodness." [10] "Beauty
and ugliness have a strict connection with the moral constitution of
the Man. In proportion as he is morally good, he is handsome; and
ugly, in proportion as he is morally bad." After making this affirma-
tion, Lavater took it upon himself to get rid of the host of objections
which might be raised up against it. He first qualified his statement
by explaining that he did not mean "that virtue is the only cause of
beauty, and that ugliness is the effect of vice alone," but rather "that
virtue beautifies, and vice renders a man ugly." He then faced the
objection "that you may everyday meet with vicious men whose
persons are beautiful, as virtue is daily found under a homely ap-
pearance" by drawing from that experience a proof of his assertion.
It is true, he argued, that one can acknowledge the physical beauty
of a woman and yet not like her, and that it is equally common for a

though he was familiar with his main ideas, it is not necessary to try to
determine which edition he was acquainted with.

It is not my purpose to trace here a history of the ideas on Physi-
ognomy, much less to discuss their scientific validity. I limit myself to an
outline of Lavater's ideas which, in Goya's time, were considered most
authoritative on the subject. The reader may consult Karl Bühler, *Aus-
drucktheorie: Das System an der Geschichte aufgezeigt*, Jena, 1933.

[8] Lavater, Vol. i, p. 17.
[9] Lavater, Vol. i, pp. 77–78.
[10] Lavater, Vol. i, p. 129.

homely man to make an agreeable impression at first sight. But, "it is found on examination, that the Beauty whom we could not endure and the Mán whose homeliness appeared agreeable, produced in us antipathy and sympathy, by the good or bad qualities imprinted on their faces." To Lavater this was proof that there were certain striking traits, agreeable or disgusting, which would reveal the true character of a person by making a stronger impression than all the rest of his or her features, whether ugly or beautiful.[11]

Lavater accepted as "a very supposable case" that a man born with a happy disposition toward what is good, noble, honest, beneficent, toward all that tends to a valuable end, may, after having cultivated and improved such innate dispositions, abandon himself to the gratification of some vice, and that his physiognomy may still preserve its beauty, though to experienced eyes it will be less agreeable, less attractive than it was before the man became "the slave of passion." Similarly, Lavater could envisage "a man naturally inclined to irregular appetites" which had been fostered by "a vicious education" until vice "imprinted disagreeable and disgusting traits on his physiognomy." Were that man to succeed in repressing the most violent of his passions, he would be mentioned "as an example of virtue united to ugliness," and yet this ugliness would be less striking than when he complacently submitted to the violence of passions.[12]

Moreover, "there is a great variety of singularities, caprices, whims, blemishes, defects in the manners, the humor and the character, all different from each other, but all disagreeable, low and disgusting, which taken either separately or together, cannot be directly charged as vicious; but which, when combined, debase, degrade and corrupt the person who is tainted with them. However, if he preserve his probity in the ordinary commerce of life, if he abstain from capital vice, and along with this fulfill the externals of piety, he shall have the reputation of a worthy man, nay, of a singularly excellent and blameless character. It is undoubtedly certain, that many worthy people of this description are at the same time very hard-favored." [13]

Since, according to Lavater, moral dispositions as well as hu-

[11] Lavater, Vol. I, pp. 135 ff.
[12] Lavater, Vol. I, pp. 138 ff.
[13] Lavater, Vol. I, p. 140.

man features and forms, were transmitted from generation to genera-
tion, one could not be surprised at the widespread deformity of the
human race.[14] Everywhere, in the country villages as well as in the
small or large towns and cities, Lavater's mind was hurt and op-
pressed at the sight of so many "persons of the vilest appearance,
both in the highest and lowest ranks of life"; he discovered every-
where "most dreadful havoc, a prodigious number of bad physiog-
nomies—caricatures of every sort." The blame for this degeneration
in creatures of the noblest species could "be imputed to Man alone
—to the species, and to every individual taken separately"; it was,
indeed, "an appendage to that capability of improvement which ex-
ists in Man." [15]

Lavater shared in the rationalist idea of the perfect harmony
of man—a topic on which he quoted a good many authors, classical
as well as contemporary. He had written in laying the foundation of
the *Physiognomical Science,* "In Man are combined all the powers
of Nature. He is the Abstract of Creation; he is at once the offspring
and the Sovereign of the earth; the summary and the center of all
other kinds of being, power and life which inhabit the Globe with
him." [16] Thus, one can understand that, after describing the world
as inhabited by human caricatures of every sort, he would find it
necessary to take shelter in his ideal of the human form by letting
his mind go from the contemplation of beautiful flowers to the "still
more alive and more affecting" representation of animal beauty, and
so rise by degrees to man, "of all beings the most elevated which
the sense can reach—a being capable of much higher perfection than
the flowers." Lavater's enraptured meditation on the true nature of
man ends abruptly as he finds himself forced to reckon with the
frightful aspect of three passers-by whose boisterous noise disturbs
the calm of the *parterre* where the physiognomist had abandoned
himself to his thoughts.[17]

It was Lavater's aim, however, to understand the complex
variety of men's characters and their capabilities of improvement,
rather than to bring them to a universal level of enlightenment, as
the believers in the reform of mankind through education thought

[14] Lavater, Vol. I, p. 145.
[15] Lavater, Vol. I, pp. 141–142.
[16] Lavater, Vol. I, p. 13.
[17] Lavater, Vol. I, p. 141.

it possible to do. For him there were "very few mistakes more gross and palpable" than the belief, held even by persons of good understanding, that "everything in man depends on education, culture, example—and not on original organization and formation." [18]

He saw every individual as differing from every other individual of the same species—whether it was a rose, an egg, an eel, a lion, an eagle, or a man[19]—and thought that, even though men's features and moral dispositions were transmitted from generation to generation, they always resulted in a new individuality. He admitted, however, that men's original dispositions were flexible to a certain point and could be either corrected or perverted by education within the limits of that flexibility. Vices and passions, sensuality, intemperance, indolence, debauchery, avarice, malignity, could turn men into "hideous spectres." In fact man could go far in falling from the beauty with which God had invested him. Were any number of men of the most accomplished beauty and their children to abandon themselves to dissolute manners and disorderly passions, their physiognomies would be degraded from generation to generation until nothing would be seen in their families "but faces coarse, bloated, disfigured, swollen or shrivelled out of all proportion; in short, the most hideous caricatures." [20]

For Lavater it was important to distinguish Physiognomy from Pathognomy, since the first was directed toward the interpretation of human powers and faculties discernible in the solid parts of the body and in the inaction of those which are movable, while the second aimed at the interpretation of passions as they can be traced in the motions of the movable parts. Thus the one considered "man as he is in general," and the other "what he is at the present moment." Physiognomy estimated "what he can or cannot become, what he can or cannot be"; Pathognomy, "what he wishes, or does not wish to be." Physiognomy, "the mirror of the Naturalist and the Sage," was the root and the stem of Pathognomy, "the mirror of courtiers and men of the world." Everyone knew something about the latter, but few understood Physiognomy.[21] And yet, this was "an inexhaustible source of moral and intellectual pleasure," since the real

18 Lavater, Vol. I, p. 143.
19 Lavater, Vol. I, p. 27.
20 Lavater, Vol. I, p. 147.
21 Lavater, Vol. I, pp. 23–24.

physiognomist, endowed with sagacity and a strong, lively imagination, could comprehend the "most eloquent, the least arbitrary, the most invariable and energetic of all languages, the natural language of the heart and mind"; he could read that natural language on the faces of his fellow-men. This language, "as clear, as diversified, as it is infallible," expressed the whole interior of man—and, in Lavater's opinion, was most gratifying as it discovered in the interior of men "the noblest dispositions, at least the germs of them, which will not perhaps be completely unfolded until the world to come." Possessed of that knowledge, the physiognomist could exalt the pleasures of Society, as well as become the terror of vice.[22]

There was a two-way relation between Art and Physiognomy. On the one hand, this approach was "of the most considerable" advantage to the painter, "whose art is reduced to nothing, if not founded on Physiognomy." On the other, the physiognomist himself—who ought to have talent of observation, a strong imagination, and a lively and discerning spirit—was supposed to have a "superior skill in the Fine Arts." [23] Drawing was "the natural language of Physiognomy, its first and surest expression"; as a powerful assistant to the imagination, it was "the only medium of fixing with certainty, of portraying, of rendering sensible an infinite number of signs, of expression, of shades, which it is impossible to describe in words, or in any other way except by drawing." [24] No wonder then that, much to the discomfort of today's readers, Lavater would quite often, in his discussion of a particular character, limit himself to expressing his physiognomical interpretation of the corresponding likeness reproduced in the book, without too meticulous an analysis of the features under consideration. Indeed the etching was supposed to be so telling by itself that, if in Lavater's eyes it contained any inaccuracy, he would say so in order to prevent the reader from being misled. Hence drawing was considered the "written" system of Physiognomy's "universal language"; that is to say, the surest expression of man's inner nature, of his virtues and vices.[25]

I have dwelt at some length on Lavater's ideas because, in spite of objections raised against them, they were widely held valid

[22] Lavater, Vol. I, p. 87.
[23] Lavater, Vol. I, pp. 78–79, and 126.
[24] Lavater, Vol. I, p. 122.
[25] Lavater, Vol. II, p. 97.

as an approach toward the nature of man in the second part of the eighteenth century. It is not for us to impugn the soundness of those beliefs, easy or difficult as such a task may seem in our age of psychoanalysis. What is of interest for us is to point out that in the two sketchbooks . . . Goya portrayed the human figure in ways which would seem to coincide with Lavater's idea of man, the "abstract" or "Masterpiece of Creation." Man is an object of contemplation to himself, who could be invested with unequalled beauty,[26] whose appearance could be enlivened or altered by passion or habit and even turned into a hideous caricature by his submission to vice.

There is no reason to think that Goya agreed with every one of Lavater's views; on the contrary, there is evidence that he disagreed with some of them, particularly with those on the power of education, a matter in which he was closer to Jovellanos' optimism. Nevertheless both seem to have shared in the belief that there was an interrelation between physical and moral or intellectual traits. Goya unquestionably accepted Lavater's idea that drawing was the best means to express the reality of man as discernible in that interrelation.

MAN AND ANIMALS

Ever since Aristotle, the resemblance between man and animals had been noted in physiognomic terms. In Lavater's opinion, Giovanni Battista Porta, next to Aristotle, was the one who had insisted most on the matter though, "hurried away by his imagination," he had committed frequent mistakes; in fact, "he perceived resemblances which no one after him could discover," while overlooking "those that are obvious and striking." [27]

Goya was undoubtedly familiar with the idea that there was a physiognomic analogy between men and animals. This is obvious from the sixteen animal-like human heads drawn by him on a sheet of paper during the period when he was working on the *Caprichos.* According to tradition, these heads were drawn by Goya at the *tertulia,* or salon, of the Marquis of Santa Cruz.[28] At the bottom of

[26] Lavater, Vol. I, pp. 13 ff., and 91.

[27] Lavater, Vol. II, p. 107.

[28] Félix Boix, *Exposición de Dibujos, 1750 a 1860, Catálogo general ilustrado,* Madrid, Sociedad Española de Amigos del Arte, 1922, pp. 104–105, no. 179.

the composition, there is an old inscription—though not in Goya's writing—which gives the artist's name and the date, 1798. The drawing depicts a variety of human faces, the features of which are more or less close to those of certain animals, or betray at least animal-like stupidity. Thus nearly all the foreheads are either flattened, or too straight, or too narrow—signs which would indicate idiocy to the experienced physiognomist. A number of these human heads are reminiscent of certain animal heads discussed by Lavater,[29] as a comparison of the plates illustrating his text with Goya's drawing indicates. Here a man exhibits a nose similar in outline to the bill of the cassowary, in which Lavater saw an expression of weakness blended with presumption; two other noses are shaped like the bills of birds of prey; a human profile has a rodentlike appearance, expressive of lasciviousness and stupid gluttony; the features of some monkeys, such as the capricious macaco, an animal "hideous" in spite of his "gentleness," may be recognized in another face; and the head of the sheep, well rounded on top and lacking in lively or penetrating expression, finds its counterpart in another of the human heads.

It would be possible to find other analogies between the rest of the heads and other animals, even though they may be of a less specific nature. We must bear in mind, however, that Goya did not make this drawing as a direct illustration of physiognomic theory; his fancy was quite at liberty to play with his notions about the meaning of man's animal-like features.

There are other drawings in which Goya went further in his rendering of the resemblance between men and animals by extending the likeness to man's garments and pose, instead of limiting it to the human face. In doing this, he broadened the meaning of physiognomy in a way parallel to Goethe's ideas. In a paper that Lavater incorporated with his own, Goethe had advanced the opinion that "rank, condition, estate, dress, all concur to the modification of Man," each one being like a veil enfolding him. For if it is true that man is acted upon by all external objects around him, he, in his turn, acts upon them. "Hence it is that a judgement may be formed of a man's character from his dress, his house, his furniture. Nature forms us, but we transform her work; and this very metamorphosis becomes a second nature. Placed in a vast universe, Man forms for himself a

[29] Lavater, Vol. II, pp. 96–144.

little separate world which he fortifies, limits, arranges according to his own fancy, and in which his image is easily traced." [30]

Goya, in caricaturing this second nature of man, this little man-made world, chose to broaden the likeness between the human and the animal to the whole figure; for example, one of his drawings [is] of a peacock-like man, an obvious symbol of vanity. Even more revealing are a series of pen drawings in each one of which a person facing a canvas sees his or her features, dress, and attitude reproduced in the form of an animal symbolic of a temperamental inclination. By making the animal's body mirror, as it were, the human being's garments, the likeness between the two embrace not only man's character but his social nature as well.

Two of these drawings are obviously connected with others—one in red wash and the other in red chalk—also in the Prado Museum; in these, the animal likeness is found in a mirror instead of on a canvas. Thus the fop who reflects in a mirror the misfortunes to which he subjects himself for the sake of fashion is the same as he who is confronted with his monkey-like resemblance depicted on a canvas. And the red chalk drawing of a woman seeing her own image mirrored as that of a viper coiling up a crutch portrays the same personage as that found in the pen drawing where the female portrait is rendered as that of a serpent climbing up a toothed scythe [Fig. 18].

However there are significant differences in each pair of these drawings. The red wash represents a fop surrounded by darkness in front of a mirror where the image of a crying woman, chained to the wall, is reflected. In this way, not only is the fop's figure compared to the buxom woman's, but the self-inflicted torment that he hides under his attire brings out the idea of a chamber of torture. As can be seen in a large number of his drawings, physical torture was most abhorrent to Goya's mind. Hence his portrayal of the coxcomb's slavishness embodied his vision of the violence done to the human form for the sake of fashion.

In the other drawing the idea of effeminacy and cruelty gives way to an expression of identity between the fop and the monkey. The fashionable man's attire and pose find their counterpart in the monkey's awkward appearance. Not only are the poses of both

[30] Goethe, *Samtliche Werke*, Vol. I, pp. 25–26. For Goethe's text see Vol. XXXIII, pp. 21–22.

almost identical, but the coxcomb's enormous cravat is the plastic equivalent of the monkey's bulky upper neck. Moreover the arms of the two show the same clumsy attitude, and the man's elongated shoes curve upwards in much the same way as do the animal's toes. The cane, as knotty as a rough branch, on which the beau leans seems to enter the area of the canvas, thus bringing together the mimetic creatures of both fashionable and wild life. The likeness between the two is much closer than any Lavater would admit, opposed as he was to those who took pleasure in degrading man by exaggerating his physical resemblance to the monkey. It was not by chance that he illustrated his discussion of the subject with an emblematical vignette where, while the two appeared in an almost identical pose, their dissimilarities were more obvious than their similarities. While in this vignette the difference in the man's and the monkey's sitting position is clearly rendered, Goya even put the two of them in an analogous attitude, and standing on grounds which are very much alike.

The chalk drawing of the woman before a mirror, reveals her character by means of the mirrored reflection of a serpent coiling on a crutch [Fig. 18]. Since the serpent may symbolize both Time and Original Sin and the crutch may allude to physical decay,[31] the composition may be understood as depicting the ageless, unremitting sinful nature of woman, and Time as the devastating enemy of her beauty.

The pen drawing's composition is more complex. For one thing, the serpent's head, "a being whose faculties are extremely limited" and whose characteristics in Lavater's words[32] are malice, falsehood and cunning, offers a striking likeness to the woman's elongated face where the lashless eyes protrude above a flat nose and a mouth which is nothing but an incision. Moreover the lace adorning her is drawn so as to bring out an analogy with the reptile's spots, suggestive "of the idea of deceit." Both the serpent and the scythe are loosely held in fetters which makes it clear that they stand as symbols of Time. Time was represented in some classical works with his feet in chains, and could have as attributes either the serpent or the scythe. Etchings reproducing such representations were contained in

[31] Goya so represented old age in a drawing now at the Prado Museum (no. 46).

[32] Lavater, Vol. I, pp. 127–128.

Bernard de Montfaucon's *L'Antiquité expliquée,* a book widely known through the eighteenth century.[33] There is no way of knowing whether or not Goya had a copy of it in his large library, since no title of any of his books has been preserved for us. But we know that Don Sebastián Martínez, in whose home in Cadiz the artist spent a long period in 1792, did have a copy of Montfaucon's book,[34] and one can well risk the opinion that Goya familiarized himself with it.

Tied to the fetters binding the serpent and the scythe there is also a white bird spreading its wings in a futile attempt to fly. Since Cupid too was represented chained by Hercules, as several illustrations in Montfaucon's book show, it may be that Goya represented in the dove tied to the fetters his vision of the punishment of Love. Needless to say the artist was not trying to illustrate a mythological subject. The salient feature of the drawing is the identity between the woman and the serpent which heightens the allusion to Eve pervading the composition. The serpent, freely coiling up the toothed scythe, acquires a meaning of ageless lewdness towering over the hopelessly imprisoned symbol of Love. Thus the artist attains an expression of the animal-like, lascivious nature of woman, as old as the dawn of mankind, which debases the dignity of man's mythical idea of love.

We find another representation of unchastity in the pen drawing where a young man, wearing a student's garb, confronts the image of a frog—the animal which, according to Physiognomy notions, was the representative of disgusting bestiality. The student's uplifted arms couple his gesture with that of the batrachian which is depicted squatting on swampy ground and raising its forelegs. The similarity between the two does not end here; contrary to any idea of verisimilitude, the man's sleeves and the cassock below his left arm are striped like the frog's skin. Even more, the heavy horizontal lines suggesting the muddy ground around the animal on the canvas are carried over into the lower part of the human figure, bringing

[33] Bernard de Montfaucon, *L'antiquité expliquée et represéntée en figures,* Paris, 1719, 5 vols. Several editions of this work were made within the eighteenth century.

[34] Antonio Ponz, *Viaje de España,* Ed. Casto María del Rivero, Madrid, 1947, p. 1588. The first edition of this work appeared in eighteen volumes during the years 1772–1794.

into it a miry quality which adds to the similar appearance of the two the idea of their common surroundings.

In the last of the four pen drawings a constable faces the image of a feline animal standing on its hind legs [Fig. 19]. The two are represented in an erect pose; the man's arm is as short as the beast's forelegs, and his fidgeting fingers seem to be as ready to scratch as the feline claws. The depiction of constables as cats and the like is an old one. It was frequent in Spanish literature, and Quevedo gave shape to it more than once in his *Dreams* which were very popular in the eighteenth century.

What is particularly significant in the four pen drawings just discussed is not the resemblance between a social type—a fop, an unchaste woman, a debauched student, or a constable—and any given animal, but the all-embracing likeness between the social type and its wild image. As such a likeness does not spare costume, gesture, expression or pose, each social type is totally identified with the beast depicted on the revealing canvas. Man is shown under different social garbs, as unable to rise above the beasts' appetites, that is to say, as having achieved a form of society which is governed by passions equal to the irrational impulses which characterize life in the wild.

THE THEME OF THE CAPRICHOS

It may be that among the hundreds of volumes that Goya is known to have accumulated in his own library, there were some on Physiognomy. It may also be that he became acquainted with this "science" in conversations with some of his many learned friends; for in eighteenth-century Spain, as elsewhere, cultivated people gathered in *tertulias* or salons to discuss books and topics of general interest, and as we have seen, Goya attended and was active in those gatherings.

At any rate, whether or not Goya had read Lavater, his own drawings furnish evidence that he was familiar with the physiognomic approach to the depiction of man. In studying the Madrid sketchbook, we have seen how the artist's fancy, which had given shape to human dignity in the freestanding figures of the Sanlúcar

drawings, enjoyed the observation and depiction of man's passions or leanings, and finally gave way to his expression of vices as ill-shaped squirmings in dark surroundings. These caricatures, which lessen the stature of man and make him awkward, refer to vulgar belief, wrongful opinions or practices and unreasonable social behavior. Such are also the themes prevailing in the eighty *Caprichos* etchings, all but one with aquatint, which were published on February 6, 1799. Moreover, in this series, Goya portrayed man once again as a mummer disgracing his role in much the same way as he had in the caricatures from the last part of the Madrid sketchbook.

Whatever the dates of his stay in Sanlúcar and his return to Madrid may have been, and whether the *Caprichos* were begun about 1793 as Carderera said, or executed in 1796–1797 as Goya's son stated, we know at least that in the latter year the artist had clear in his mind the central idea for this series.[35] In fact 1797 is the date on one of the drawings which was obviously intended for the head plate, though the composition, somewhat changed, was finally incorporated in the body of the series.

Goya made at least two preparatory drawings for this composition. In the one less like the final aquatint, he represents himself slumbering over a desk. The light spreading from behind him illuminates what is visible of his face. Leaning against the chair there is an etcher's plate on which is sketched a female figure wearing a helmet and holding a lance and a shield. The area above the slumbering artist is filled with grimacing human faces, some of them placed sidewise, among which the artist's own likeness appears at least twice; the darker part of the background is occupied by vagrant bats, and in the lower section there is the figure of a feline standing on all fours. Of the two animal heads in the upper right, the one seen from beneath the throat has vulpine traits and the other is lion-like. As if presiding over these raving images, there is the half-figure of a donkey which leans forward from the top, its long right

[35] Valentín Carderera, "François Goya," *Gazette des Beaux-Arts*, Paris, September 1, 1863, pp. 237–249. Pedro Beroqui, "Una biografía de Goya escrita por su hijo," *Archivo Español de Arte y Arqueología*, Madrid, 1927, pp. 99–100. Javier Goya wrote this biographical sketch of his father on March 13, 1831, and it was sent by him to Carderera. Carderera seems to have concluded from Javier Goya's text that the *Caprichos* "appeared in part in 1796–1797 in seventy-two plates"—a statement which lacks factual support.

ear extending along the composition's upper frame, and its shaggy forelegs wrapped together in a transparent mantle.

Among the human physiognomies, several express pain or terror; at least one has traits strongly indicative of cunning, and another of malignity; the grin on the one below Goya's right-side-up likeness recalls that on the portrait of Democritus reproduced from a fanciful portrait by Rubens and considered in Lavater's discussion of the perpetual laugher.[36] From a mythological point of view, the bats may represent the infernal deities of harassing dreams,[37] while to a physiognomist they would have been expressive of "an ignoble passion which shuns the light."[38] And according to superstitious belief, they played a part in the whirlabouts peculiar to the witches' malefic arts. Probably all these notions were present in Goya's creative fancy when he rendered the atmosphere which overtook the artist as he was working on his representation of Minerva, the goddess of science and art, whose figure seems to be the one sketched on the plate.

The grimacing faces obviously refer to the variety of human passions; their grouping somewhat resembles the general arrangement of the vignette in which Lavater offered for the reader's consideration a number of physiognomies, all of them brutal, vulgar, or contemptible.[39] The only two faces which are not distorted are those portraying Goya himself; the one placed sidewise has its outline confused with the others' and a distrustful expression in its sidelong, glancing eyes. The traits of the other face are so firmly delineated that it stands out against the others; its calm, penetrating expression is undisturbed by the turmoil going on under the donkey's mock gesture of blessing at the top.

In the drawing closer to the aquatint, the human physiognomies are omitted, leaving a large blank area in the background to the left [Fig. 20]; the only animal figures are now those of bats and owls, and a huge weird cat, sitting on the ground and looking toward the slumbering artist. The middle area is taken by a gigantic bat which is counterpoised to a bulky owl. This crouches on the dream-

[36] Lavater, Vol. I, p. 159.
[37] See the Spanish translation of Pierre Chompré's *Dictionnaire abregé de la fable* (*Diccionario abreviado de la fábula,* Madrid, 1783, p. 491).
[38] Lavater, Vol. II, p. 125.
[39] Lavater, Vol. I, p. 96.

er's back peering at his hidden face, while the bat hovers above
displaying its lurid breasts and belly in a show of obscenity. The
actions and attitudes of the various huge animals make all the
clearer the world of superstition they represent. The man's pose is
somewhat different from that in the other drawing and his face is
not visible at all. The side of the desk is covered by an inscription
which reads: "Universal Language. Drawn and Etched by Francisco
de Goya. Year 1797." And in the upper part of the drawing there
is the word "Dream," *Sueño*, obviously referring to a spiritual ex-
perience of the artist as the caption at the bottom explains: "The
artist dreaming. His only purpose is to banish harmful, vulgar beliefs,
and to perpetuate in this work of caprices the solid testimony of
truth."

It would seem that as early as 1797—two years before the
actual publication of the series—Goya aimed his *Caprichos* at
banishing vulgar beliefs and reaffirming the solidity of truth. One
cannot help seeing in that a rationalist attitude, whatever those who
have looked at the *Caprichos* from a romantic, realist, or surrealist
point of view may claim.

GOYA ON THE MEANING OF THE CAPRICHOS

Goya's idea about the scope of his own work—so clearly ex-
pressed in the caption of the 1797 drawing—was later developed
in the announcement of the *Caprichos* published on February 6,
1799, in *Diario de Madrid*.[40] That announcement has been more
often quoted from than attentively read; thus, it may not be amiss
to give its entire text:

A Collection of Prints of Capricious Subjects, Invented and Etched
by Don Francisco Goya. Since the artist is convinced that the cen-
sure of human errors and vices (though they may seem to be the
province of Eloquence and Poetry) may also be the object of
Painting, he has chosen as subjects adequate for his work, from

[40] Carderera, in his above cited article, mentioned Goya's manuscript for
this announcement as being in his possession. A briefer announcement
was published in *Gazeta de Madrid* on February 19, 1799; its text is
almost identical with the first paragraph of the one we are considering.
(See, Pedro Vindel, *Los Caprichos, La Tauromaquia, Los Desastres de
la Guerra y Los Proverbios de Don Francisco de Goya*, Madrid, 1928,
plate II).

the multitude of follies and blunders common in every civil society, as well as from the vulgar prejudices and lies authorized by custom, ignorance or interest, those that he has thought most suitable matter for ridicule as well as for exercising the artificer's fancy.

Since the majority of the objects represented in this work are ideal, it may not be too daring to expect that their defects will perhaps meet with forgiveness on the part of the connoisseurs as they will realize that the artist has neither followed the examples of others, nor been able to copy from nature. And if imitating Nature is as difficult as it is admirable when one succeeds in doing so, some esteem must be shown toward him who, holding aloof from her, has had to put before the eyes forms and attitudes that so far have existed only in the human mind, obscured and confused by lack of illustration, or excited by the unruliness of passions.

One would be assuming too much ignorance of the fine arts, if one were to warn the public that in none of the compositions which form this series has the artist had in mind any one individual, in order to ridicule particular defects. For truly, to say so would mean narrowing overmuch the boundaries of talent, and mistaking the methods used by the arts of imitation in producing perfect works.

Painting (like Poetry) chooses from the universal what it considers suitable to its own ends: it reunites in a single fantastic personage circumstances and characteristics that nature has divided among many. From such a combination, ingeniously arranged, results the kind of successful imitation for which a good artificer deserves the title of inventor and not that of servile copyist.

There are those who content themselves with thinking that such an announcement had little, if anything, to do with Goya's views as expressed in the plates of the *Caprichos*. In fact, they venture to suggest that the text was probably written by Ceán Bermúdez or some other of Goya's learned friends.[41] Underlying this attitude there has always been the gratuitous conviction that Goya was a man of little learning. Today, however, we know that by 1812 the artist had accumulated a personal library of several hundred volumes,[42] and that his opinions on works of art were accepted and

[41] Félix Boix, *Los dibujos de Goya*, Madrid, 1922, p. 16; F. D. Klingender, *Goya in the Democratic Tradition*, London, 1948, p. 101 [see pp. 36–70 in this volume], and F. J. Sánchez Cantón, *Los Caprichos de Goya y sus dibujos preparatorios*, Barcelona, 1949, p. 16. I first questioned the validity of such assumption in *Goya y el mundo a su alrededor*, Buenos Aires, 1947, pp. 27–28.

[42] See the inventory of Goya's household effects, F. J. Sánchez Cantón, "Cómo vivía Goya," *Archivo Español de Arte*, 1946, pp. 73–109. In

quoted by so well-known an historian as Ceán Bermúdez, and respected by art-lovers.[43] In the present case, we find that the text of the announcement corresponds exactly with the explanation given by the artist himself in the sketch for the title-plate of the *Caprichos* made two years earlier. It is immaterial—as well as unknown— whether or not any of his friends helped Goya to put his ideas into words. On the other hand it is obvious and significant that this text is an elaboration of the already quoted explanation penciled by the artist at the bottom of his 1797 sketch: "The artist dreaming. His only purpose is to banish harmful, vulgar beliefs, and to perpetuate in this work of caprices the solid testimony of truth."

The final plate was entitled by Goya *The sleep of reason pro-duces monsters,* and his own commentary on this aquatint reads, "Imagination, deserted by reason, begets impossible monsters. United with reason, she is the mother of all arts, and the source of their wonders." This explanation coincides with a passage in Addison's essay, *Pleasures of Imagination* which, approximately at the time when the *Caprichos* were published, was being translated by Don José L. Munárriz, one of Goya's friends. Addison wrote: "When the brain is hurt by an accident, or the mind disordered by dreams or sickness, the fancy is overrun with wild, dismal ideas and terrified with a thousand hideous monsters of its own framing." [44] It may be

1812, Goya's library was valued at 1500 reales which, according to Sánchez Cantón, would indicate that it consisted of several hundred volumes. Nevertheless, Sánchez Cantón remains convinced that Goya's was an uncultivated mind ("ingenio lego"). Long before the discovery of this inventory, the present writer had affirmed the rather cultivated nature of Goya's mind and his interest in books as it can be ascertained from his paintings ("The San Antonio de la Florida Frescoes" in *Gazette des Beaux-Arts,* April 1944, pp. 231–248; "Goya and the World Around Him," *Gazette des Beaux-Arts,* New York, September 1945, pp. 129–150).

[43] José López-Rey, "Goya and the World Around Him," and "Goya's Drawing of Pietro Torrigiano," *Gazette des Beaux-Arts,* March 1945, pp. 165–170. In the latter article I called attention to a significant passage in Agustín Ceán Bermúdez' *Diccionario histórico de los mas ilustres profesores de las Bellas Artes en España,* Vol. v, Madrid, 1800, pp. 66–69. In this passage which had escaped all Goya's biographers, Ceán, referring to Torrigiano's *St. Jerome,* writes that he would not have dared to express so admirative an opinion of this statue, "had he not heard it from Don Francisco de Goya."

[44] See: José López-Rey, "Goya and the World Around Him," *Gazette des Beaux-Arts,* September 1945, pp. 146–147, and *Goya y el mundo a su*

that Goya knew that text, or discussed the matter with Munárriz; in any case, we know that his final explanation of *Capricho 43* did not depart essentially from the caption he penciled on the 1797 sketch.

UNIVERSAL LANGUAGE

As we have just seen, there is unquestionable evidence that the artist's aim, as it appeared in print when the *Caprichos* were published, did not deviate from what he had written two years earlier. Thus the assumption that Goya tried to hide the *Caprichos'* actual meaning behind a fabricated explanation becomes baseless. It is true that in a preparatory drawing the working title was *Universal Language,* but it is also true that in the same sketch Goya referred to the contemplated series of etchings as a "work of caprices" and "Caprices" was the title he finally adopted.

We can be satisfied that from the beginning the aim of that work of caprices was to banish vulgar beliefs and to perpetuate the solidity of truth—an aim which is restated in the announcement of the series—to ridicule human blunders, prejudices and lies. The symbols of the universal language referred to in 1797 were described in the announcement as "forms and attitudes that so far have existed only in the human mind, obscured and confused by lack of illustration, or excited by the unruliness of passions." And if we look at the *Caprichos* plates we find that those "forms and attitudes" are rendered as caricatures in which man's debased condition is expressed by means of coarse, bloated, disfigured human appearances. We can now see just how akin Goya's "universal language" was to Lavater's. Lavater was led by his physiognomic observations to see men as diversified caricatures of their original beauty; he had the conviction that the physiognomist, who ought to have sagacity and a strong, lively imagination, could be the terror of vice by branding tyrants, misers, epicures, cheats, or any other moral wrecks; and, we should remember, drawing was to him the surest medium for expressing the infinite number of signs and shades indicative of human character.

alrededor, Buenos Aires, 1947, pp. 32–33. Addison's essay was first published in "The Spectator," July 3, 1712. Munárriz' translation appeared in the periodical *Variedades de Ciencias, Literatura y Artes,* Madrid, 1804, Vol. III. Munárriz, however, stated that he had completed the translation of Addison's essay several years earlier.

There are, nevertheless, some significant differences between the work of the physiognomist and that of the artist. Lavater's ultimate end is to reach an understanding of man's character by observing his exterior; he is convinced that by doing so one can always have the gratification of discovering at least the germs of some unfolded, latent, noble disposition in the interior of man. Goya, on the contrary, is bent on bringing before the eyes forms and attitudes expressive of man's wretchedness which no external observation could detect; thus the physiognomic traits become part of his satirical imagery of the world rather than empirical signs.

Furthermore Lavater, though believing that it may be possible by means of education to give a favorable direction both to the temperament and to the moral disposition, considered as a gross mistake the idea, current at the time, that "everything in man depends on education, culture, example—and not on original organization and formation." [45] Goya, holding the opposite view, expressed his conviction that human failings were the result of lack of enlightenment and the prevalence of passion over reason. In fact Goya's commentaries on the *Caprichos* make it clear that, running parallel to his exposure of human behavior, there is a philanthropic hope of the possibility of man's improvement through enlightenment and education. Not only is this true of the commentaries, it is equally to be discovered in the aquatints themselves, all of which are set in the dreamlike atmosphere that enables Goya to unloose the forms and attitudes of man's vices and absurd beliefs. The real significance of Goya's fantastic world could not be grasped were we to forget that it is the product of the "sleep of reason," in the artist's own words, and that it is brought before the eyes in order to banish harmful beliefs and to perpetuate the solid testimony of truth.

Such ideas were not alien to those held by certain contemporary psychologists who considered dreams to be a result of the sleeping of the human will or reason, coupled with an intense imaginative activity, as Ludwig-Heinrich von Jakob thought in 1791. Toward the end of the eighteenth century another psychologist, Karl-Philip Moritz, insisted on the need for studying the world of dreams in order to give a firmer support to truth by establishing the difference between it and the dream. [46]

[45] Lavater, Vol. i, p. 145.
[46] Cf. Albert Béguin, *L'Âme romantique et le rêve*, Paris, 1939, pp. 7–8, and 24.

It is Goya's emphasis on the dreamlike nature of the world depicted in the *Caprichos* which provides a background of rationalist optimism for his devastating satire. As a matter of fact, the artist does not find a fitting expression of the genuine nature of man in these forms and attitudes which he digs up from the obscured or excited human mind; on the contrary, such forms and attitudes are meant to expose man's departure from reason, the core of his very self.

For a number of years forceful minds—artistic as well as scientific—have tried to find in the world of dream a valid expression of the reality of the individual. But that was not the case with Goya or with his time. What he saw in that obscured world was a multitude of "human errors and vices, follies and blunders common in every society." For him, dreams were not the innermost autobiographical expression of man, but the symbolic stage where human follies could fittingly be enacted and brought before the wakeful eyes of reason. The vagary of dream, the overwhelming power of superstition, man's obedience to passions or obscure impulses—widely spread though they may have been—were considered by the best minds in Goya's time to be negations of man's rational dignity. They result from a "lack of illustration"—an expression used by Goya in the announcement of the *Caprichos* and frequently employed in the period of the Enlightenment.

GOYA'S OWN EXPLANATION

The rationalist attitude, clearly visible in the *Caprichos* aquatints, was made explicit by Goya not only in the announcement of the series which we have just discussed, but also in the commentaries in his own handwriting preserved at the Prado Museum. Beruete, in publishing this text, rightly pointed out that these explanations are but amplifications of the titles given the aquatints.[47] However, he often failed to grasp the meaning of both the aquatint and the artist's comment on it. In fact, Beruete dismissed as unpleasant, inconsequential or even meaningless any composition which did not lend itself to his impressionist idea of the picturesque.

Goya's text is, nevertheless, most valuable, since the artist seems

[47] Aureliano de Beruete y Moret, *Goya, grabador*, Madrid, 1918, pp. 36–37. Goya's manuscript, now in the Prado Museum, belonged to Carderera.

to have tried in it to make the meaning of the aquatints unmistak-able. The idea that he wrote in order to hide the actual meaning of the plates is one of those trivialities which even scholars are unfor-tunately willing to accept. Nobody seems to have realized that a number of those explanations concur rather closely with the legend in the preparatory drawings for the plates in question, as can be seen by comparing the captions in the drawings with Goya's commen-taries.[48] This should also dispose of the suggestion that the com-mentaries were written by one of Goya's friends and then copied by the artist in his own handwriting.[49]

To be sure, there are a number of instances in which the com-mentary embodies a different shade of the idea expressed in the earlier legend, or even departs from it. But in such cases, as we shall see, the change in meaning corresponds to those undergone by the composition itself in passing from the sketch to the aquatint—of which *Capricho 14* is one of the subtlest and most conclusive exam-ples. Furthermore such changes are not limited to the commentaries, we find them also in the plate titles which often differ from those in the preparatory drawings or even in the proof of state. There are some instances where the difference is only one of shade of meaning, and others in which it is substantial; in the latter cases, however, the verbal modifications are always in harmony with the final composi-tion.

Goya's desire of putting in writing the intended meaning of the *Caprichos* must be linked to the opening statement in his an-nouncement of the series, that by aiming his art at the censure of human errors and vices he was entering a realm usually held to be the province of eloquence and poetry. We do not know when Goya wrote these explanations, or what use he intended to make of them. Nevertheless their unquestionable adherence to the compositions to which they refer would seem to indicate that he was expressing *ex-abundantia* what he had conveyed in the plates. In other words, he was probing the accuracy of his satirical fancy and the legibility of his plastic language. As a rationalist, he did not hesitate to make easier for others the task of understanding his work. Indeed the last thing Goya may have wished was to create obscurity about the

[48] This is particularly true of the *Caprichos 16, 18, 54, 60,* and *65.*
[49] Such suggestion has been made by Sánchez Cantón, *Los Caprichos de Goya y sus dibujos preparatorios,* p. 19.

Caprichos—a fate which nevertheless has overtaken this work for more than a century.

In trying to ascertain the meaning of the *Caprichos,* we have several texts in the artist's own hand: the titles or legends on a number of the preparatory drawings, the titles of the plates and those on some proofs of state, the announcement of the series, and the artist's holograph explanations of each of the plates from number 2 on.

In a considerable number of instances such texts provide us with excellent tools to apprehend the workings of Goya's fancy from his first seizing upon a subject until the moment when it has been given its final shape. They also provide us with the artist's exhaustive reflections upon his own work. The *Caprichos* aquatints are the real object of our study, and Goya's texts will be used only as documentary evidence bearing upon them. In doing so, we will merely conform to the artist's views, and to the exigencies of art criticism. It is needless to apologize, however, if here and there our task is made easier by Goya's leaning toward enlightening explanation.

PORTRAITS OF THE FOUR TEMPERAMENTS

Folke Nordstroem

In the Museo del Prado in Madrid there is a series of four pen draw-
ings, executed by Goya, which by their subject and composition show
a close mutual relationship.[1] They are generally believed to have
been done at about the same time as the sketches for *Los Caprichos,*
that is to say during the second half of the 1790's, probably in 1797
or 1798. Each of the four drawings depicts a man or a woman stand-
ing in front of a large upright canvas upon which a painting, in the
form of an animal, repoduces something of the human being, his
pose and gestures. That the paintings really are intended to expose
men and women and their second natures is clear also from two
other sketches by Goya in the same museum, one in wash and the
other in red chalk, whose striking resemblance to two of the pen
drawings indicates that they are merely variants of the same sub-
ject.[2] In the wash and chalk drawings the figure, instead of facing a
canvas, stands before a mirror which reflects not his realistic image
but quite evidently his *alter ego,* his true character, in symbolic

[1] J. López-Rey, *Goya's Caprichos,* II, figs. 68, 70, 72, and 75. An earlier
study of these drawings has been published by the same author in the
essay "Goya and the World Around Him," *Gazette des Beaux-Arts* vol.
87:2, 1945, pp. 130 ff. They are also reproduced in their original size
and colour in Museo del Prado, *Los dibujos de Goya,* II, pls. 268–271.

[2] J. López-Rey, *Goya's Caprichos,* II, figs. 67 and 69. Museo del Prado,
Los dibujos de Goya, I, pls. E and 56d.

form. In all these six drawings the persons represented do not in any single case fix their attention upon their own images but look just a little to the side. The mirror and the portrait respectively do not unmask character for *them,* Goya seems to say, but for an outside observer. Man is blind to his own errors, he cannot grasp his true nature. For him the image in the mirror or on the canvas does not reveal anything whatever.

1. THE SANGUINE TEMPERAMENT

In his fascinating work on Goya's *Caprichos* José López-Rey thoroughly discusses these six drawings, too.[3] The wash in his opinion, depicts a young fop standing against a dark background in front of a mirror which reflects the image of a screaming woman chained to a wall. "In this way, not only is the fop's figure compared with the buxom woman's, but the self-inflicted torment that he hides under his attire brings out the idea of a chamber of torture."

But our main interest here is especially the series of pen drawings. The first of these shows a young coxcomb rendered in the painting before him in the form of an ape.[4] López-Rey comments on this drawing, after describing the wash with the analogous motif, as follows:

"In the other drawing the idea of effeminacy and cruelty gives way to an expression of identity between the fop and the monkey. . . . The fashionable man's attire and pose find their counterpart in the monkey's awkward appearance. Not only are the poses of both almost identical, but the coxcomb's enormous cravat is the plastic equivalent of the monkey's bulky upper neck. Moreover the arms of the two show the same clumsy attitude, and the man's elongated shoes curve upwards in much the same way as do the animal's toes. The cane, as knotty as a rough branch, on which the beau leans seems to enter the area of the canvas, thus bringing together the mimetic creatures of both fashionable and wild life."

[3] J. López-Rey, *Goya's Caprichos,* I, pp. 67–72. [See pp. 114–37 in this volume.]

[4] Sánchez Cantón (Museo del Prado, *Los dibujos de Goya,* II, no. 270) names the drawing *El espejo indiscreto: El hombre oso,* i.e. "The indiscreet mirror: the bear man," the latter a term which I find difficult to understand. A bear was painted by Goya ten years later in the Madrid coat-of-arms in an allegory for the law courts of that city. For illustration, see F. J. Sánchez Cantón, *Vida y obras de Goya,* pl. LXI.

Thus far López-Rey. But just as the similarity in composition and subject connects the four pen drawings, so also does their quality as allegorical representations with a common programme. While the wash drawing may seem to express in more general terms the dandy's subservience to outward conventions and perhaps to his own vanity as well in conforming to fashion, the other drawings have a more special significance. The pen drawing now under consideration depicts, according to López-Rey, a young fop whose portrait on canvas exhibits the features of an ape. But let us continue with our analysis of the drawing. A young fop with an ape as symbolic animal is a frequent representation of one of the four temperaments, the sanguine. We find the sanguine person rendered in that very manner in several series or other fairly large compositions, whose subject is the four temperaments, dating from the end of the fifteenth century and the beginning of the next. There is, for instance, an illustration of *The Visceral Planet Man* and the four temperaments in Denis Moslier's *Hours,* printed in Paris in 1489–90; an illustration of the four temperaments alone in *Calendrier des Bergers,* also printed in Paris and only three or four years later, in 1493; and yet another in a manuscript book of hours of the late fifteenth century now in the Fitzwilliam Museum in Cambridge but of French provenance.[5] But the ape symbolism was not unknown either in old Spanish art. Thus El Greco used an ape in a painting, usually named *Una fábula,*[6] when illustrating the passion of the sexes, and Velázquez, too, put an ape in his picture of the sanguine temperament in his painting *Los músicos.*[7] The different temperaments corresponded, as we know, with definite seasons of the year, elements, directions of space, and so on. The sanguine temperament was thus associated with the spring, the air, and the east. It is therefore interesting to note that when two French artists, Charles Lebrun and Jacques Bailly, composed in 1668 a series of allegorical representations of the four elements, among other things, for a beautifully embellished manuscript

[5] H. W. Janson, *Apes and Ape Lore in the Middle Ages and the Renaissance,* pp. 248–253, figs. 17, 18, and pl. XLV*b*.

[6] This picture is known in several variations. See e.g. M. Legendre and A. Hartmann, *Domenico Theotocopuli genannt El Greco,* Paris, 1937, pp. 471–475.

[7] *Velázquez y lo Velazqueño.* Catalogo de la exposicion homenaje a Diego de Silva Velázquez en el III centenario de su muerte 1660–1960, Madrid 1960, no. 36, p. 50, and pl. XXVI.

with the title *Devises pour les tapisseries du Roy où sont representez les quatre Elémens et les quatre Saisons de l'année,* they also made the ape a prominent feature of the scene symbolizing the air—the element traditionally associated with the sanguine temperament.[8] Lebrun's and Bailly's illustrations were soon after engraved by Sébastian Leclerc and Pierre Lepautre and were published in 1670 in a work with descriptive text entitled *Tapisseries Du Roi ou sont représentez Les Quatre Elemens et Les Quatre Saisons,* a book quoted already in connection with Goya's cartoons, and it is by no means unlikely that the artist came in contact with this book when painting cartoons for the Royal Tapestry Factory in Madrid.

The young coxcomb depicted in Goya's pen drawing thus betrays in his features, pose, and even character his connection with and absolute subservience to the sanguine temperament. But, of course, there is also a touch of satire when Goya represents the ape in the image of the sanguine man. If we now revert to the wash drawing with the similar motif we shall discover why the young fop is this time mirrored as a woman. The sanguine temperament was considered to be typically feminine. And so Goya, conforming to tradition, wishes to tell us here that the sanguine person is frequently a dandy who submits to the tortures of fashion and also has something feminine in his character.

2. THE MELANCHOLIC TEMPERAMENT

The next pen drawing is perhaps the most interesting of the four in the series from an iconographical point of view. It shows us a woman in front of a painting that displays a serpent coiling round a scythe with an almost saw-toothed blade. At the bottom of the picture both serpent and scythe are held in fetters, which are linked by a chain to an invisible wall behind—just like the tortured person in the wash drawing already discussed. And to the right of the serpent and the scythe there is a winged hourglass. The preliminary red chalk drawing [Fig. 18] so closely connected with this pen drawing presents the same woman before a large, steeply inclined mirror, in

[8] Jean Cordey, "Un manuscrit à miniatures du XVIIᵉ siècle: 'Devises pour les tapisseries du Roy'," *Les Trèsors des bibliothèques de France,* Paris, I, 1926, pp. 105–111, and the illustration with the device "Semper sublimis."

which is reflected as her image a serpent wound round a crutch. This motif has previously been interpreted on moralizing lines. Ramón Gomez de la Serna, for instance, describes the first of these variants as "la mujer vibora," the wicked, viperish woman.[9] Sánchez Cantón for his part applies this term to the red chalk drawing instead, and defines the pen drawing as "la mujer serpiente mortifera," which means "the fatal serpent woman."[10] López-Rey has the following to say about these two drawings:

> "The chalk drawing of the woman before a mirror, reveals her character by means of the mirrored reflection of a serpent coiling on a crutch [Fig. 18]. Since the serpent may symbolize both Time and Original Sin and the crutch may allude to physical decay, the composition may be understood as depicting the ageless, unremitting sinful nature of woman, and Time as the devastating enemy of her beauty.
>
> The pen drawing's composition is more complex. For one thing, the serpent's head, "a being whose faculties are extremely limited" and whose characteristics in Lavater's words are malice, falsehood and cunning, offers a striking likeness to the woman's elongated face where the lashless eyes protrude above a flat nose and a mouth which is nothing but an incision. Moreover the lace adorning her is drawn so as to bring out an analogy with the reptile's spots, suggestive "of the idea of deceit." Both the serpent and the scythe are loosely held in fetters which makes it clear that they stand as symbols of Time. Time was represented in some classical works with his feet in chains, and could have as attributes either the serpent or the scythe."[11]

Examples of this last were found by López-Rey in Bernard de Montfaucon's famous work, *L'Antiquité expliquée* of 1719.[12] At the same time he convinces us that Goya really knew of this work, said to have been in the library of his friend Don Sebastián Martínez[13]

[9] Ramón Gomez de la Serna, *Goya,* Madrid (about 1945), pl. XLVIII. This interpretation is probably based on the Spanish expression "la mujer serpiente" or "la dama serpiente" meaning "the bad woman." Concerning this symbolism see further below p. 150.
[10] Museo del Prado, *Los dibujos de Goya,* II, no. 268, and I, no. E.
[11] J. López-Rey, *Goya's Caprichos,* I, pp. 69 f. [See pp. 114 ff. in this volume.]
[12] Bernard de Montfaucon, *L'Antiquitée expliquée et représentée en figures,* Paris, 1719, 5 vols., and J. López-Rey, *op. cit.,* I, p. 70.
[13] See Antonio Ponz, *Viaje de España* (18 vols. 1772–94), ed. Casto María del Rivero, Madrid, 1947, p. 1588.

at Cadiz, where he paid a lengthy visit during his illness in 1792. From Montfaucon we also learn that Kronos is almost identical with Saturn. And Saturn is represented in one of the illustrations in *L'Antiquité expliquée* as a half-naked man with the following two symbols: a scythe or sickle with a saw-toothed blade lying on the ground and a serpent coiling round a high stump.[14] The irons at the bottom of Goya's composition fettering the scythe and the snake, which López-Rey associated with Time, may just as well allude to Saturn himself. On one of the plates in a supplementary volume to Montfaucon's great work Saturn, or Time, is depicted as an old man with a scythe in his hand and both feet tied with a rope.[15] It should be noted further that in the chalk drawing the crutch, which has there replaced the scythe of the pen drawing, is, like the scythe, a typical attribute of Saturn.[16]

The scythe and the serpent, in addition to the fetters, can thus represent Saturn just as well as Kronos. But the planet Saturn controls the melancholic temperament. This is clear, for instance, from the caption accompanying "melancholy" in a representation of the four temperaments in a German woodcut from the third quarter of the fifteenth century: "Saturnus und herbst habent die schulde." [17] Erwin Panofsky also says in his fascinating investigation of the *Melancholia* motif: "Once established, this "consonance' between melancholy and Saturn was never questioned." [18] That this must also have applied to Spain is evident among other things from the fact that the Spanish adjective *saturnino* means both "Saturnian" (i.e. under the influence of Saturn) and melancholic. The connection between Saturn and melancholy would therefore have been obvious to

[14] Bernard de Montfaucon, *op. cit.*, I: 1, pp. 19 f. and pl. VI: 1.

[15] Bernard de Montfaucon, *Supplément en livre de l'Antiquité expliquée et représentée en figures*, Paris, 1724, I, pl. II: 1.

[16] See e.g. Fritz Saxl and Hans Meier, *Verzeichnis astrologischer und mythologischer illustrierter Handschriften des lateinischen Mittelalters*, III: *Handschriften in englischen Bibliotheken*, 2, London, 1953, pl. LXXXIX, fig. 231, and A. Hauber, *Planetenkinderbilder und Sternbilder* (*Studien zur deutschen Kunstgeschichte*, 194), Strasbourg, 1916, pls. XIV, fig. 18, and XV, fig. 20.

[17] Erwin Panofsky, *Albrecht Dürer*, 2nd ed., London, 1945, II, fig. 214. See also the investigation of the *Melencolia* motif in Erwin Panofsky and Fritz Saxl, *Dürers "Melencolia I." Eine Quellen- und Typengeschichtliche Untersuchungen* (*Studien der Bibliothek Warburg*, II), Leipzig, Berlin, 1923.

[18] E. Panofsky, *Albrecht Dürer*, I, p. 166.

Goya from the language itself. And in the 1788 edition (by the art historian Don Antonio Ponz) of Don Felipe de Guevara's *Comentarios de la pintura*,[19] which it is reasonable to suppose that Goya may have read, there are expressions such as "las pinturas de un melancólico saturnino," that is, "paintings of a Saturnian melancholiac." Thus there was more than one source from which Goya could have learned about melancholy and its relation to the planetary god Saturn.

Besides, it fits admirably with the interpretation of Saturn as a symbol of melancholy in Goya's two drawings that it is a woman and not a man whose temperament is revealed in the mirror and on the canvas. For the melancholic temperament, like the sanguine also for that matter, was considered typical of the female sex just as the other two temperaments, especially the choleric, were typical of the male sex.[20] Moreover, the melancholic temperament was the only one of the four which had a female personification, *Melancholia*. And also worth mentioning in this connection is Albrecht Dürer's famous engraving *Melencolia I* with its female personification of the temperament.[21] There one can also find among the symbols the hour-glass, as in Goya's pen drawing of the melancholic temperament.

3. THE PHLEGMATIC TEMPERAMENT

The third pen drawing depicts a young man in student's garb standing in front of a painting that portrays him as a frog, "the animal which, according to Physiognomy notions was the representative of disgusting bestiality." López-Rey calls this "another representation of unchastity" and adds:

[19] Felipe de Guevara, *Comentarios de la pintura*, ed. Antonio Ponz, Madrid, 1788, p. 12. This book had already been written in the 16th century during the reign of the Emperor Charles V, to whom it was dedicated, but it was published in 1788 for the first time.

[20] H. W. Janson, *Apes and Ape Lore*, p. 252. The serpentine aspect of the woman or perhaps more correctly of her dress is repeated in a very similar way in *Capricho* 16 and particularly in a sketch for this etching. See J. López-Rey, *Goya's Caprichos*, II, figs. 116 and 117.

[21] E. Panofsky, *Albrecht Dürer*, I, pp. 70 f. and II, fig. 74.

"The student's uplifted arms couple his gesture with that of the batrachian which is depicted squatting on swampy ground and raising its forelegs. The similarity between the two does not end here; contrary to any idea of verisimilitude, the man's sleeves and the cassock below his left arm are striped like the frog's skin. Even more, the heavy horizontal lines suggesting the muddy ground around the animal on the canvas are carried over into the lower part of the human figure, bringing into it a miry quality which adds to the similar appearance of the two the idea of their common surroundings." [22]

Sánchez Cantón merely calls the motif "El hombre rana," the frog man. [23]

The frog, however, suits most excellently as a symbol of the phlegmatic temperament, which was held to be wet and cold like water. Among the four elements it was, in fact, water with which it was believed to correspond. [24] And water as an element is found combined with those very batrachians, for instance, in Charles Lebrun's and Jacques Bailly's above-mentioned illustrations of 1668. [25] Otherwise the phlegmatic person was considered difficult to describe, since "as was already observed by Galen, his humor does not make for 'characteristic' qualities." [26] Besides the frog, a fish or a pig often occurs as the symbolic animal for this temperament because of its association with water and mud. The combination of a frog with a student may perhaps have arisen from the Spanish expression *no ser rana,* "not to be a frog," that is "to be learned in a subject." The young student is still a "frog." Already in one of his very first tapestry cartoons Goya had combined stu-

[22] *Goya's Caprichos,* I, p. 71. [See pp. 114 ff. in this volume.] Later on Goya remodelled this motif in quite a different direction, as can be seen from two other drawings in the Museo del Prado. See Museo del Prado, *Los dibujos de Goya,* I, pl. 209, and II, pl. 272. Cf. also André Malraux, *Saturne: Essai sur Goya,* Paris, 1950, pp. 74 f.

[23] Museo del Prado, *Los dibujos de Goya,* II, no. 271.

[24] E. Panofsky, *Albrecht Dürer,* I, p. 157, and H. W. Janson, *Apes and Ape Lore,* p. 250.

[25] Jean Cordey, "Devises pour les tapisseries du Roy," p. 109, and the illustration with the device "Facit omnia laeta." Published for the first time in 1670 in *Tapisseries Du Roi ou sont representez Les Quatre Elemens et Les Quatre Saisons,* p. 31.

[26] E. Panofsky, *Albrecht Dürer, I,* p. 159.

dents and winter, the season usually associated with the phlegmatic temperament.[27]

Goya's interest in physiognomy is particularly apparent in this sheet. It is also amply confirmed by a study made in 1798 of sixteen animal-like human faces.[28] The frog-like man, as López-Rey points out,[29] occurs in the work of the famous Swiss physiognomist Johann Kaspar Lavater, *Physiognomische Fragmente zur Beförderung der Menschenkenninis und Menschenliebe,* published in four volumes between 1775 and 1778. López-Rey also emphasizes the possibility of Goya's having studied this work in some French edition.

4. THE CHOLERIC TEMPERAMENT

On the last sheet in this series of pen drawings Goya depicts a constable complete with wig, cloak, and sword on hip [Fig. 19]. He stands, like the other figures, in front of a painting which this time represents some kind of feline animal rearing and ready to spring: "The two are represented in an erect pose; the man's arm is as short as the beast's forelegs, and his fidgeting fingers seem to be as ready to scratch as the feline claws. The depiction of constables as cats and the like is an old one. It was frequent in Spanish litera- ture, and Quevedo gave shape to it more than once in his *Dreams* which were very popular in the eighteenth century." [30] Sánchez Cantón says that this drawing depicts "El hombre gato. Alguacil, archer ou sergeant," i.e. the cat man, a constable or sergeant.[31]

A warrior clad in armour and bearing a sword or a man with- out armour but always equipped with a sword is a symbol often employed for the choleric temperament. Such a figure is found in all the representations of the four temperaments cited earlier in this chapter.[32] In two of them the man with the sword is accompanied by

[27] See G. Cruzada Villaamil, *Los tapices de Goya,* p. 136, no. 30.

[28] J. López-Rey, *Goya's Caprichos,* I, pp. 66 f. [see p. 114 ff. in this vol- ume], and II, fig. 61.

[29] *Ibidem,* I, pp. 59–66, and 71. [See pp. 114 ff. in this volume.]

[30] *Ibidem,* I, pp. 71 f. [See pp. 114 ff. in this volume.]

[31] Museo del Prado, *Los dibujos de Goya,* II, no. 269.

[32] See above p. 138, and H. W. Janson, *Apes and Ape Lore,* figs. 17, 18 and pl. XLV *b.*

another, frequent symbol of the choleric temperament, a lion. The sword and the lion in this context are also encountered in Cesare Ripa, for example.[33] A similar meaning is already attached to the leopard in Albertus Magnus' *De animalibus,* written about 1256, where it is said to be "autem animal fortis irae." [34] In Goya the animal seems more like a very big cat. The substitution of the cat for the lion here is certainly due to the fact that constables, as López-Rey says, were often depicted as cats in Spain. But in this drawing, no less than in the others, there can be no doubt about the actual significance.[35]

López-Rey concludes his analysis of the drawings here reinterpreted by remarking that their essential feature is not the physical resemblance between a social type—a fop, an unchaste woman, a debauched student, or a constable—and any given animal, but the all-embracing likeness between the social type and its wild image: "Man is shown under different social garbs, as unable to rise above the beast's appetites, that is to say, as having achieved a form of society which is governed by passions equal to the irrational impulses which characterize life in the wild." [36]

These new interpretations of the four sheets given above necessarily involve some changes in the final analysis. In the pen drawings Goya depicts four different people, typical embodiments of each of the temperaments. The images on canvas may be described as portraits of the persons facing them, portraits showing us their temperament and character as revealed in face, pose, gestures, dress. But Goya goes still further. He also connects the different temperaments with different social and physical types, for he represents the sanguine person as a young fop, the melancholic as a woman, the phlegmatic as a student, and the choleric as a constable.

[33] Cesare Ripa, *Della più che novissima Iconologia,* I, p. 121.

[34] Albertus Magnus, *De animalibus libri XXVI, nach der cölner Urschrift* (*Beiträge zur Geschichte der Philosophie des Mittelalters,* XVI), ed. Hermann Stadler, Münster in W., 1920, p. 1407.

[35] In Ripa (*Iconologia,* III, pp. 122 f.) a man with a lion-like face stands for "Terror," which I think may have inspired Goya at this time to produce some other compositions with lion-faced constables (*Capricho* 21 and 24). See J. López-Rey, *Goya's Caprichos,* II, figs. 128, 129, and 134.

[36] J. López-Rey, *Goya's Caprichos,* I, p. 72. [See pp. 114 ff. in this volume.]

This association of a particular sex, age, profession, or social status with an individual temperament is already found in the fifteenth century, and thus it is not an innovation on Goya's part. But his brilliant success lay in suggesting so vividly and directly the link between various human types and their animal symbols that we do not immediately think of the drawings as inspired by, for instance, prototypes and emblematic manuscripts many centuries old but as independent creations of Goya alone. Similarly, the animals are also represented not only and primarily as symbols but as real living beings, almost on the point of coming down from the canvas to meet their human counterparts.

In this connection we should recall that some twenty years earlier—in 1778—the four temperaments, or more correctly their personifications, were actually depicted studying a painting. The picture was first published in the original German edition of Johann Kaspar Lavater's *Physiognomische Fragmente*, Part IV.[37] And López-Rey, as we have already said, refers to Lavater precisely in connection with one of the pen drawings under discussion, pointing out that Goya was probably acquainted with his work in a French edition.[38] What interested Lavater was the four persons' extremely different and characteristic reactions to the very same painting, Chodowiecki's *Farewell of Calas*. Goya's concern was to show that a portrait must also reveal temperament. Despite the difference in presentation and purpose I cannot help feeling that Lavater's illustration may possibly have inspired Goya to combine a painting with each of the representatives of the four temperaments.

It is also interesting to note the remarkable correspondence between Goya's four pen drawings and two other sketches with similar motifs, on the one hand, and contemporary developments in

[37] Johann Kaspar Lavater, *Physiognomische Fragmente*, Leipzig, 1778, IV, the title-page. On the presence of this illustration in other early editions see George Levitine, "The Influence of Lavater and Girodet's *Expression des sentiments de l'âme*," *Art Bulletin*, XXXVI, 1954, p. 43, and n. 91.

[38] J. López-Rey, *Goya's Caprichos*, I, p. 59, n. 7, and pp. 65 ff. [See p. 116, n. 7, and p. 117 in this volume.] The first French edition of Lavater's work under the title of *Essai sur la Physiognomie destiné à faire Connoître l'Homme et à la faire Aimer*, consisting of the first two volumes, was published in 1781 and 1783; the second volume included the illustration cited in the text. Goya learned French in 1787 at the latest.

Paris, on the other. The drawings have been dated to the same period as the sketches for *Los Caprichos*, that is to 1797–98, or perhaps slightly later.[39] And in the first of these years there was an exhibition in the *Musée central des arts* which included the *Suite de dessins représentant le rapport de la physionomie humaine avec celle de divers animaux* by Charles Lebrun (1619–1690).[40] These eight sheets, which had been selected from a larger collection of similar drawings, had of course been done long before Johann Kaspar Lavater's *Physiognomische Fragmente*, and some of them had even been engraved by L. P. Baltard and L. C. Legrand.[41] Many of these drawings were, however, utilized by Lavater and reproduced in his work, and the fact that they were exhibited just at that time was certainly due to the enormous interest aroused by Lavater's ideas in the French capital, as so skilfully shown by George Levitine.[42] We observe with interest that Le Mercier came even closer to Goya's conception when describing in a very critical article on Lebrun's drawings the reaction of the public on this occasion: ". . . Après cet examen, tel file furtivement vers les grands miroirs du fond de la galerie, pour vérifier dans la glace sa figure et sçavoir si elle tient du coq d'Inde, ou de l'aigle, du dromadaire ou du lion, du singe ou du cochon.[43] This coincidence is worthy of mention particularly because it can hardly be explained by anything but a direct or indirect contact between Goya and the events in Paris. Sánchez Cantón assumes a similar incident in the case of Goya's painting *El Naufragio (The Shipwreck)*, executed some twenty years later. He believes that Goya was probably inspired to paint his shipwreck by a literary description of Géricault's *The Raft of the Méduse*, which is known to have been exhibited at the Salon

[39] J. López-Rey, *Goya's Caprichos* I, pp. 66 ff. [See pp. 114 ff. in this volume.]

[40] *Notice des dessins originaux, cartons, goaches, pastels, émaux et miniatures du musée central des arts*, Paris, An V (1797), part I.

[41] Archives des Musées nationaux et de l'École du Louvre, *Inventaire général des Dessins du Louvre et du Musée de Versailles*, École française, ed. by Jean Guiffrey and Pierre Marcel, VIII, Paris, 1913, pp. 76–79, nos. 6623–6762, with many figures.

[42] G. Levitine, "The Influence of Lavater," p. 38.

[43] "Observation de Le Mercier sur cette exposition de dessins," *Collection Deloynes*, XIX, no. 505, MS. p. 131.

in 1819.[44] But the artist probably also had other sources of inspiration in this case.[45]

It is difficult to know from what person or persons Goya could have received this and other similar information concerning contemporary events in the art circles of Paris at the end of the century. Many of Goya's learned friends in Madrid had close relations with the French liberal pioneers. One source may also possibly be Don Andrés del Peral, who is said to be "the Financial representative in Paris of the Spanish Government at the close of the 18th century"[46] and who was painted by Goya probably in 1798. As Edith Helman has pointed out, an art critic reporting that year on a current exhibition says that this portrait would be enough to give a reputation "to an Academy, to a whole nation, to the present age, so perfect is the drawing and choice of color, the naturalness with which the subject is portrayed, the use of light and shade, in a word, so great a skill with which this Professor executes his works."[47] This portrait by Goya obviously shows a great emotional involvement. And Don Andrés del Peral for his part had, according to Valentín Carderera, a great collection of works by the artist, among other things four "scenes populaires," which were "des plus parfaites et des plus finies."[48]

What is most probable, in my opinion, is that the two separate sketches by Goya, the wash drawing and the red chalk drawing, are the preparatory drafts, which consequently precede the complete series of pen drawings of the four temperaments. These, the two earliest versions, are also closest in subject to Le Mercier's description, for both are concerned with a person who looks in a mirror "pour vérifier dans la glace sa figure et sçavoir si elle tient . . . du singe," etc.

We may now assume the following line of development in Goya's creation of these motifs. He read Le Mercier's or some other

[44] F. J. Sánchez Cantón, *Vida y obras de Goya*, p. 115.

[45] This motif was not unknown at this date in romantic circles in Spain. Thus Juan Meléndez Valdés wrote a romance *El Naufrago*, published in his *Poesias* II, Madrid, 1820.

[46] Neil Maclaren, *The Spanish School*, p. 11. The portrait is now in the National Gallery, London (no. 1951).

[47] Edith Helman, "Why did Goya paint 'The Injured Mason'?", p. 3.

[48] Valentín Carderera, "François Goya. Sa vie, ses dessins et ses eaux-fortes," *Gazette des Beaux-Arts*, vol. 7, 1860 (pp. 215–221), pp. 217 f.

very similar critique of the Lebrun exhibition of 1797,[49] or heard
about it through some friend, and his interest in it was all the
greater because he already knew about Lavater's physiognomical
study and also about some of Lebrun's physiognomical drawings,
published in the same study. Inspiration for his own compositions
now came to him from both sources. He first adopted the mirror
as the revealing medium and made his two preliminary sketches, of
which the one with the ape in particular closely resembles the de-
scription of Le Mercier. In the meantime he himself thought of
utilizing Lebrun's and Lavater's idea of the similarity between the
human face and certain animal faces and combining it with the
ancient theory of the four temperaments and their traditional ani-
mal symbols. Goya was well versed in lore of this kind, as is shown
in many of his earlier works. And when changing the subject he
also introduced the artist's canvas to replace the mirror. In this way
the four final pen drawings became not only a representation of the
temperaments but also a programme for the portrait artist: the
portrait should not only project a physical likeness, it should reveal
the temperament as well, that is to say the spiritual and moral qual-
ities of the sitter.[50] The result of such a portrait painting could not
very well be an idealization but an unveiling of human and moral
infirmity, aptly shown, for instance, in his remarkable portraits of
the Royal Family.

[49] Moreover, a small booklet with explanations of Lebrun's various motifs
was on sale at the exhibition. Concerning this see *Notice des dessins
originaux*, etc., mentioned above.

[50] At this time Goya once more gave his view of the portrait painter. That
is in *Capricho* 41, where an ape is painting a portrait of an ass. See
J. López-Rey, *Goya's Caprichos*, I, p. 130 and II, figs. 168 and 169.

IMAGERY AND ART IN THE ROMANTIC PERIOD

Ernst H. Gombrich

Most print rooms of Europe have in their care vast accumulations of prints brought together for the sake of their subject matter rather than for any artistic merits. These collections of historical and topographical illustrations, of fashion plates, theatrical subjects, and portraits are now rarely consulted except by antiquarians or writers of popular books in search of suitable illustrations. The British Museum's collection of political and personal satires has, on the whole, shared this fate. These prints are rarely considered as art. They are more frequently looked upon as part of the imagery of the past that is the domain of the historian of manners rather than of the historian of stylistic trends. This estimate is hardly surprising, for side by side with the best works of Gillray, Rowlandson, or Cruikshank, these folders contain a good many prints whose æsthetic value is scarcely higher than that of the humorous seaside postcards and comic strips of our own day. Nevertheless, the neglect of this imagery by the art historian cannot be reasonably defended. As a class of images, caricatures are neither more nor less embedded in a definite historical con-

"Imagery and Art in the Romantic Period." From Ernst H. Gombrich, *Meditations on a Hobby Horse* (London: Phaidon Press Ltd.). Reprinted by permission of the author and publisher.

This article represents some marginal notes to the *Catalogue of Political and Personal Satires preserved in the Department of Prints and Drawings in the British Museum,* VIII, 1801–10, by Mary Dorothy George, London (1947).

text than are state-portraits or altar paintings. And if art history were to restrict its attention to inspired masterpieces we would have to exclude many a work that usually figures in histories of style.

As a matter of fact the art historian's reluctance to deal with this type of material has been due much less to theoretical or æsthetic scruples than to practical difficulties. The knowledge and research needed to unravel the symbolism of these ephemeral productions and to resuscitate the humour of their topical allusions have often appeared to be out of all proportion to the intrinsic value of the works themselves. We have all the more reason to be grateful to the distinguished social historian who has undertaken this prodigious labour, thereby opening up to the non-specialist the greatest collection in existence of English caricatures. With every new volume of Mrs M. D. George's Catalogue that appears, it becomes increasingly evident that only now will it be possible to study the great period of English graphic journalism and to see its most creative phase in a wider perspective.

A few examples, picked almost at random from the last volume that has so far appeared, the volume covering the years 1801–10, must suffice to show the value to the art historian of the information placed at his disposal. The connection between these caricatures and the art and taste of the times can well be exemplified in a print such as Gillray's spirited work of 1803, entitled *A Phantasmagoria; Scene —Conjuring-up an Armed Skeleton* [Fig. 21].[1] It is an impressive warning against the Peace of Amiens and its Francophile sponsors who are caricatured as the witches in Macbeth. The skeleton emerging out of the cauldron (in which the claws and tail of the British lion are seen to simmer) is the gruesome phantom of Britannia conjured up by Addington (ladling guineas into the pot and raising the olive branch entwined with serpents), Hawkesbury (feeding the fire with papers inscribed *Dominion of the Sea, Egypt, Malta, Cape . . .* etc.) and Fox (holding up the broom). The crouching figure in the foreground, we learn, is Wilberforce in monkish robes, chanting a *Hymn of Peace*. The lavish display of French insignia on the politicians and the Gallic cock in the foreground perching on the decapitated head of the British lion drive home the point of Gillray's attack.

The link between this Shakespearean fantasy and the preoccu-

[1] B.M. No. 9962.

pations of contemporary academic art needs no elaboration. It is clear that Gillray—who had satirised Boydel and his Shakespeare Gallery—knew and exploited the vogue for these Romantic subjects.[2] But the catalogue helps us to recognise another link with the taste and mentality of the time:

> *"Phantasmagoria"*—Mrs George tells us—"was the name invented in 1802 by Philipsthal for an exhibition of optical illusions produced by a projecting lantern. It was a new French invention. . . . Philipsthal exhibited on a transparent screen at the Lyceum representations 'in a dark scene' of apparitions and spectres which appeared to advance or recede . . . by means of lenses and concave reflectors."

Philipsthal's magic lantern lights up, in a flash, the background of Gillray's print and the taste for which it catered. It is the exact parallel to Loutherbourg's *Eidophusikon,* which appealed to the lovers of Romantic scenery, by presenting on the stage such sensational effects as "thunder and lightning, the changes of cloud forms, the tumbling of waves and a shipwreck. . . ."[3] Romanticism pervaded political imagery no less than it transformed topographical imagery. In the sphere of literature it changed from an affair of lonely poets to a widespread fashion affecting the reading matter of the circulating libraries and producing the mystery novel, best remembered through Peacock's parodies. In the visual sphere it found its reflection not only in the art of those masters we now call the Romantic painters but also in the cheaper thrills of Philipsthal's and Loutherbourg's stage effects and in the fantastic inventions of Gillray and his followers.

Mrs George draws attention to a number of satirical prints called *Phantasmagoria*.[4] Many more deserve the same label. In fact the prints of the period exceed in extravagance and daring nearly everything that the official art of this time produced. In passing in review these grotesque inventions we are reminded of Haydon's description of Fuseli's studio with its "Galvanized devils—malicious witches

[2] Cf. T. S. R. Boase, "Illustrations of Shakespeare's Plays in the Seventeenth and Eighteenth Centuries," *Journal of the Warburg and Courtauld Institutes,* X (1947); for Fuseli's version of the subject see Ruthven Todd, *Tracks in the Snow* (1946), Fig. 19.

[3] John Piper, *British Romantic Artists* (1942), p. 13.

[4] B.M. Nos. 9971, 10,059, 10,366.

brewing their incantations—Satan bringing Chaos, and springing up-
wards like a pyramid of fire—Lady Macbeth . . . humour, pathos,
terror, blood and murder, met one at every look!" [5]

How are we to explain this ready response of graphic satire to
the Romantic trend? Should we merely attribute it to the crudeness of
popular taste which relished spectral visions and horrors? No doubt
it was partly the conservatism of the Academy which—despite
Fuseli's prestige—prevented the Romantic movement from finding
full outlet in great art. Unlike the acknowledged artist, the graphic
journalist could give the public what it liked without fear of infring-
ing any real or imagined code of good taste. But perhaps there is yet
another reason for the prevalence of the "phantasmagoric" spirit in
the great period of English caricature; a reason more intimately
bound up with the specific problems of pictorial satire: a glance at
the history of these problems suggests that the specific methods of
visual propaganda could only be absorbed by the language of art,
when Romanticism had brought about a shift in the function of the
image.

To express the complex meaning of his message the satirical
artist must often resort to the methods of the rebus and of primitive
ideographic script.[6] He must crowd on to his page a number of in-
congruous images which stand for the ideas or forces he wants to
symbolise. In periods such as the Middle Ages, when artistic conven-
tions were entirely based on the symbolic use of images, no special
problems arose from this need. The configuration of images is under-
stood and read as purely symbolic. With the victory of a realistic con-
ception of art, however, a dilemma makes itself felt. To a public, ac-
customed to see images as representations of a visual reality, the mere
juxtaposition of disconnected symbols produces a disquieting para-
dox in need of resolution. Thus, while the medieval idiom and medi-
eval motifs lived on in satirical broadsheets with astonishing tenac-
ity,[7] we also witness continuous efforts to rationalise and justify this

[5] Piper: *British Romantic Artists*, p. 26.
[6] The most recent book on the subject is J.V. Kuyk, *Oude politieke Spot-
prenten*, The Hague (1940).
[7] I have collected some examples in footnotes to F. Saxl, "A Spiritual En-
cylopedia of the Later Middle Ages," *Journal of the Warburg and Cour-
tauld Institutes*, V (1942), pp. 100 and 128, and in *The Public's Prog-
ress*, a Contact Book, London (1946).

antiquated language and to reconcile it with realistic conventions. This problem was tackled in various ways. The simplest is also the most frequent: to give up all pretensions at artistic coherence and to rely on an elaborate text in verse or prose explaining the meaning of the political emblems or "hieroglyphicks." Here the very disjointedness of their imagery is used to attract attention and to force the public to resolve the paradox by reading the "key." Close to this form—which has returned in a different guise in our posters and advertisements—is the exploitation for humorous effects, of the contrast between symbolic sense and visual absurdity. The literal illustration of figures of speech, a legitimate means of didactic imagery in the Middle Ages, shades off into comic art at the time of Bruegel. His proverb illustrations rely on the shock effect of a topsy-turvy world in which real people try to run with their heads through the wall or to kill two birds with one stone.[8] Hogarth chose the opposite way. Following Dutch seventeenth-century precedents he was fond of hiding his symbolic meaning behind a plausible pseudo-realistic façade. His cuckold does not show symbolic horns: he happens to stand "accidentally" in front of a bull whose horns seem to be protruding from his head. The symbolic image is given a witty rational justification.[9]

 In between these possibilities there lie a number of other methods of combining the emblematic use of imagery with a satisfying visual aspect. To the seventeenth century the apparatus of classical mythology and allegory provided the favourite instrument for the translation of complex statements into accepted pictorial forms. Here, where the borderline between symbol and illustration is blurred, where Mars represents war and envy may be chased from the Temple of Peace, realism and symbolism are less likely to clash. In Rubens's political paintings and—on a lower plane—in some of Romeyn de Hooghe's complicated allegorical prints the world of human beings

[8] Cf. K. Fraenger, *Der Bauernbruegel und das deutsche Sprichwort*, Leipzig (1923): the whole genre of proverb illustrations is exhaustively treated in P. de Keyser, "De Blauwe Huyck," *Gentsche Bijdragen tot de Kunstgeschiedents*. VI (1939–40). For the psychological aspect of this type of "literal" illustration, cf. E. Kris, "Zur Psychologie der Karikatur," *Imago* (1934). I am greatly indebted to Dr Kris and his approach to a field of research in which we collaborated for many years.

[9] The example is from Hogarth's *Evening* (The four Times of the Day).

and conceptual symbols appears to be reconciled.[10] But there is yet another form of rationalisation of visual symbolism and this is of the greatest interest in our present context. It is in the transference to the field of visual art of the stock method of justification, used by medieval poets. To justify the incongruities of symbolic narratives these poets were fond of representing their allegorical stories as real dreams or visions. A realistic introduction describes how the poet fell asleep and leads us to a different level of reality. This simple device allowed the narrator to introduce fantastic beings into a realistic setting without being accused of "lying." The application of this formula to visual imagery has a long and varied history. There are a number of sixteenth- and seventeenth-century prints whose fantastic agglomerations of incongruous images are explained as the literal transcriptions of portents, visions, and prophetic dreams.[11]

It was in this mode of justification that the political print may have met the Romantic movement half-way, as it were. There are certainly many social and political reasons which account for the mounting tide of graphic satire towards the end of the eighteenth century. There are also obvious stylistic elements like Hogarth's heritage and the influence of Italian *caricatura* which had its share in the increasing popularity of the pictorial lampoon. But besides these reasons the congenial climate of the Romantic era might well have been an important contributory factor in the transformation of the hieroglyphic print into the triumphant idiom of Gillray and Rowlandson. For now the weirdest combinations of symbols, the most grotesque conglomerations of images were no longer merely tolerated as the pardonable licence of a low medium of illustration. They could be attuned to the taste of the time if they were presented as phantoms, nightmares, and apparitions.[12] It seems that the Romantic movement gave new sanction to the inevitable visual inconsistencies

[10] For the Neo-Platonic elements in this approach to the visual image, cf. my article "*Icones Symbolicæ,*" *Journal of the Warburg and Courtauld Institutes,* XI (1948). The problem of justification is an aspect of this question which I have not treated there.

[11] Cf. for instance B.M. 167, 198, 315, 1047.

[12] It is characteristic that Mrs. George had to introduce the catchword ghosts and apparitions into her index of selected subjects in Vol. VII (1793–1800) (eighteen entries) and VIII (1801–10) (twenty-three entries).

of political imagery much in the way in which surrealism to-day has given licence to the gayest absurdities of our humorists on the screen, the air, and the comic weeklies.[13] The device of the *phantasmagoria* is one instance of such a rational framework for an irrational vision. It not only enabled Gillray to find a unified theme for his collection of symbols, it allowed him to endow the warning image of Britannia as a skeleton, with truly visionary intensity.

There was no need for the caricaturists to discard the older methods of allegory, humorous illustration and allusive realism. But the new spirit of the Romantic era made it possible for them to stray beyond the narrow limits of traditional emblems and allegories into the open field of free imagination. The artist was now entitled to create his own images of spiritual forces and psychological states. Figures like Woodward's *Income Tax*[14] or Williams's *Jack Frost*[15] [Figs. 22 and 23] are not only the direct ancestors of those kindly or malevolent imps which now haunt our daily lives—Mr Therm, the Squanderbug, or the Traffic Jimp—they are the legitimate offspring of Fuseli's phantoms and the poor relations of Blake's noble visions. But while Blake held fast to the belief that his figures represented a higher reality,[16] the ghosts and spectres of the caricatures are presented with the same "suspension of unbelief" which must have given its edge to Philipsthal's show. Without disbelief this Romantic thrill is impossible. The grotesque ghost is a child of Enlightenment.

In his stimulating "picture book" on Hogarth and English caricature,[17] Mr F. D. Klingender has not only drawn attention to the influence of Fuseli's *Nightmare* on the caricaturist's stock images, he has also suggested a parallel between these fantastic scenes in English political prints and the art of their greatest contemporary, Goya. If our analysis is correct it allows us to specify the nature of this parallel. Like Gillray, but on a still higher plane, Goya sought

[13] The fact that one of the most brilliant exponents of humorous absurdity, James Thurber, likes to make fun of Dali and the psycho-analysts does not refute, but confirms, the common background. In the same way Gillray's caricature of Monk Lewis and his "tales of wonder" (B.M. No. 9932) only emphasises the atmosphere that is common to both.

[14] B.M. No. 9861.

[15] B.M. No. 10,190.

[16] Cf. R. Todd, *Tracks in the Snow*, pp. 29 ff. The similarity of Blake's views with the neo-platonic tenets on visual symbols as analysed in my article quoted above is striking.

[17] London (1944), pp. 16–20.

social justification for his fantastic visions by pouring them into the pre-existing mould of satirical art. Under different social conditions he was also forced—unlike Gillray—to exploit the twilight region of the grotesque for camouflaging his political comments in the guise of mere *Caprichos* and dreams of a fevered brain. But the motto of his capriccios, "The Dream of Reason produces Monsters," sums up his own personal approach to the problem of the age. To him the suspension of unbelief, or the recurrence of belief, may not have been a free fancy to be relished for its thrills but the oppressive nightmare of the sleep of Reason.[18]

These examples illustrate one way in which the study of imagery may benefit the understanding of art. It can focus attention on latent tendencies which were never allowed to unfold fully in the sphere of high art and sought expression in more pliable media; a period's imagery may, through its very crudity, throw light on the more subtle problems of its great artists. It so happens that Mrs. George's present volume also contains an example of yet a different type of interaction between imagery and art, of the direct influence, that is, which works of indifferent quality may yet exercise on the creations of genius. Once more the material of the volume leads back to the giant of the period, to Goya.

Among the anti-Napoleonic prints of the year 1803, Mrs. George lists various plates illustrating atrocities perpetrated by Buonaparte.[19] They bear the signature of R. K. Porter, a poor artist but an interesting figure. A pupil of Benjamin West, Porter seems to have been very active in various patriotic schemes.[20] In 1805 he displayed his powers in a huge panorama of the battle of Agincourt on more than 2800 sq. ft. of canvas.[21] This Romantic showpiece of a patriotic theme was displayed at the Lyceum, the same place where Philipsthal had conjured up his Phantasmagorias. Porter then went to Russia and published illustrated travel books on Russia and

[18] Cf. José López-Rey, "Goya and the world around him," *Gazette des Beaux-Arts*, 1945, II. p. 129, where the motif of the Sleep of Reason is traced back to Addison and further instances of Goya's relation to the champions of Enlightenment are discussed.

[19] B.M. Nos. 9992, 10,062, 10,063, 10,095, cf. also Mrs. George's introduction, Vol. VIII, pp. xxi and xxxix.

[20] The Victoria and Albert Museum possesses diplomas of the Patriotic Society for the years 1803 and 1805 with cartouches drawn by Porter.

[21] W. T. Whitley, *Art in England*, 1800–20, Cambridge (1928), p. 93.

Persia. He also accompanied Sir John Moore on his unsuccessful expedition to Salamanca, which ended in the evacuation of Corunna, and finally married a Russian Princess.[22]

What is interesting in the propaganda prints conceived in his facile melodramatic idiom [Fig. 24] is their date and their motif. They anticipate by some nine years Goya's terrifying scenes of Napoleonic massacres in and after the Spanish wars [Figs. 2, 3, and 25]. It is tempting to speculate if the two could have met. There is a tradition that Goya went to Saragossa in the autumn of 1808 to paint scenes of the war which had broken out—during the very same months, that is, when Porter was attached to Sir John Moore for the identical purpose. But the tradition is unsubstantiated.[23] It is possible that Porter may have distributed his prints in Salamanca and that this is the way in which they reached Goya, but it is not necessary to make this assumption. We know that British propaganda prints were circulated (and copied) in Spain[24] and we need not strain our historical imagination to explain the connection between these violent designs and Goya's grandiose compositions. It is not only the tenor and the character of the episodes with their mixture of horror and defiance which are similar but also many individual features: the protruding eyes and violent distortions of the victim's face, the effective contrast between pointing guns and helplessly kneeling figures, the abbreviated forms through which the masses of similar victims are conveyed while attention remains focused on the principal scene—all these recur in many variations in the paintings and etchings of Goya's war scenes.

A detailed comparison between Porter's crude atrocity prints and Goya's heartrending protests against human cruelty only serves, of course, to enhance the magnitude of Goya's achievement. But it does more. It helps us to adjust our assessment of the historical role of these works. Recent descriptions of Goya's anti-Napoleonic compositions have stressed the documentary realism of this phase of his

[22] The fullest biography of Porter is still the one in the D. N. B. Porter's sketchbook of the campaign in Portugal and Spain in the British Museum is an interesting document.

[23] Enrique Lafuente Ferrari, *Goya, El Dos de Mayo y los Fusilamientos,* Barcelona (1946), pp. 19 f. [See the essay by Lafuente Ferrari on pp. 71–91 of this volume.]

[24] Cf. *B.M. Catalogue, loc. cit.* s.v. Spain and Nos. 11,058–11,061. For Goya's interest in English imagery cf. also J. López-Rey, "Goya and the world around him."

development. They have represented these creations as a revolutionary break with tradition and as the true beginning of the nineteenth century approach to art which sees in the painter the eye-witness who fashions his work out of his personal experience.[25] The existence of Porter's prints does not altogether disprove this interpretation but it shows up its dangers. The very idea of "documentary realism" requires qualification. These are not scenes at which a Spaniard and a patriot could easily have been present and survived. But even if Goya should have been eye-witness to one or the other of the terrible episodes he portrayed (and this cannot be proved) he might never have recorded his experience in visual shape had not the existing type of atrocity imagery, as exemplified in Porter's prints provided the crystallising point for his creative imagination. We realise to-day more and more how long and tortuous is the road from "perception" to "expression." The original genius who paints "what he sees" and creates new forms out of nothing is a Romantic myth. Even the greatest artist—and he more than others—needs an idiom to work in. Only tradition, such as he finds it, can provide him with the raw material of imagery which he needs to represent an event or a "fragment of nature." [26] He can re-fashion this imagery, adapt it to its task, assimilate it to his needs and change it beyond recognition, but he can no more represent what is in front of his eyes, without a pre-existing stock of acquired images than he can paint it without the pre-existing set of colours which he must have on his palette.

Seen in this light the importance of imagery for the study of art becomes increasingly apparent. In tracing the motifs, methods, and symbols of these modest productions we not only study the pale reflections of creative art, but the nature of the language without which artistic creation would be impossible.

[25] E. L. Ferrari, *Goya*, pp. 1 ff. and F. D. Klingender, *Goya in the Democratic Tradition*, London (1948), pp. 150 f. [See the essay by Klingender on pp. 36–70 of this volume.]

[26] For important parallels in the fields of science cf. R. F. Popper, "Towards a Rational Theory of Tradition," *The Rationalist Annual*, (1949).

GOYA'S PORTRAIT OF THE
ROYAL FAMILY

Fred Licht

Ever since Théophile Gautier described Goya's *Charles IV and His Family* as "the corner baker and his wife after they won the lottery," scholars, amateurs, and casual visitors to the Prado have asked themselves how it was possible for Goya's royal patrons to accept so degrading a portrait.[1] Even if one takes into consideration the fact that Spanish portraiture is often realistic to the point of eccentricity, Goya's portrait still remains unique in its drastic description of human bankruptcy.

Portraits, and especially ceremonial portraits, are always the expression of an urge to eternalize. They are, at least to some degree, monuments. The artist, for reasons he makes obvious, recommends his sitter to us as worthy of our regard and as something more than the mere sum of physiognomic features. Goya was the first artist to rob the portrait of its magic, transcendental properties. From his day onward, portraiture was the genre most deeply affected by the spiritual upheavals of the nineteenth century. Nor has the art of portraiture ever recovered its former power and popularity.

The problem surrounding the acceptability at court of Goya's fiercely intransigent realism is only one of a number of puzzles that surround this crucial work by one of the most eminent founders of the modern spirit in art. One of these riddles arises from the peculiar location of the artist himself, behind, instead of in front of his sitters.

[1] Though all the standard Goya monographs contain fairly long passages related to this painting, the most complete gathering of information concerning the sitters as well as the most complete discussion of its position in Goya's work is to be found in F. J. de Salas, *Goya, la familia de Carlos IV*, Barcelona, 1944.

Most important of all, one must consider the significance of Goya's seemingly clumsy use of a compositional prototype: Velázquez's *Meninas* [Fig. 11]. A single glance at the general construction of the two paintings is enough to prove this universally accepted fact. In both pictures the painter himself stands at a slightly inclined canvas at stage left; in both pictures the prospect is closed off by two large canvases hung on the rear wall; in both pictures the major figures are disposed in a very loose arrangement centering on a female figure brilliantly costumed (the Infanta in the Velázquez, Maria Luisa in the Goya), who, her head slightly cocked, stares straight out of the picture.[2]

Rarely, if ever before, has a painter referred so pointedly to the work of a predecessor. Goya's use of Velázquez's *Meninas* is not comparable to the usual "borrowing" of motifs and compositional ideas. When Tintoretto makes use of compositional schemata invented by Michelangelo or when Rubens uses figures derived from Titian, these "borrowings" are consistently adjusted to their new stylistic environment. They do not intrude as foreign elements into an essentially alien framework, as does the position and attitude of Queen Maria Luisa, who uncomfortably apes the stance of Velázquez's Infanta. Goya is perhaps the first artist to take motifs invented by earlier artists and use them with a minimum of change in conjunction with utterly changed stylistic circumstances. He not only makes art out of art, but he reveals the process instead of hiding it. He forces us to superimpose our memory of another painting onto his own work by collating—instead of absorbing—the borrowed elements. In this way, comparison with a prototype becomes an integral component of the significance of his work, instead of merely being an incidental homage paid to an earlier artist.

Without going too deeply into the problems *Las Meninas* poses to current scholarship, it is safe to say that the thematic and compositional core of the picture is bound up with the presence of the mirror behind the group in the foreground, in which the parents of the Infanta are reflected. The insistent stares of Velázquez, the Infanta, and the chamberlain in the background give the entire paint-

[2] Goya's admiration for *Las Meninas* is most concretely demonstrated in his interesting etched copy, which is in many ways a link between *Las Meninas* and his portrait of the royal family. In the etching, Goya already reduces the space behind the figures and begins to destroy the equilibrium between figures and surroundings which is so essential in the Velázquez.

ing an element of suspense which is resolved by the putative pres-
ence of the king and queen, who stand (according to the reflection)
somewhere outside the picture. Were it not for the mirror, which
tells us what the cynosure of the major figures is, *Las Meninas* would
be inexplicable.

In the Goya, too, the attentive glances of most of the portrait
sitters are just as strongly focused on an object outside the picture.
In fact, Maria Josefa, the king's grotesque old sister, pokes her head
forward in purposeful, birdlike curiosity. But we look in vain for the
one object that might yield a clue as to what all these people are
looking at. After all the trouble to which Goya has gone to base his
composition on *Las Meninas,* he withholds the one element which
makes the *Meninas* take on meaning: he withholds the mirror and its
telltale reflection.

Or does he? Perhaps the very lack of the key element in *Charles
IV and His Family* is deliberately meant to irritate us into finding the
mirror that Goya has so sardonically hidden. Perhaps his superficially
clumsy reference to *Las Meninas* was purposeful after all. We must
at least try to hunt for the mirror in the hope that when it is found,
it will do for the Goya what it did for the Velázquez: deliver the
answer to one of the most disturbing group portraits ever painted.

In Goya's work, references to mirrors are fairly frequent. In
Capricho #45 (*Hasta la muerte*) a vain old woman primps before a
mirror, undismayed by the hideous face that stares back at her. The
mirror in this instance serves the conventional purposes to which it
is often put in allegories of Vanity, and as such reveals nothing
original about Goya's manipulation of the mirror image.

More interesting is a series of drawings in which coquettish
young ladies and gentlemen admire themselves in front of tall mir-
rors [Fig. 19].[3] Here, the rational relationship between reflection and
object reflected has been fabulistically changed in favor of a reflection
moralisé. The mirror in each case reflects not the human figure pos-
turing in front of it, but an animal image which mimics the gestures
and attitudes of the protagonist. Another peculiarity of these draw-
ings is that the mirrors themselves are equivocal in their appearance.
In some drawings the object in front of the figure is unquestionably

[3] For the most fascinating and plausible interpretation of these drawings
as well as for the most complete bibliographical references, see Folke
Nordström, *Goya, Saturn and Melancholy* (*Studies in the Art of Goya*),
Stockholm-Uppsala, 1962, 76 ff. [See pages 138 ff. in this volume.]

a mirror. In others it looks much more like a stretched canvas attached to a rudimentary easel [Fig. 19]. What is hinted at here is probably the age-old relationship of painting and mirror: art being the mirror of nature.[4] Mirror surface and canvas surface are confusingly interchangeable in this singular series of drawings, which, significantly, dates from the same epoch as *Charles IV and His Family*.

There exists yet another important court painting in which Goya speculates on the relationship between mirror image, reality, and painted image: the portrait of Count Floridablanca [Fig. 26].[5] This is a monumental work and not just a group of drawings. What is more, we know from a letter written by Goya to Zapater that Goya attached great importance to this portrait of the powerful minister of finance, for by it he hoped to establish himself as the most fashionable portraitist at the court of Madrid. In his letter to Zapater[6] he speaks jubilantly of Floridablanca's satisfaction with the portrait and obviously feels that Floridablanca's benevolent reception of the picture will stand him in good stead.

In this painting, which was commissioned in 1783, Goya has represented himself (as he was to do later in *Charles IV and His Family*) in the presence of his patron. He stands lower left with his back to us, presenting an unframed, stretched canvas to Floridablanca; the count, his lorgnette poised in the direction of the canvas, stares *away* from the sketch, out of the picture, his head

[4] For the various uses to which mirrors are put in paintings, see G. Hartlaub, *Zauber des Spiegels*, Munich, 1951. Unfortunately, this work does not include any very satisfactory discussion of *Las Meninas* and its progeny.

[5] The most acute description and interpretation of this important and much-ignored portrait can be found in Folke Nordström, "Goya's State Portrait of the Count of Floridablanca," *Konsthistorisk Tidskrift*, 30, 1962, 82 ff. Nordström, too, interprets the gesture of Floridablanca's right hand holding his spectacles as conveying a critical pronouncement regarding the sketch that Goya holds up for his inspection. In his further discussion, Nordström identifies the sketch held up by Goya with a sketch for the St. Bernardino altar in San Francisco el Grande, which plays a prominent role in the correspondence between Goya and Count Floridablanca. The format of the canvas Goya holds speaks against this supposition, especially since the correspondence documents Goya's dissatisfaction with the tall format imposed on him by the commission for the altarpiece. Nordström's article also includes a fascinating new insight into Goya's methods by convincingly relating the Floridablanca portrait to an illustration from Cesare Ripa's *Iconologia*. [See the essay by Nordström on pp. 138–51 of this volume.]

[6] Francisco Zapater y Gomez, *Goya, Noticias biograficas,* Saragossa, 1868, 17, 25.

quite rigid, a slight smile beginning to grow on his lips. His secretary, standing behind him, stares out in the same direction.

What Goya has done in this portrait is to incorporate Floridablanca's approval into the subject of the ceremonial portrait, turning it into an advertisement of his gifts as a painter. The stance and gesture of Floridablanca suggest that he compares his reflected image in a looking glass (which must be presumed to hang just in front of him) with the painted image that Goya presents to him. His spectacles are proof enough of the fact that only a moment ago he must have been busy scrutinizing the painted portrait sketch. Now he complacently regards his mirror reflection in order to test the painter's accuracy. Successful portraiture is shown to be equivalent with fidelity to the mirror reflection.

New possibilities begin to appear in *Charles IV and His Family* if one transfers the idea of the mirror from the Floridablanca portrait and the group of mirror-sketches to the royal group portrait. For one thing, the otherwise inexplicable position of Goya *behind* his sitters begins to make good sense if he is presumed to be portraying them from their reflection in a mirror, instead of from a direct confrontation, which would be impossible given his position behind his subjects. The previously vexing problem of Goya's plagiarization of Velázquez is also solved. The mirror is still there, but it is no longer within the picture. It *is* the picture.

The original question concerning the acceptability of such an unflattering group portrait is now no longer quite so enigmatic. The reason Goya could get away with his unashamedly naked revelation of his sitters' appearance lies in the intricate situation he has set up, which is derived from the common procedure used in self-portraits. Goya has not presented his sitters as *he* saw them. He has presented them as they saw themselves. He records the unimpeachable evidence provided by the mirror image. The hard fact of this reflection is witnessed by the sitters themselves. We do not have in this painting an aesthetically conditioned image for which the artist takes full responsibility; the artist has abdicated his traditional prerogative, that of interpreting reality by recasting it in accordance with the dictates of his personal style. In a peculiarly modern speculation on the relationship which binds artist, perceived reality, and the artist's product, Goya has chosen to bring us into direct confrontation with the "Ding an sich," avoiding the traditional transcendental heightening of his subject. We are not far from de Kooning's dictum, "I

know that a painting is finished when I have painted myself out of it." Goya relinquishes the position of the artist as an agent who transmits an ideally transformed reality by means of an inspired act of creation. Instead, he bears witness to the existence of certain phenomena without deigning to become involved in the meaningful interpretation of the truths to which he testifies. If we wish to draw conclusions about the meaning of paintings such as this, we do so at our own risk.[7]

[7] Further implications of Goya's portrait of the royal family pertain to the development of the group portrait in the 19th century. This genre, which was so important in conveying the benevolent virtues of companionship, atrophied very quickly in the 19th century, and survived only under exceptional conditions. These were due either to the extreme privacy of the group portrait (cf. Degas' *Bellelli Family* in the Louvre) or to the deliberately artificial situation fabricated by the artist (cf. Fantin-Latour, *Hommage à Delacroix,* Louvre). And even in these paintings the sense of communion, the pleasures of sociability are entirely suppressed. The compositions are forced, and the figures do not look at each other or focus on some shared perception. Even in the work of more conventional artists such as Ingres, Winterhalter, or Sargent, the group portrait becomes highly problematical. In Ingres it exists primarily in commissioned sketches and not in the form of fully executed paintings. Winterhalter usually preferred to paint group portraits as pendants or as a series of separately framed paintings. Sargent, too, produced his best work in this manner (e.g., the various members of the Wertheimer family in the Tate Gallery, London). In Sargent's true group portraits, quality decreases in exact ratio to the quantity of social cohesion of the sitters. The quite justly admired masterpiece among Sargent's group portraits is his *Boit Children* (Boston, Museum of Fine Arts), which, thematically, deals not so much with the bonds of sentiment between the figures as with their distinct antagonism and deliberate isolation. In Sargent's *Wyndham Sisters* (New York, Metropolitan Museum) it is only the costuming and the brilliant brushwork that hold our interest. As a group portrait, the picture is quite still-born. Degas' group portrait *Baron Lepic Crossing the Place de la Concorde with His Two Daughters,* formerly in Berlin, foretells Sargent's *Boit Children* by making the structural and psychological composition of the picture centrifugal instead of centripetal. The drama of the picture does not depend on the connection between the figures; it depends instead on their dispersal. Though the fate of the group portrait in the 19th century is still largely unstudied, I can think of only one exception to the general trend, and that is Renoir's *Portrait of Mme. Charpentier and Her Children* in the Metropolitan Museum, New York. Perhaps photography dominated the group portrait more completely than the single portrait. Today, though the single and the family portrait survive in a debased and made-to-order form, the group portrait is entirely extinct. Colleges and other institutions will still commission portraits of presidents or benefactors; but wherever a group portrait is required (athletic teams, committees, etc.), the photograph has become the inevitable substitute.

Biographical Data

1746 March 30	Born at Fuendetodos, near Saragossa, Aragon
1760	Studies under José Luzan in Saragossa
1763 and 1766	Competes unsuccessfully for scholarships offered by the Royal Academy of San Fernando, Madrid
1771	In Rome, submits a painting to a competition held by the Academy in Parma
1771	Submits sketches for frescoes in the Cathedral of El Pilar, Saragossa
1773	Marries Josefa Bayeu
1774	Summoned by Mengs to paint cartoons for tapestries to be woven at the Royal Factory of Santa Barbara, Madrid
1775–1792	Occupied intermittently with tapestry cartoons
1778	Publishes eleven etchings after paintings by Velázquez
1780	Elected to membership of the Royal Academy of San Fernando
1785	Appointed Deputy Director of Painting in the Academy
1786	Appointed Painter to the King (*Pintor del Rey*)
1789	Raised to the rank of Court Painter (*Pintor de Camara*)
1792	Falls seriously ill during a journey to Andalusia and is left permanently deaf
1793	Paints a group of uncommissioned cabinet pictures during convalescence
1795	Appointed Director of Painting in the Academy of San Fernando
1797	Resigns directorship for reasons of health
1798	Paints fresco decorations in San Antonio de la Florida, near Madrid

1799	Announcement of the publication of the *Caprichos* (a series of etchings of satirical and fantastic subjects)
1799	Appointed First Court Painter
1800	Paints portrait of *Charles IV and his Family*
1803	Presents plates of the *Caprichos* to the King
1804	Applies unsuccessfully to be made Director-General of the Academy of San Fernando
1808	French invasion of Spain. Goya paints an equestrian portrait of Ferdinand VII; swears allegiance to Joseph Bonaparte, placed on the Spanish throne by Napoleon
1810	Dates some of the etchings of the *Desastres de la Guerra* (a series of etchings on the disasters of war)
1811	Awarded the Royal Order of Spain by Joseph Bonaparte
1812	Paints an equestrian portrait of the Duke of Wellington
1814	French expelled from Spain; restoration of Ferdinand VII. Goya paints the *2nd of May* and the *3rd of May* to commemorate the War of Independence
1815	Summoned to appear before the Inquisition because of the *Naked Maja* and the *Clothed Maja*
1816	Publication of the *Tauromaquia*
1819	Suffers serious illness; paints the *Last Communion of St. Joseph of Calasanz* (in the Church of San Anton, Madrid)
1820	Makes his last appearance at the Academy to swear allegiance to the newly restored Constitution
1820	Decorates his house, the Quinta del Sordo, with the Black Paintings; etches the *Disparates* (or *Proverbios*)
1823	After a liberal interlude, the King restored to absolute power
1824	Goya goes into hiding; applies for leave of absence to go to France; settles in Bordeaux
1826	Visits Madrid
1828 April 16	Dies in Bordeaux

Notes on the Editor and Contributors

Théophile Gautier (1811–1872). Though primarily known as a poet, Gautier was an early prototype of the *flaneur*. Fascinated by the world around him, impartial and yet impassioned in his observations, he had the knack of catching the imagination and the allegiance of revolutionary young artists and writers while commanding the respect of the cautious bourgeoisie. He was, above all, extraordinarily able at the art of self-advertising. His *Spanish Journal,* published in 1842, is among his most charming works. Written with flair and with the dramatics of a pioneer who admits to a great deal of self-irony, it is especially noteworthy for the sensitive depiction of landscape, customs, and monuments. He captures with great skill all those aspects that made Spain at once romantically remote and extremely modern to French intellectuals of the 19th century.

Charles Baudelaire (1821–1867). First published in 1857, Baudelaire's essay on Goya is one of the major milestones not only of the bibliography of Goya but also of modern art criticism. In Goya, Baudelaire finds one of those germane souls (Edgar Allan Poe was another) whose life and work sum up and interpret the spiritual *locus* of modern man. The anguish; the fierce rebellion against traditions that have turned into rancid conventions; the incorruptible will to question all values; the sense of loneliness, futility, and moral pride in being alone in an alien universe —all are expressed in Baudelaire's poetry and in his critical essays on artists in whose style he finds a confirmation of his own sentiments. In his poem "Phares," Baudelaire again alludes to Goya as one of those titans who retain their guiding steadfastness despite the impenetrable darkness of the modern condition.

Enrique Lafuente Ferrari. Professor Lafuente Ferrari is the *doyen* of Spanish art history. The pervasive influence of his teaching and his writing has already left its mark. The study of Spanish art is no longer the restricted terrain of a few *aficionados* but has established a broad base

at universities and museums and also among a large public more and more involved in the study of the nation's great artistic heritage. The essay presented here is reprinted without its vast apparatus of scholarly footnotes, which really form an independent series of essays.

Francis Klingender (1907–1955). Born of English parents in Germany, Klingender received a thoroughgoing classical education. Returning to England after World War I, he enrolled in the London School of Economics and devoted the rest of his life to studies that centered around his Marxist convictions and his desire to make the plight of the proletariat clear to an indifferent public of intellectuals. His book on Goya was written during the years of the Spanish Civil War but went unpublished for nearly a decade. It is a work of extraordinary interest for those who, like Goya, are fascinated by the political forces at play during the crucial years of modern history.

Theodor Hetzer (1890–1946). Hetzer's career was marked by a certain shyness. Living through decades that saw the growing popularity of art history, he never took his share of the public applause gathered by many of his contemporaries in a Germany that was willing to pay respect and even homage to art historians. His major influence was as a teacher. His writings on Giotto and Titian are only now being recognized for their essential worth. His lecture on Goya, one of the most fundamental essays ever written on the master, has not been available in translation until now and has never been discussed to the extent it deserves.

José López-Rey. Professor López-Rey can look back on a distinguished career as professor at the Institute of Fine Arts of New York University. He has taken Goya's political lessons seriously and, like his compatriot Pablo Casals, has not returned to Spain since the end of the Civil War. His background is formed by his studies of Spanish philology and literature; the authority of his knowledge in these fields has greatly enlarged the scope of his monumental work on Goya and of his understanding of the unique significance of Spanish art in general.

Folke Nordstroem. An active and highly original school of art history has developed over the past half-century around the University of Upsala and the Royal Museum of Art at Stockholm. Nordstroem is one of the most highly esteemed members of this group, and his publications on Goya have contributed greatly to our knowledge of Goya's intellectual and artistic milieu. A whole new aspect of Goya's personality, his scholarly erudition, and his knowledge of traditional baroque literary and emblematic sources has emerged as a consequence of Nordstroem's research. Independently, a similar series of fruitful investigations have been pursued by George Levitine of the University of Maryland.

Ernst Gombrich. Professor Gombrich is one of the central figures of international art history. He is best known for his encyclopedic knowledge of all aspects of Renaissance culture. In that respect, he continues the great traditions first founded by such men as Jacob Burckhardt. Like

Burckhardt, he is not exclusively devoted to the Renaissance and has made epochal contributions to the study of very different periods of civilization. Unlike so many of his colleagues, Gombrich's work is never hermetic or meant primarily for the eyes and minds of his peers. He is deeply aware of the need to penetrate to the essential meaning of the works of art he deals with and to transmit his findings to all whose attention in life is focussed on man, his mind, and his sensibilities. The essay that is presented here represents only a small and peripheral fragment of Professor Gombrich's work. Yet he has brought about an important reorientation in the study of modern art. The minor and the "commercial" arts as sources of inspiration for artists whose sense of reality was totally different from that of artists before the French Revolution have become major fields of study because of Professor Gombrich's article.

Selected Bibliography

Goya's complete graphic works in four paperback volumes: *Los Caprichos* (1969), *Disasters of War* (1967), *The Disparates* (1969), *La Tauromaquia* (1969) (New York: Dover Publications, Inc.).

ADHÉMAR, JEAN. "Essai sur les débuts de l'influence de Goya en France au XIXe siècle." In *Goya: Exposition de l'oeuvre gravé, de peintures, de tapisseries et de cent dix dessins du musée du Prado,* pp. xx–xxxiv. Paris 1935.

――――. *Goya.* Paris, 1941. English ed.: London and Paris, 1948.

AGUILERA, EMILIANO M. *Pintores españoles del siglo XVIII,* 3rd ed. Barcelona, 1952.

――――. *Las pinturas negras de Goya.* Madrid, 1950.

ARCE, RICARDO DEL. "El circulo de pintores aragoneses en torno de Goya." In *Revista de ideas estéticas,* 4 (1946), 379–415.

――――. "Jovellanos y las bellas artes." In *Revista de ideas estéticas,* 4 (1946).

BENESCH, O. "Rembrandt's Artistic Heritage," Pt. 2, from "Goya to Cézanne." In *Gazette des beaux-arts,* 56 (1960), 101–16.

BEROQUI, PEDRO. "Una biografía de Goya escrita por su hijo." In *Archivo español de arte y arqueología,* 3 (1927), 99–100.

BERUETE Y MORET, A. DE. *Goya, pintor de retratos,* 2nd ed. Madrid, 1919.

BOELCKE-ASTOR, A. C. "Die Drucke der Desastres de la Guerra von Francisco Goya unter Zugrundelegung der Bestände des Berliner Kupferstichkabinetts." In *Münchner Jahrbuch der bildenden Kunst,* 3/4 (1952/53), 253–334.

BOIX, F. *Los dibujos de Goya.* Conferencia pronunciada en el local de la exposición de dibujos. Madrid, 1922.

CAMÓN AZNAR, JOSÉ. "Cuadros de Goya en el Museo Lazaro." In *Seminario de arte aragonese*, 4, 5–14. Zaragoza, 1952.

————. *Goya en los años de la Guerra de la Independencia*. Zaragoza, 1959.

CARDERERA, VALENTÍN. "François Goya: Sa vie, ses dessins et des eaxfortes." In *Gazette des beaux-arts*, 7 (1860), 215–21.

CLARK, KENNETH. "Goya: The Third of May 1808." In *Looking at Pictures*, pp. 123–31. London, 1960.

COOK, W. "Portraits by Goya." In *Gazette des beaux-arts*, 28 (1945), 151.

CRUZADA VILLAAMIL, GREGORIO. *Los tapices de Goya*, Biblioteca de El arte en España, Vol. 8. Madrid, 1870.

DELTEIL, L. *Le Peintre-graveur illustré*, Vol. 14. Paris, 1922.

DESPARMET FITZ-GERALD, XAVIÈR. *Goya*. Paris, 1956.

————. *L'Oeuvre peint de Goya: Cataloque raissoneé*, Texte I–II. Paris, 1928–1950.

DODGSON, H. "Some Undescribed States of Goya's Etchings." In *The Print Collector's Quarterly*, 1927, pp. 30–45.

EZQUERRA DEL BAYO, JOAQUIN. *La Duquesa de Alba y Goya*. Madrid, 1928.

GASSIER, PIERRE. *Goya: Biographical and Critical Study*. Lausanne, 1955.

———— and WILSON, J. *Oeuvre et vie de Francisco Goya*. Fribourg, Switzerland, 1970.

GLENDENNING, NIGEL. "Goya and England in the 19th Century." In *The Burlington Magazine*, 106 (January 1964), 4–14.

GOMBRICH, E. H. "Imagery and Art in the Romantic Period." In *The Burlington Magazine*, 91 (1949), 153–59.

GOMEZ DE LA SERNA, RAMON. *Goya*. Madrid, c. 1945.

Goya and His Time (exhibition catalogue). London, 1963.

GUDIOL, J. *Catalogo analitico de las pinturas de Goya*. Barcelona, 1970.

————. "Les Peintures de Goya dans la Chartreuse de L'Aula Dei à Saragosse." In *Gazette des beaux-arts*, 57 (1961), 83–94.

GUÉ TRAPIER, E. DU. "Only Goya." In *The Burlington Magazine*, 102 (1960), 158–61.

HARRIS, EBRIQUETA. "A Contemporary Review of Goya's *Caprichos*." In *The Burlington Magazine*, 106 (January 1964), 38–43.

HARRIS, T. *Goya: Engravings and Lithographs*. Oxford, 1964.

HELD, JUTTA. "Literaturbericht: Francisco de Goya, Die Gemaelde." In *Zeitschrift fuer Kunstgeschichte*, 28, no. 3 (1965), 229.

————. "Literaturbericht, Francisco de Goya, Die Grafik." In *Zeitschrift fuer Kunstgeschichte*, 27, no. 2 (1964), 60.

————. "Literaturbericht, Francisco de Goya." In *Zeitschrift fuer Kunstgeschichte*, 27, no. 1 (1964), 60–74.

HELMAN, EDITH. "Identity and Style in Goya." In *The Burlington Magazine*, 106 (1964), 30–37.

————. "El Transmundo de Goya." In *Revista de ideas estéticas*, (1956).

————. "Why did Goya paint the Injured Mason?" In *10th Anniversary of the Simmons Review*, pp. 2–3, 56. Boston, 1957.

————. "The Younger Moratín and Goya: On Duendes and Brujas." In *Hispanic Review*, 27:103–22. Philadelphia, 1959.

HERRAN, D. A. DE LA. *Pinturas negras y apocalípticas de Goya*. Bilbao, 1950.

HOFER, PHILIP. "Some Undescribed States of Goya's Caprichos." In *Gazette des beaux-arts*, 87, no. 2 (1945), 163–80.

HOFMANN, J. *Francisco de Goya: Katalog seines graphischen Werkes*. Wien, 1907.

HYATT MAYER, A. "Goya's Hannibal crossing the Alps." In *The Burlington Magazine*, 97 (1955), 295–96.

INIGUEZ, D. ANGULO. "La familia del infante Don Luis de Borbón pintada por Goya." In *Archivo español de arte*, 14 (1940), 49–58.

————. "The Family of Infante Don Luis by Goya." In *The Burlington Magazine*, 87 (1945), 303.

KLINGENDER, FRANCIS D. *Goya in the Democratic Tradition*. London, 1948.

LAFUENTE FERRARI, ENRIQUE. *Antecedentes, coincidencias e influencias del arte de Goya*. Madrid, 1947.

————. *Goya: Les Fresques de San Antonio de la Florida à Madrid*. Lausanne, 1955.

————. "Goya y el arte francés." In *Goya: Cinco estudios*, pp. 43–66. Zaragoza, 1949.

————. "Sobre el cuadro de San Francisco el Grande y las ideas estéticas de Goya." In *Revista de ideas estéticas*, 4 (1946), 307–37.

LEFORT, P. *Francisco de Goya: Etude biographique et critique, suivie de l'essai d'un catalogue raisonné de son oeuvre gravé et lithographié*. Paris, 1877.

LEVITINE, GEORGE. "The Elephant of Goya." In *The Art Journal*, 20 (1961), 145–47.

————. "The Influence of Lavater and Girodet's *Expression des sentiments de l'ame*." In *Art Bulletin*, 37 (1954), 33–44.

————. "Literary Sources of Goya's *Capricho 43*." In *Art Bulletin*, 37 (1955), 56–59.

————. "Some Emblematic Sources of Goya." In *Journal of the Warburg and Courtauld Institute*, 22 (1959), 106–31.

LICHT, FRED. "Goya." In *L'Oeil*, October 1970, p. 3.

————. "Goya's Portrait of the Royal Family." In *The Art Bulletin*, 49 (1967), 127.

VON LOGA, VALERIAN. *Francisco de Goya*, 2nd enl. ed. Berlin, 1921.

LONGHI, R. "Il Goya Romano e la cultura de Via Condotti." In *Paragone*, 5, no. 53 (1954), 36 ff.

LÓPEZ-REY, JOSÉ. "A Contribution to the Study of Goya's Art, the San Antonio de la Florida Frescoes." In *Gazette des beaux-arts*, 86 (1944), 231–48.

————. *A Cycle of Goya's Drawings: The Expression of Truth and Liberty*. London, 1956.

————. "Four Visions of Woman's Behavior in Goya's Graphic Work." In *Gazette des beaux-arts*, 90, no. 2 (1948), 355–64.

————. *Francisco de Goya*. London, New York, Toronto, 1951.

————. "Goya and the World around Him." In *Gazette des beaux-arts*, 87, no. 2 (1945), 130–50.

————. *Goya's Caprichos: Beauty, Reason and Caricature*, Vols. 1 and 2. Princeton, New Jersey, 1953.

MALRAUX, ANDRÉ. *Saturne: Essai sur Goya*. Paris, 1950.

————. *Saturn: An Essay on Goya*. English trans. by C. W. Chilton. London, New York, 1957.

MATHERON, LAURENT. *Goya*. Paris, 1858.

MILICUA, J. "Anotaciones al Goya joven." In *Paragone*, 5, no. 53 (1954), 21.

NEGRI, R. *Goya*. Amsterdam, 1968.

NORDSTRÖM, FOLKE. "Goya och hertigparet av Osuna." In *Spanska mästare: En konstbok från Nationalmuseum (Arsbok för Svenska statens konstsamlingar*, 8), pp. 157–69, 174n. Stockholm, 1960.

————. *Goya och melankolien: Studier i Goyas konst*. Uppsala, 1956.

————. "Goya's State Portrait of the Count of Floridablanca." In *Konsthistorisk tidskrift*, 30 (1962).

ORTEGA Y GASSET, J. "Pinceladas son intenciones." In *Goya*, pp. 11–18. Madrid, 1958.

DE PANTORBA, B. "La ermita de San Antonio de la Florida." In *Museos de pintura en Madrid*, pp. 127–34. Madrid, 1950.

PARIS, PIERRE. *Goya (Les Maîtres de l'art)*. Paris, 1928.

PEMAN Y PEMARTÍN, C. *Los goyas de Cadíz*. Cadiz, 1928.

PIOT, E. "Catalogue raisonné de l'oeuvre gravé de Goya." In *Le Cabinet de l'amateur*, 1, no. 5, 346.

RAGGHIANTI, C. L. "Goya e i suoi pensieri sull'arte." In Ragghianti, *Il Pungolo dell'arte*, pp. 151–57. Venice, 1956.

ROTHE, H. *Las Pinturas del panteón de Goya*. Barcelona, 1944.

ROUANET, G. *Le Mystère Goya: Goya vu par un médecin*. Paris, 1960.

SALAS, X. DE. *Goya*. London, 1962.

————. "Goya in Paris." In *The Burlington Magazine*, 104 (1962), 104.

————. *Goya: La familia de Carlos IV*. Barcelona, 1944.

————. *Goya y sus pinturas negras en la Quinta del Sordo*, p. 63 ff. Mailand-Barcelona, 1963.

————. "Portraits of Spanish Artists by Goya." In *The Burlington Magazine*, 106 (January 1964), 14–19.

————. "Sur les tableaux de Goya qui appartinrent à son fils." In *Gazette des beaux-arts*, 63 (1964), 98–110.

SALTILLO, MARQUES DEL. *Goya en Madrid: Su familia y allegados (1746–1856)* (*Miscelanea madrileña, historica y artistica*, Primera serie). Madrid, 1952.

SAMBRICIO, VALENTÍN DE. "El casticismo en los tapices de Goya." In *Revista de ideas estéticas*, 4 (1946), 449–72.

————. "Les Peintures de Goya dans la Capelle du Palais des Comtes de Sobradiel." In *Revue des arts*, 4 (1954), 215–22.

————. "Los retratos de Carlos IV y Maria Luisa por Goya." In *Archivo español de arte*, 30 (1957), 85–113.

————. *Tapices de Goya*. Madrid, 1946.

SÁNCHEZ CANTÓN, F. J. *Los caprichos de Goya y sus dibujos preparatorios*. Barcelona, 1949.

————. "Como vivia Goya." In *Archivo español de arte*, 19 (1946), 73–109.

————. "La elaboración de un cuadro de Goya." In *Archivo español de arte*, 18 (1945), 301–7.

————. "Goya, pintor religioso." In *Revista de ideas esteticas*, 4 (1946), 281.

————. *The Prado Museum*, 2nd ed. Madrid, 1954.

————. "El primer viaje de Goya a Madrid." In *Archivo español de arte y arqueología*, 5 (1929), 193–95.

————. *Vida y obras de Goya*. Madrid, 1951.

SAYRE, ELEANOR A. "Eight Books of Drawings by Goya." In *The Burlington Magazine*, 106 (January 1964), 19–30.

————. "Goya's Bordeaux Miniatures." In *Boston Museum Bulletin*, 64 (1966), 84.

————. "An Old Man Writing: A Study of Goya's Albums." In *Bulletin of the Museum of Fine Arts*, Boston, 56, no. 305 (1958), 117–36.

SHERMAN-FONT, E. "Goya's Sources for the Margato Series." In *Gazette des beaux-arts*, 57 (1958), 289.

SORIA, MARTIN S. *Augustin Esteve y Goya*, pp. 35 ff. Valencia, 1957.

————. "Goya's Allegories of Fact and Fiction." In *The Burlington Magazine*, 90 (1948), 196–200.

STARKWEATHER, WILLIAM. *Paintings and Drawings by Francisco Goya in the Collection of the Hispanic Society of America* (Publication of the Hispanic Society of America, 96). New York, 1916.

STOLZ, R. "Technique de Goya fresquiste." In Enrico Lafuente Ferrari, *Goya: Les Fresques de San Antonio de la Florida,* pp. 135–39. Geneva, 1955.

TRAPIER, ELIZABETH DU GUÉ. *A Study of His Portraits 1797–99* (*Hispanic Notes and Monographs,* Essays, studies, and brief biographies issued by The Hispanic Society of America). New York, 1955.

VINAZA, CONDE DE LA. *Goya: Su tiempo, su vida, sus obras.* Paris, 1887.

WEHLE, H. B. "An Album of Goya's Drawings." In *Bulletin of the Metropolitan Museum of Art,* 21, no. 2 (February 1936).

———. *Fifty Drawings by Francisco Goya.* New York, 1938.

WYNDHAM LEWIS, D. B. *The World of Goya.* London, 1968.

YRIARTE, CHARLES. *Goya: Sa biographie, les fresques, les toiles, les tapisseries, les eaux-fortes et le catalogue de l'oeuvre.* Paris, 1867.

ZAPATER Y GOMEZ, F. *Goya: Noticias biográficas,* p. 11. Zaragoza, 1868.

List of Illustrations